PHOTOGRAPHER'S
HANDBOOK

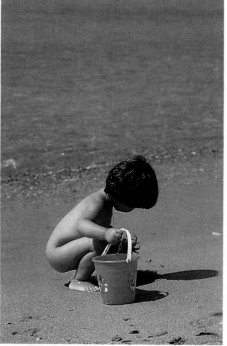

PHOTOGRAPHER'S
HANDBOOK

Michael Busselle
and John Freeman

Octopus Books

4 CONTENTS

First published in 1985 by
Octopus Books Limited
59 Grosvenor Street
London W1

© 1984 Octopus Books Limited

ISBN 0 7064 2115 9

Produced by Mandarin Publishers Limited
22a Westlands Road
Quarry Bay
Hong Kong

Printed in Hong Kong

Reprinted 1987

6 INTRODUCTION

Photography is now one of our most popular leisure pursuits and there can be few families that do not own a camera. However, in spite of, or indeed, perhaps because of, the simple and effortless way in which photographs can now be produced, the techniques of photography still remain something of a mystery to a large proportion of people. This not only detracts considerably from the pleasure involved in taking photographs but also limits the way a photographer can progress, taking good pictures then becomes something of a hit or miss affair. Taking the most popular themes as a basis, this compact book is designed to explain and demonstrate how the reader can extend his knowledge of both equipment and photographic techniques in a logical and easily understandable way, as well as increasing his visual awareness. Using examples drawn from the subjects which most interest the amateur photographer such as family and child photography, and holiday and travel pictures, together with the use of 35mm equipment and colour film, a series of frequently asked questions are answered in a direct and practical way enabling the book to be used as a convenient means of reference as well as being a readable and progressive course in photography.

1 CAMERA EQUIPMENT AND ACCESSORIES

There are two main types of 35mm camera. The difference between them is the way in which they are aimed and focussed.

The viewfinder type camera uses a separate optical system through which the subject is viewed. Focussing is achieved either by judging the distance and setting it onto a scale on the lens mount or by using a rangefinder or automatic focussing mechanism to obtain a more precise measurement. Most cameras of this type have a fixed lens, usually between 45 and 55mm focal length, which gives a normal angle of view. Some more advanced (and expensive) viewfinder cameras, such as the Minolta CLE system, have a wide range of interchangeable lenses. Many cameras of this type can be bought with either built-in or automatic exposure meters. Some have automatic film winding. Specialized versions of the viewfinder camera include underwater and weatherproof models and panoramic cameras.

The second basic type of 35mm camera is the SLR (single lens reflex), in which both the viewing and focussing is carried out through the camera lens itself. This is at once more accurate and more flexible. Most cameras of this type are equipped with interchangeable lenses and a very wide range of different focal lengths is available.

The optical design of the SLR makes it possible for many other features to be fitted into it, making it far more flexible in its applications than the viewfinder type, although in general it is more expensive and complex. Very accurate exposure metering systems, both automatic and manual, are usually fitted and specialist equipment, such as motor drives and specially designed lenses, is readily available.

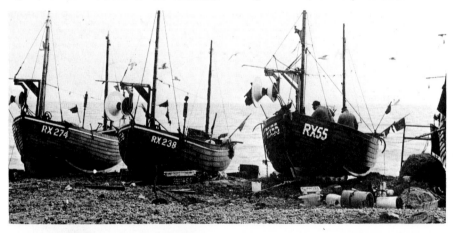

Above For this type of middle distance subject a compact type camera with a symbol or distance scale focussing, such as the Mamiya shown here, to estimate the setting is perfectly satisfactory, since depth of field will easily take care of any inaccuracies.

Q Why do SLR cameras have much faster shutter speeds than the viewfinder type?
A Because the SLR uses a focal plane shutter, which is capable of much faster speeds than the between lens type fitted to most viewfinder cameras.

Q Is the SLR more accurate to focus than a rangefinder?
A No. But the SLR gives a good indication of the *effect* of focussing whereas the viewfinder shows you the whole image sharp through the viewfinder, even where it is out of focus.

Q Does the rangefinder have any advantages?
A It is easier to focus in poor light.

Q Why do SLR cameras have a special flash setting on the shutter speed dial?
A Because the focal plane shutter will not synchronize with shutter speeds faster than about $1/125$ second. However, you can use flash with the speeds slower than that of the flash setting.

Q Will an SLR take better pictures than a viewfinder camera?
A No. Price for price the results from both are likely to be identical in their basic form, but the SLR can be adapted to produce better pictures under certain conditions.

Q What advantage does the viewfinder camera have?
A As a general rule, they are less complex, less bulky and lighter and can be made in a simpler form than the SLR. Therefore they are less expensive. They are also quieter in operation.

Below *More critical and accurate focussing is vital for this type of picture, such as that provided by a rangefinder or autofocus type camera, such as the Minolta shown here, or an SLR.*

12 TYPES OF CAMERA

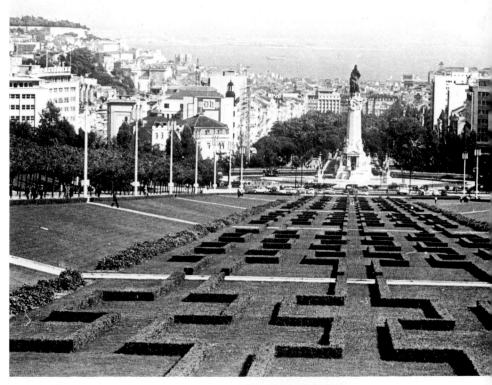

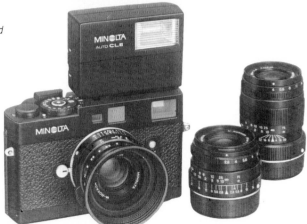

Above The ability to change lenses
makes this type of shot possible. Both
wide angle and long focus lenses can add
considerable scope to a basic camera
and interchangeable lens designs are
available in both SLR and rangefinder
models, such as this Minolta CLE.

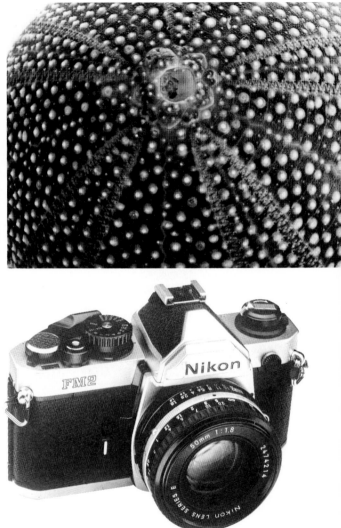

Above *For extreme close-up pictures, like this shot of a sea anemone shell, the SLR camera, such as this Nikon FM2, is the best choice since it offers accurate focussing and viewfinding at every focussing distance.*

It can even be used with a microscope when fitted with the necessary attachment. To the left is a small diagram showing the principle by which the single lens reflex system works.

14 CHOOSING A CAMERA

Since the term holiday and travel photography embraces a wide variety of subjects, you must have a fairly firm idea of the type of pictures you will want to take in order to make the most sensible camera choice. There are two main considerations: the size of the film you will use and the degree of versatility that you will require in the camera. You will also want to con-

If your main purpose is simply to make a personal record of a family holiday, for which colour prints of up to 20 × 15cm would be adequate, then a cartridge-loading, disc or instant picture camera might be a suitable choice. The bonus with this sort of camera is that its size and weight will not encroach too much on your holiday activities. However, if you feel that you might want occasionally to make larger prints or to have colour transparencies for projection, then a 35mm camera would be a more suitable choice. If you select a compact type with an optical viewfinder, it will still be of modest size, weight and cost.

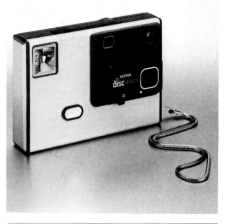

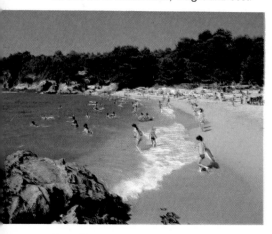

Above The two illustrations show the Kodak disc camera and film. Even the simplest version can produce good results with the type of subject shown above, and when only relatively small colour prints are wanted.

Right When the subject is closer than about three or four metres, as in the picture above, then a camera such as the Canon autofocus, which enables the image to be accurately focussed, is a better choice, especially when larger prints or transparencies are needed.

Q Is there any point in buying a 35mm SLR if my main interest is in family holiday photography?
A Yes, because if your interest grows then you will be able to add to the camera you already have.

Q Is a simple cartridge-loading camera going to give very much inferior results to, say, a 35mm SLR?
A Not within its limitations, that is small prints and good lighting.

Q I have heard that battery-powered cameras are a bad choice for travel photography because of their dependence on availability. Is this true?
A Not really. If you can remember to carry spare film then a couple of sets of batteries should not be a problem.

Q I would like to try underwater photography. Is the equipment very expensive?
A You can buy quite inexpensive compact cameras that are capable of being used at modest depths.

Q Having chosen which type of camera I want, how do I choose the model?
A Fix a price range and try to see everything within it. Choose according to the way the camera feels. Within a given price bracket, there is unlikely to be much difference in quality, but cameras can have very different handling characteristics.

Q Is there an advantage in buying the well-known makes or is it just the name?
A You will find it easier to hire or buy accessories for the big name cameras, and servicing facilities are likely to be more widely available away from home.

16 CHOOSING A CAMERA

For those who want to be able to cope with a wider range of subjects than will be anticipated on a family holiday – to pursue a specialized interest, for example, or to make large prints for exhibition or transparencies for reproduction – then a camera with an interchangeable lens facility, possibly one that takes the larger roll film formats, should be considered. Although the viewfinder/rangefinder type of camera can be bought with an interchangeable lens facility, and there is a wide range of accessories for cameras like the Leica M series, most photographers would agree that the SLR system offers the greatest flexibility. There are few subjects that cannot be handled with the same basic SLR camera body, which can be fitted with long telephoto and ultra wide angle lenses, and an immense variety of specialist accessories. This type of camera can be obtained in most film formats, but 35mm is the most popular because it combines maximum flexibility at reasonable cost.

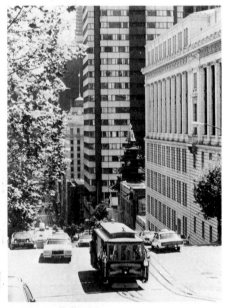

Above The scope of a camera greatly increases when it is possible to change the focal length of the lenses, as these two pictures demonstrate. Although most cameras of this type are of the SLR design some rangefinder versions, such as the Minolta CE shown on the right, also have interchangeable lenses.

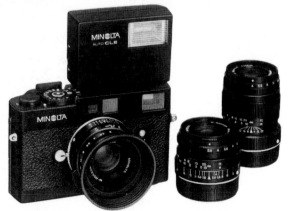

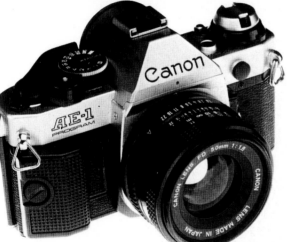

Left Close-up pictures like this shot above are easily and effectively taken with an SLR such as the Canon AE1 illustrated here, since a variety of close-up attachments are available and the camera can be accurately framed and focussed at very close distances.

Right When pictures are intended for reproduction in magazines or travel brochures the larger format and additional image quality shown in the picture right can be an advantage and a roll film camera such as the Mamiya RZ67 can be the best choice.

18 CHOOSING ACCESSORIES

The capability of even a quite simple camera can be extended to handle a wider range of both subjects and lighting conditions by the use of a few basic accessories. In particular, when travelling with a camera it is helpful to be prepared for as many situations as possible. One or two additional lenses are the most important extras for those with an interchangeable lens camera. A wide angle lens of between 24 and 35mm focal length on a 35mm camera will be invaluable for subjects such as landscape and architecture, and a long focus lens of between, say, 85 and 150mm for general-purpose photography of people and scenic subjects. A longer focal length of 200 to 300mm should also be considered for more specialist subjects such as wildlife or sport. A

zoom lens can provide a good compromise. These are available in wide angle, telephoto and mid ranges. To increase the ability to cope with unfavourable lighting conditions both a small flash gun and a tripod will be of considerable help. They need not add much bulk and weight to the outfit, although you should ensure that the tripod is firm. A filter system such as the Cokin is also a good investment, since black and white filters, colour-correction filters and special effects attachments can all be incorporated into a single mount adapted to fit a variety of lenses. Supplementary or close-up lenses can be included in this type of system, but for those who specialize in this style of picture a set of extension tubes, a bellows attachment or a macro lens would be useful.

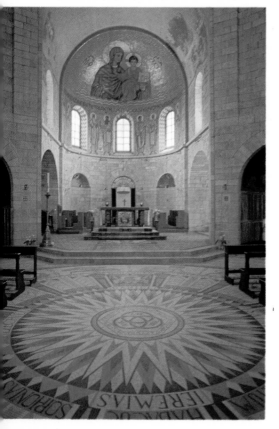

Left and above A tripod is an invaluable accessory for subjects such as this church interior, where low levels of light or the need for a small aperture make it necessary to use shutter speeds longer than that which can be safely made with a handheld camera.

Q What sort of wide angle lens is best for photographing buildings?
A A 24mm is a good compromise between the ultra wide 16 to 20mm and the 28 to 35mm with its narrower angle of view. A perspective control lens is worth.considering if architecture is your special interest.

Q Would not a 70 to 210mm zoom be the best choice for a long focus lens?
A A zoom lens of this type can be quite bulky and heavy when carried all day and is also likely to have a smaller maximum aperture than a normal long focus lens.

Q Is a separate exposure meter better than one built into the camera?
A It can be more convenient for taking close-up and incident light readings and is very useful to have in addition to the integral meter in the case of a breakdown.

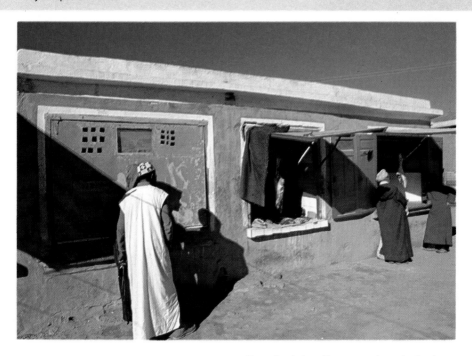

Above A polarizing filter was used to make the sky a richer and darker tone cf blue in this shot of a Moroccan market. It can also help to make colours more saturated and improve the quality of water and other reflective surfaces.

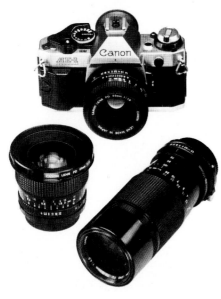

The two most useful filters for colour photography are the skylight or the 81A and the polarizing filter. The former is effective in preventing the blue cast created when shooting on a cloudy day, in open shade or at high altitudes, when there is an excess of ultraviolet light. The polarizer is invaluable for improving the colour saturation and clarity of images by reducing the amount of scattered and reflected light. It will also add depth and colour to blue skies and seas. The graduated filters are also effective in emphasizing the tone and colour of skies in landscape pictures.

A UV filter or an 81A is invaluable for pictures such as this mountain shot, where the presence of ultraviolet light can create a blue cast on colour film.

22 THE CAMERA CONTROLS

In spite of the many different types of design of camera their basic components are all the same: a light-tight compartment to hold the film, a method of focussing and viewing, an aperture to control the amount of light passed through the lens and a shutter to control the length of time that the image is allowed to play on the film. The complexities of the more expensive cameras are mainly ways of making these basic components more convenient and efficient, but a simple camera has the same facilities.

Most simple 35mm cameras have either a graduated distance scale to assist focussing or a number of symbols such as a head and shoulder portrait, a full-length portrait and a distant view. While this is quite adequate for snapshots more critical focussing – such as that provided by a rangefinder or an SLR – is vital for serious work.

Both the aperture scale and the shutter speed dial of the camera enable the exposure to be either halved or doubled at each step. The exposure is halved as the aperture number (f number) increases: f8 is half the exposure of f5.6 for example; and on the shuttter speed dial, of course $\frac{1}{60}$ second is half the exposure of $\frac{1}{30}$ second and so on. With most 35mm cameras the aperture scale can also be set between the f numbers.

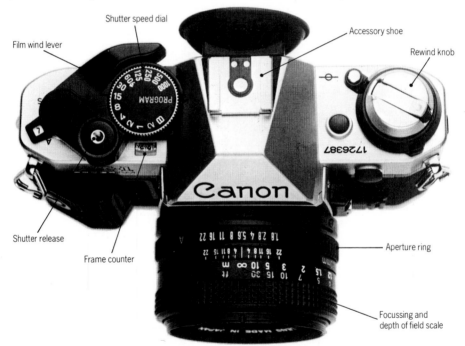

Film wind lever

Shutter speed dial

Accessory shoe

Rewind knob

Shutter release

Frame counter

Aperture ring

Focussing and depth of field scale

Above and right These two illustrations show a typical comparison between the camera control layouts of a compact and an SLR. Although there are variations between makes of camera the main difference is that the shutter speed dial is set on the top of the SLR but on the lens mount of the compact. The main point, however, is that the basic functions are the same.

Right Light exposure meters work by showing the correlation between shutter speed and f stops, and their changing relationship under different light conditions. As the light changes, necessary adjustments will be indicated.

Q What exactly is an f number?
A An f number denotes the size of the aperture in relation to the focal length of the lens. It is calculated by dividing the focal length by the diameter of the aperture and means that any given aperture will pass the same amount of light, regardless of the focal length of the lens.

Q What is the B setting on the shutter speed dial?
A This enables you to hold the shutter open for as long as the shutter release is depressed to allow you to give exposures of seconds or even minutes.

Q What is the difference between the M and the X flash setting?
A The M setting is for use with flash bulbs and the X for electronic flash.

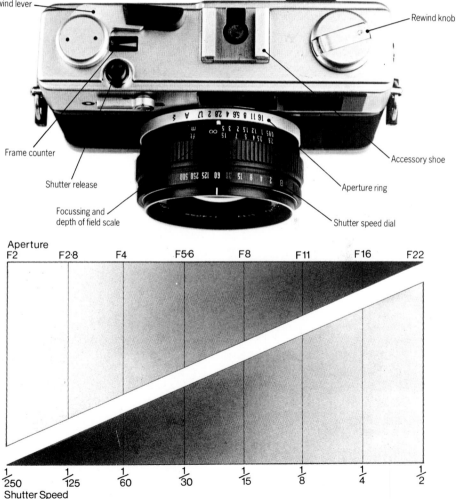

Film wind lever

Rewind knob

Frame counter

Accessory shoe

Shutter release

Aperture ring

Focussing and depth of field scale

Shutter speed dial

Aperture
F2 F2·8 F4 F5·6 F8 F11 F16 F22

$\frac{1}{250}$ $\frac{1}{125}$ $\frac{1}{60}$ $\frac{1}{30}$ $\frac{1}{15}$ $\frac{1}{8}$ $\frac{1}{4}$ $\frac{1}{2}$

Shutter Speed

24 CAMERA LENSES

The lens that is fitted to or supplied with most 35mm cameras has a focal length of between 45 and 55mm. This gives a field of view of between 45° and 55°, which approximates that of normal eyesight. A shorter focal length than this will give a wider angle of view and a longer focal length will provide a narrower field of view.

Wide angle lenses have a focal length of 35mm or less and they can be obtained to provide a field of view of up to 180°. A long focus or telephoto lens has a focal length ranging from 85 to 1000mm or more. A zoom lens is one in which the focal length can be continuously varied between two limits. It is possible to get lenses which cover the range of medium wide angle to medium long focus, offering an alternative to a standard lens. In addition to being more expensive than a standard lens, however, a zoom also tends to be larger and heavier and have a smaller maximum aperture.

Many SLR cameras can also be fitted with specialist lenses such as fish-eye and perspective control lenses for architectural photography.

Below A long focus or telephoto lens can give a completely different view of the world, revealing distant details and creating interesting perspective effects, as this shot taken on a 400mm lens demonstrates.

Below The wide angle lens is an invaluable aid to many types of photography including landscape, architecture and photojournalism. This shot was taken on a 20mm lens used to deliberately create exaggerated perspective.

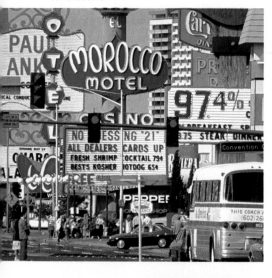

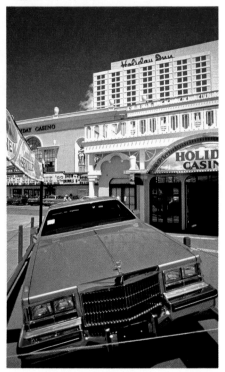

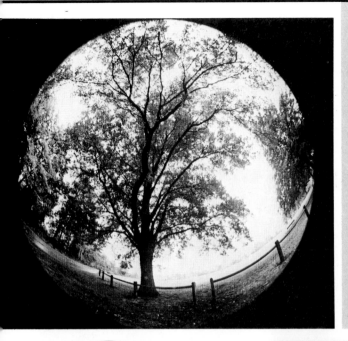

Q What is the difference between a long focus lens and a telephoto?
A A telephoto is simply a long focus lens which has been designed to be more compact.

Q Are teleconverters as good as a telephoto lens?
A A teleconverter which doubles the focal length of the prime lens will also reduce its maximum aperture by two stops, so will make it slower. Even a good-quality converter will reduce the performance of the prime lens significantly unless it is used at an even smaller aperture.

Q What is a mirror lens?
A It is a long focus lens built with mirrors to make it exceptionally compact. Its disadvantage is that it has a fixed and usually relatively small maximum aperture.

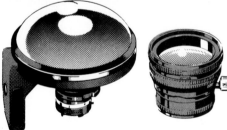

Above The fish-eye lens is one of many interesting accessories that can be fitted to an SLR, giving a field of view of 180° and allowing you to create unusual and effective images. Since it is not an item that is likely to be used too frequently, it is worth considering hiring this type of equipment for special occasions.
Right The perspective control lens is particularly useful to photographers specializing in photographing buildings. It is a wide angle design with a facility to raise the optical axis of the lens and avoid the need to tilt the camera upwards, which produces converging verticals.

There are three basic types of exposure meter: separate meters which give a reading which is then set manually onto the camera, meters which are built into the camera but take their reading from a separate lens or window in the camera body, and meters that actually read the light which is transmitted by the lens. TTL is the system used in most SLR cameras. They are available in a semi-automatic version in which the camera settings are adjusted until a needle is centred or an LED is illuminated, or as a fully automatic device, in which the meter controls either the aperture or the shutter speed or both.

A separate handheld meter is useful for taking close-up readings of subjects such as portraits when the camera is mounted on a tripod. As well as measuring the light which is reflected from the subject they can also be used to measure the incident light. This is done by holding the meter in front of the subject and aiming it towards the camera.

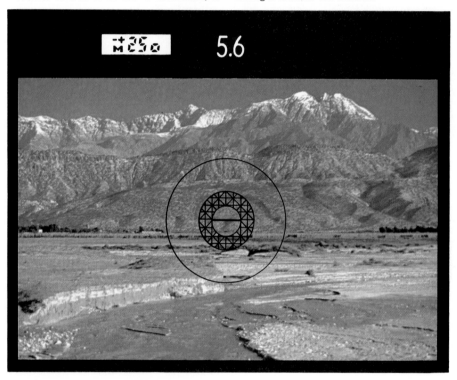

Above The illustration show a typical screen read-out for a TTL meter. In the manual mode the shutter speed and aperture are adjusted until, in this case, both the plus and minus sign are illuminated, with other types a needle is centred, or an LED illuminated. In the automatic mode the camera simply displays the shutter speed and/or aperture which has been selected by the auto mechanism.

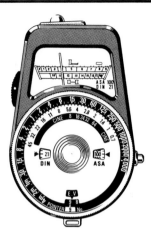

Above A hand meter. Having set the film speed, the reading indicates combinations of aperture and shutter speed.
Below This type of meter can be used for reading the light reflected from the subject, or by sliding a translucent white dome over the light cell, directly from the light source itself.

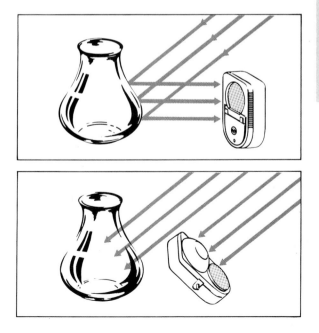

Q What does aperture priority mean?
A This is an automatic metering system in which you select the aperture and the meter sets the appropriate shutter speed.

Q What does centre weighted mean?
A This is a TTL metering system which is biased towards a reading taken from the centre of the picture area.

Q What is a spot meter?
A This is a meter which has a very small angle of acceptance and enables a reading to be taken from a very small and precise area of the subject.

Q What is the point of incident light readings?
A They can give a more accurate result with subjects that have an abnormal tonal range or are very light or dark, where reflected light readings would be misleading.

Q Can you use an ordinary exposure meter for flash photography?
A No. The very brief duration of the flash exposure requires the use of a special meter.

28 CALCULATING EXPOSURE

Correct exposure is one of the most vital factors in producing consistently good pictures. Yet in spite of the quite sophisticated meters incorporated in even modestly priced cameras, incorrect exposure remains a prime cause of disappointing results. This is because the meter can only give a reading and it is the way in which the reading is made and interpreted that will determine the correct exposure.

All meters are calibrated on the assumption that the scene at which they are aimed is of average tonal range, without excessively large areas of very dark or light tones, and that if all the tones in the subject were blended together the result would be a medium grey. If you were to take a reading from a medium grey wall the exposure it indicated would give you a grey wall: but if the wall was white or black, the reading would still give you a grey wall. For this reason, it is vital that you aim your meter in such a way that it 'sees' only the area of a scene that you want it to see and that misleading details such as bright highlights or dense shadows are either excluded from its view or are allowed for in your final calculation.

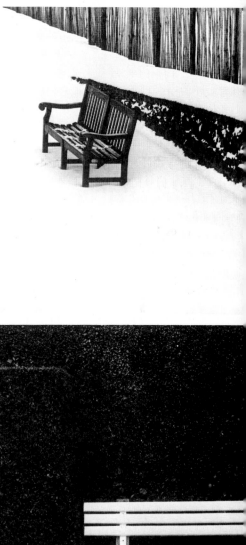

Above Shooting against the light usually gives a reading resulting in underexposure. Here two stops of extra exposure were needed.
Above right A subject containing a large area of white will mislead all meters, except a spot meter, resulting in underexposure, unless an allowance is made.

Q How do you take a reading from a subject which has mainly very light and very dark tones, such as a night scene?
A You can take an average of readings from the two extremes.

Q How can you take a reading from a very dark subject?
A Either by using an incident light reading or by reading from a substitute grey placed in front of the subject, such as an 18% grey card (obtainable from Kodak).

Q How can you take a reading from a very light subject?
A Either as above or by increasing a normal reading by three to four stops.

Q How can you make allowances when using a fully automatic camera?
A You can set the film speed dial to a higher ISO number than the film you are using to give less exposure, and to a lower ISO number to give more exposure.

Above An average subject on which an exposure meter will give a correct reading. It contains a full range of tones.
Left A subject with an unusually large area of dark tones, like this park bench, will trick most types of meter into giving a misleading reading, indicating more exposure than is really required.

30 OPERATING A CAMERA

It is easy to tell the difference between an amateur and a professional photographer simply by looking at the way they hold their cameras. Constant use enables the professional to handle his camera almost subconsciously, allowing him to devote his full attention to the subject. However, even the most casual amateur can easily acquire a similar familiarity with a little effort and practice, and it can make a significant difference to the results.

Even simply unloading and loading a camera is important since careless practice can result in fogged or lost pictures. Always load and unload in subdued light, even if this is just the shade of your body. Make sure that both sets of sprocket holes are engaged before closing the camera back and that the film is slightly tensed. Always wind off two or preferably three frames before you start shooting and check that the film is actually winding on. When you get near the end of the film avoid undue pressure in winding to avoid the possibility of pulling the film off the spool. Make sure the film is completely rewound before opening the camera back.

It is very helpful to establish a routine procedure when taking a picture and always to do things in the same order to help avoid mistakes. Always check that the camera is loaded and the correct film speed is set. Even with an automatic camera check that the selected settings are compatible with the lighting conditions; don't just shoot blindly.

Right These two illustrations show a 35mm camera being loaded and unloaded. The first procedure involves making certain that the film is inserted correctly into the take-up spool with both sets of sprockets engaged and the film slightly tensed before closing the camera back. Using the rewind knob carefully will enable you to feel when the film has been wound off the take-up spool by the loss of tension. It is then safe to open the camera.
Far right The eye-level camera in the landscape position is held so that both upper arms form a strut between the camera itself and the chest, with the upper arms pressed gently back against the body. In the upright position, only the left elbow is held against the body and the right arm with the back of the hand pressed gently against the forehead and the camera against the nose and cheekbone.

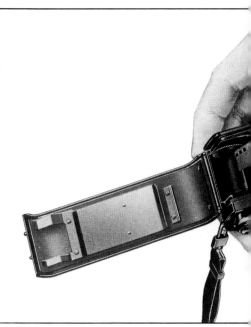

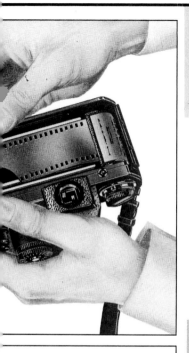

Q How can I be sure the film is winding on?
A With most 35mm cameras the rewind knob will rotate. The film counter is not a reliable guide since this will often advance without film.

Q How can I be sure that the film is wound off?
A You will feel a sudden drop in tension as the film comes off the winding spool.

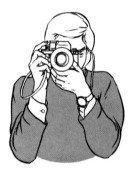

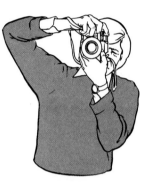

CHECK LIST

1 Make sure film is loaded correctly and is winding on properly – the camera instruction leaflet will describe how to do this.

2 Set the correct film speed on your camera or separate meter. With automatic cameras ensure that the exposure compensation setting is at zero.

3 Check that there are no unwanted filters or attachments in place on the lens and, with a viewfinder camera, that the lens cap is removed. Check that the lens is free from smears or condensation.

4 Choose the most effective camera position for subject composition.

5 Set the shutter speed required to ensure freedom from camera shake and subject movement.

6 Aim the camera and frame the image for the most effective composition.

7 Focus on the main centre of interest.

8 Use the exposure meter to determine the aperture required, making an allowance for any special lighting conditions or subject tones, or any filters or attachments.

9 Check that the aperture indicated will provide the necessary depth of field. If not, set the required aperture and adjust the shutter speed accordingly.

10 Release shutter and wind on the film.

NOTE: With aperture priority automatic cameras, set the aperture at Step 5 and check that the shutter speed is appropriate at Steps 8 and 9.

32 CHOOSING SHUTTER SPEED

The shutter speed, like the aperture, is a means of controlling the exposure, but in addition can have an important effect on the sharpness and quality of the image.

Both subject and camera movement are influenced by the choice of shutter speed. When a handheld camera is used, you should select a fairly fast shutter speed wherever feasible to eliminate the possibility of camera shake. Even with a shutter speed of say $\frac{1}{250}$ second camera shake is not impossible, especially if the camera is jerked during the exposure. The danger is increased when using long focus lenses. As a general rule, $\frac{1}{60}$ second should be considered the minimum safe speed to avoid camera shake unless some additional support is used. With a long focus lens of 200mm or more $\frac{1}{250}$ second or less is preferable.

Freezing subject movement also requires the use of a fast shutter speed and the choice will depend on the speed and direction of the subject. A horse galloping across the picture might need $\frac{1}{1000}$ second to freeze it, whereas with a man walking towards the camera $\frac{1}{125}$ might be sufficient. However, it is important to appreciate that blur can create effective images and even enhance the impression of speed and movement. Slower shutter speeds with a moving subject can sometimes produce a more pleasing result than the 'correct' speed.

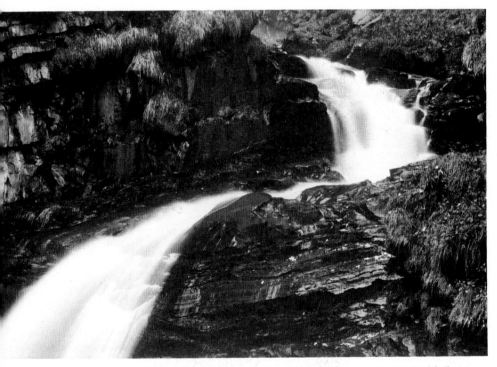

Above This waterfall was shot using a shutter speed of two seconds, with the camera mounted on a tripod. Even with the lens stopped right down, this would have resulted in overexposure, so a neutral density filter was used.
Above right A shutter speed of $\frac{1}{60}$ second was used for this shot of a racing car. The camera was panned so that the car was recorded sharply while the background was blurred.
Right To freeze the action of this rodeo rider as he emerged from the stall, a shutter speed of $\frac{1}{500}$ second was selected. Panning is not really possible with this type of subject.

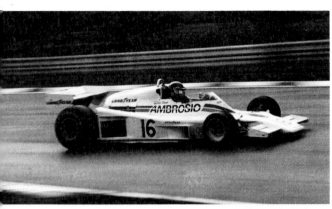

Q Is it impossible to take pictures of very fast subjects – motor racing for instance – unless you have $\frac{1}{1000}$ second facility?
A No. You can manage with quite slow speeds if you pan the camera with the subject.

Q Can you freeze movement without a fast shutter speed?
A Yes. When indoors you can use the brief duration of electronic flash to achieve this effect.

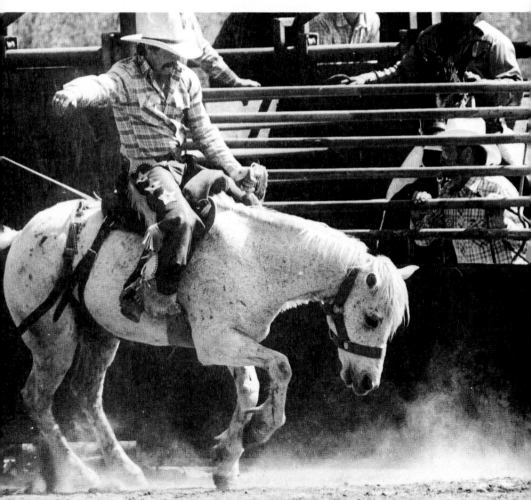

34 CHOOSING AN APERTURE

In addition to controlling the amount of light which passes through the lens, the aperture also helps to control the sharpness of the image.

When a lens is focussed at a certain point, details in front of and beyond the point of focus will also be acceptably sharp.

This range of sharpness is called the depth of field and it is partly controlled by the aperture. A wide aperture will create a shallow depth of field which will increase as the aperture is made smaller. So, you can select a small aperture to give you maximum definition in both close and distant objects in a scene, or a wide aperture which will let you isolate a subject by throwing surrounding details out of focus.

Most lenses have a depth of field scale marked on the focussing mount. With an SLR camera you can view the effect by means of a button which stops the lens down manually to the selected aperture.

Below *To separate this man's face from a fussy background, a wide aperture was chosen to limit the depth of field. A long focus lens has emphasized the effect.*
Below right *A small aperture was used for this landscape shot to ensure that both the foreground*

details and the distant mountains were in sharp focus.
Right *Close-up subjects like this pine cone usually need a small aperture, since the depth of field diminishes rapidly at close focussing distances. Unless the subject is on a completely flat plane, it is best to stop down as far as possible.*

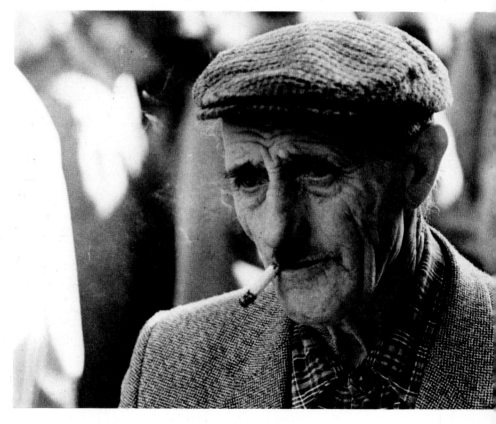

Q Is the depth of field the same both sides of the point of focus?
A No. It is less in front than behind, at a ratio of about one-third to two-thirds.

Q Is the depth of field the same for all lenses?
A No. Wide angle lenses have an effectively greater depth of field than standard lenses at the same aperture. Long focus lenses have less.

Q Is the depth of field the same at every focussing distance?
A No. It becomes much less as the lens is focussed at closer distances.

36 FILTERS FOR BLACK & WHITE

Normal panchromatic films are equally sensitive to all colours and record a subject in terms of its brightness level. A green object and a blue object of the same tone would therefore be recorded as equal shades of grey on the film. This means that in some circumstances a subject which appears as a boldly contrasting image in colour can record as a rather flat, dull picture in black and white. It is possible, however, to use coloured filters to modify the response of the film and to increase the contrast and separation of colours in a black and white picture.

The filter passes light of its own colour freely but 'holds back' other colours. If you imagine a scene in which there is a red house, a green field and a blue sky, a picture taken without a filter would show them all as equal shades of grey: a red filter would make the red house much lighter and the field and the sky darker; a blue filter would make the sky much lighter and the house and the field darker; and a green filter would record the field as lighter and the sky and house darker. The effect will vary according to the density of the filter and the purity of the colours in the subject.

Below left A deep blue filter was used for this portrait in order to emphasize the texture of the skin.
Below A green filter was used for this alpine landscape to help separate the shades of green in the image.
Right A yellow filter recorded the sky as a darker tone.
Below right A deep red filter was used to create this dramatic effect, recording the blue sky as nearly black.

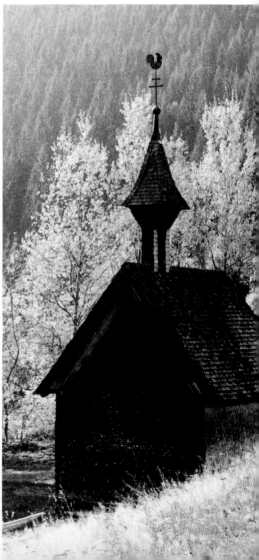

Q Do you give the same exposure when using a filter?
A No. The exposure will have to be increased according to the density of the filter. A filter factor is given with the filters: an X2 requires a one-stop increase, an X4 a two-stop increase, and so on.

Q What is the best filter for sky effects?
A A yellow filter has a quite subtle effect, making a blue sky slightly darker and any white clouds more prominent. An orange filter has a stronger effect, and a red filter can be very dramatic, making a blue sky record as nearly black.

Q What can green and blue filters be used for?
A A green filter can be effective in summer landscapes by making foliage lighter. A blue filter can emphasize skin texture in character portraits.

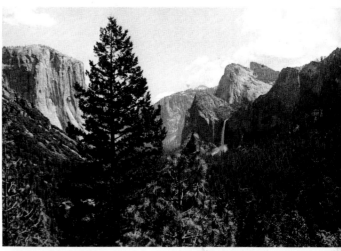

38 FILTERS FOR COLOUR

There are essentially two main types of filter for use with colour film: correction filters, which are used to avoid a colour cast as a result of the lighting quality being different to that for which the film is balanced; and effects filters, which are used to deliberately create a colour cast.

The most useful colour correction filters are the UV (ultraviolet) and the skylight, which counteract the blue cast caused on cloudy days and in open shade. For a stronger effect, choose the 81A or 81B. The 82A and 82B filters are also useful for reducing the warm colour cast created when shooting in the even-ing light. It is also possible to buy filters which enable daylight film to be used in artificial light-ing and vice versa.

The polarizing filter is particularly useful in colour photography since it reduces the light which is reflected from surfaces such as water and foliage. It also helps to create stronger and brighter colours and will make a blue sky a deeper colour. Graduated filters are very effec-tive in creating dramatic skies such as sunsets and can be bought in a range of colours as well as grey. Only half of the filter is tinted so that it can be used to alter the sky but not the fore-ground.

Above A Wratten 81B filter was used for this shot of a girl taken in open shade on a sunny day.
Right above Two graduated filters were used for this into-the-light shot, a neutral to reduce the brightness of the sky and a tobacco to add a little colour.

Right A polarizing filter was used to increase the density and colour saturation of the blue sky in this Hawaiian seascape.

Q Do you need to give extra exposure when using filters for colour?
A The pale filters such as the UV and the skylight require no increase, but the more dense filters such as the polarizing need additional exposure according to the filter factor.

Q Can you use black and white filters for colour photography?
A Only for special effects, since they will create a strong colour cast.

Q Can you use a polarizing filter for black and white pictures?
A Yes. It will reduce unwanted reflections and glare.

Q Will TTL metering adjust the exposure for colour filters?
A Yes.

40 FILTERS FOR COLOUR

One of the most effective ways of modifying and controlling the colour quality of an image is to use colour filters. These are simply glass or plastic squares or discs, tinted in a range of colours, which can be mounted onto the front of the lens. A modest selection of these filters is basic equipment for the photographer who wishes to produce more than just a record of a scene. There are now a number of systems available which allow you to collect a more than adequate selection of filters and effects attachments at a reasonable cost. With the aid of different mounts, these can be used on a number of different lenses and cameras.

The first basic is the *UV filter*, the one which many photographers leave in position on their lenses all the time; although it is intended to reduce the effects of ultraviolet light, it will not have a detrimental effect when there is none present and it does afford protection to the far more costly lens. The second filter which should be in every photographer's kit is the *81A colour correction filter*. This is a pale, straw colour and offsets the blue cast created when shooting on overcast days and in open shade. It also reduces the effect of ultraviolet light, and some photographers use it in place of a UV filter. You might also find it useful to pack the stronger versions of this filter, the *81B* and the *81C*, for more extreme conditions.

Although less frequently needed, the *82A or B filter* can also be useful when the light source would otherwise create a warm cast, such as early evening sunlight, or when shooting in normal room lighting on tungsten type film. In addition, it can be handy to have the *conversion filters* from tungsten to daylight and vice versa for those occasions when you find you have the wrong type of film loaded into your camera. These are the *80A* for daylight film in tungsten light and the *85B* for tungsten type film in daylight.

Above A polarizing filter was used to enhance the effect of the dramatic sky. As well as making the sky a richer and deeper blue, it has also emphasized the clouds.

Right These two pictures show the effect of a tobacco-coloured graduated filter used to add colour to the blank sky tone of a lake scene. The exposure was calculated before fitting the filter.

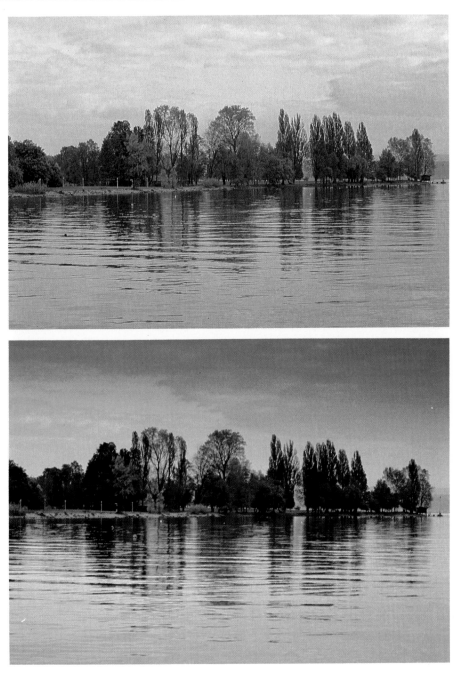

42 CLOSE-UP ATTACHMENTS

With the exception of the very simple versions, most 35mm cameras will focus down to about a metre. While this is more than adequate for most subjects there are occasions when you will need to focus at much closer distances. There are a number of ways of achieving this.

The simplest and least expensive method – and one that can be used with viewfinder cameras – is the close-up or supplementary lens. This is fitted to the camera lens like a filter and, depending on its strength, will reduce the close focussing distance down to only a few centimetres. You must appreciate that at close focussing distances the optical type of viewfinder is no longer accurate and you will have to judge the exact picture area.

For an SLR camera a set of extension tubes or a bellows unit is a more satisfactory and flexible way of close focussing. This is fitted between the camera lens and the camera body and by increasing the separation you will reduce the focussing distance.

It is also possible to obtain macro lenses for SLRs, in which the focussing mount is designed to focus down to give a one to one ratio without the need for other attachments.

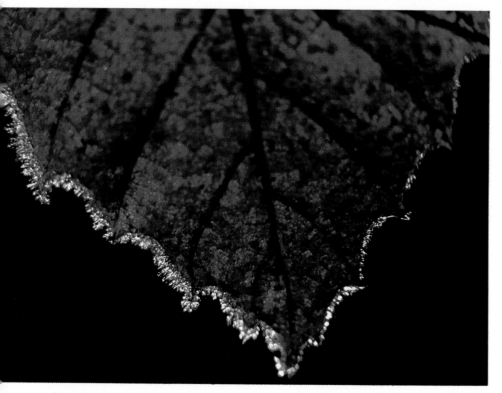

Above An extension tube was used for this extreme close-up of a frost-fringed leaf. It required an exposure increase of one and a half stops to compensate for the extension.

Right A supplementary lens was used to enable closer focussing for this shot of a lichen-covered tree trunk. No exposure increase was required.

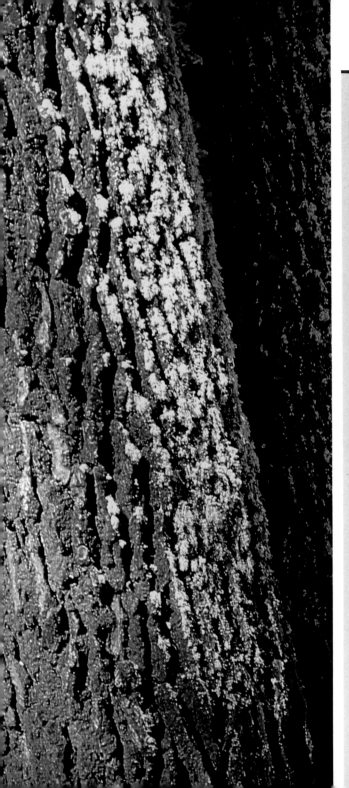

Q Do you need to give extra exposure when using close-up attachments?
A Not for supplementary lenses, but you do for extension tubes and bellows units.

Q How do you calculate the extra exposure when using extension tubes?
A You must increase the exposure in proportion to the square of the distance of the extended lens from the film, divided by its focal length. For example, the exposure for a 50mm lens extended to 100mm will be four times the meter reading.

$$\left|\frac{100}{50}\right|^2 = 2^2 = 4 \times \text{the exposure}$$

Q Is a supplementary lens as good as a bellows unit?
A It will adversely affect the performance of the prime lens, but if it is of good quality and you set your lens at a small aperture it will give satisfactory results.

Q I find it difficult to get all the subject sharp when I shoot close-ups. Why is this?
A Because depth of field is very shallow indeed at close focussing distances. You will need to use a very small aperture.

Q Even when using a small aperture I find that my close-up shots are not sharp, why is this?
A Because the depth of field is so restricted you must also ensure that the most important parts of the subject are on a similar plane, and you should choose a camera angle with this in mind. In addition you must also be careful to avoid both camera shake and subject movement, effects which will be magnified in close-up photography.

44 SPECIAL EFFECTS

In addition to filters there is also a wide range of other attachments which can be fitted to the camera lens to alter the effect and quality of the image. Many of these can be obtained as part of an integrated filter system, such as the Cokin, and can be combined with each other to increase the variety of effects.

The soft focus attachment can be particularly effective with, say, portrait or landscape pictures by reducing the sharpness of the lens to create a romantic mood. The pastel filter can also help to produce a similar quality by reducing the contrast and colour saturation of the image.

In pictures which have strong highlights or light sources, you can use a starburst filter to create streaks of light radiating out from each one. A similar attachment called a diffraction grating or a colour-burst filter produces a pattern of rainbow-coloured streaks in the same way. Other useful devices include multiprisms, which create a pattern of repeated images of the subject, and split focus attachments, which enable pictures that contain both very close foregrounds and distant objects to be recorded sharply.

Above A soft focus attachment was used for this landscape shot. As well as reducing the definition of the image, a soft focus device will also create a pleasing halo of light with backlit shots, as this picture shows.

Right A starburst filter was used to create the streaks of light from the sparkle on the water in this shot of a girl. The dark tone of the water has helped to emphasize the effect.

Q Can you use these attachments on any type of camera?

A Yes, most of them, but only with an SLR will you be able to see the exact effect through the lens.

Q Do you need to give extra exposure with these attachments?

A No. Most of them do not require an alteration in exposure.

Q Is it possible to obtain soft focus effects without the use of manufactured devices?

A Yes there are several ways; smearing clear petroleum jelly onto a piece of glass, or filter, in front of the lens; or by stretching Sellotape or nylon mesh across the lens are effective methods. Remember to leave a clear spot in the centre to create a core of sharpness.

Q Can you not get a soft focus effect by simply throwing the image slightly out of focus?

A No. A soft focus attachment retains a central core of sharpness surrounded by the soft effect and is much more pleasing than an out-of-focus image.

46 USING A WIDE ANGLE LENS

A wide angle lens has two immediately obvious qualities: it allows more of the subject to be included in the frame and it reduces the size of the objects in the image. For these reasons, a wide angle lens is particularly useful for shooting in confined areas, such as interiors, or when you cannot include the whole of a subject – a large building for example – from your selected viewpoint. It is also very useful for pictures which include close foreground details as well as distant objects, such as in landscape pictures, especially since the greater effective depth of field of a wide angle lens will help to produce a sharp overall image. However, this ability does exaggerate perspective and this can produce an unpleasant effect in some cases – when photographing groups of people for example.

Left Deliberate exaggeration of perspective was introduced in this wide angle shot of a rock band by using a very close viewpoint.
Below A 20mm wide angle lens was used for this shot of a village in Alsace enabling close foreground details to be included and increasing the impression of distance.
Right A 28mm wide angle lens was used for this shot of San Francisco to enable the top of the building to be included from a close viewpoint.

Q What is the best focal length to buy for architectural pictures?
A A 28mm or a 24mm are good choices since they have a substantially wider angle of view than the standard lens but less perspective distortion than the 20mm. However, the 20mm can be more useful when shooting interiors.

Q How can I avoid converging verticals when using a wide angle lens?
A Keep the camera perfectly upright and do not tilt it even slightly up or down, even if this means moving further back to include, say, the top of a building.

Q What is a perspective control lens?
A It is a specially designed wide angle lens in which the optical axis can be raised to include more at the top of the picture without you having to tilt the camera upwards.

Q What is a fish-eye lens?
A A fish-eye lens is a wide angle lens which is specially designed to produce an angle of view of 180°. In doing so, it creates a circular image in which straight lines are progressively more curved the closer they are to the edge of the frame.

Q What would you use an extremely wide angle lens for?
A As this type creates an obviously wide angled effect, it would only be used when deliberate exaggeration was wanted, or in a confined space such as a room interior.

48 USING A LONG FOCUS LENS

A long focus lens has a narrower field of view than a standard lens and has the effect of enlarging the subject in the frame. This makes it very useful when you want to exclude foreground detail or to isolate a small area of a distant scene. It is also invaluable for subjects which you are unable to approach closely, such as sporting events and wildlife. A long focus lens is ideal for portrait work since it allows you to obtain a close-up image of your subject's face without having to use a close viewpoint, which can create unpleasant perspective effects.

This type of lens has a more limited effective depth of field than a standard lens. For this reason precise and accurate focussing is essential and you will often need to use a small aperture to obtain sharp focus over the whole subject.

The risk of camera shake is considerably increased with a long focus lens and a tripod is recommended when shutter speeds of less than, say, 1/125 second are used, particularly with lenses of 200mm or more.

Below left A long focus lens has enabled a close-up image of this zoo elephant to be obtained from a distant viewpoint, effectively isolating it from its surroundings.

Below A 200mm lens was used for this picture of a Kentish hopfield. This, combined with the distant viewpoint, has resulted in a compression of planes and a picture in which the impression of depth is diminished.

Q What is the best focal length for portrait photography?
A Between 85 and 150mm is a very useful range for this type of picture. A 70 to 150mm zoom can be an ideal choice.

Q What is the best focal length for sports photography?
A This depends a great deal on the type of sport, but for general work between 200 and 300mm is a safe choice. With subjects such as football, a longer lens can be a benefit.

Q Is a mirror lens better than a long focus lens?
A A mirror lens has a fixed aperture, which is usually smaller than that of most ordinary long focus lenses. This makes them less suitable for shooting in poor light. It is also more difficult to vary the exposure, since this can only be done by altering the shutter speed.

Above *A 150mm lens was used for this portrait, so that it could be tightly framed without having to move the camera too close to the subject which would have created an unpleasant perspective effect.*

50 CHOOSING FILM

The choice of a suitable film depends on two main considerations: the lighting conditions under which you will be taking your pictures and the purpose to which you will put the photographs.

Whether you are shooting in black and white or colour, you must decide on the speed or sensitivity of the film. In poor light or when shooting action pictures, for instance, a fast film might be called for, whereas in bright light or with a static subject a slower film would be adequate. However, a fast film has a more prominent grain structure than the slower types, so if large prints are made or if the subject contains fine details it is better to use a slower film if possible.

If you are shooting in colour, you will also have to decide whether to shoot on colour negative film, from which prints must be made, or on colour transparency film for slides. With the latter, you also have a choice between film balanced for use in either daylight or artificial lighting.

In addition to the conventional films, you can also buy specialist films such as the infra-red type, which can be used to create interesting and unusual effects.

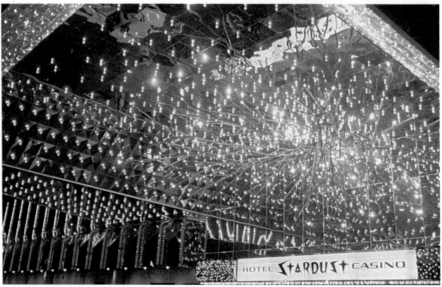

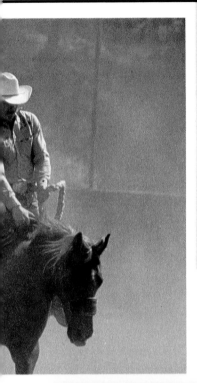

Q Is there much difference between different makes of film?
A There can indeed be. The colour quality of transparency films in particular can vary considerably from one manufacturer to another. It is wise to experiment to determine which you prefer.

Q Can you make black and white prints from colour films?
A It is possible to print directly from colour negatives onto a special black and white paper, but from colour transparencies you will first have to make a black and white negative.

Q How is film speed measured?
A There are two main systems, DIN and ASA. ASA shows a doubling of the film speed by a doubling of the ASA number: for example 100 ASA is twice the speed of 50 ASA. The DIN system shows a doubling of the film speed in terms of a three-digit increase in the number: 21 DIN is twice the speed of 18 DIN and so on.

Q What is the ISO number on film packets?
A This indicates the film speed by combining both the DIN and ASA system of measurement: ISO 400/27 is therefore the same as 400 ASA or 27 DIN.

Left This well-lit action shot needed an ISO 200/24 film. A long focus lens with a maximum aperture of f5.6 was used.
Below left This night shot of a Las Vegas Casino was lit by tungsten light and artificial light film was used.
Below Where maximum definition and image quality are needed, like this shop window detail, it is best to use a slow, fine-grained film.

52 CHOOSING COLOUR FILM

It is important to choose the most suitable type of colour film for your particular purpose in order to obtain the best possible results. Your first choice is between colour negative and colour transparency (positive) film. If colour prints are your main requirement, then colour negative film is the most obvious choice, since the cost of producing prints from negatives is lower than from transparency film, and the quality is higher (unless very expensive, professional prints are made from transparencies). If you are inexperienced, colour negative film can also be preferable since there is more latitude for exposure and minor errors to be corrected in the printing process. If you intend to process you own film and make your own colour prints, you will learn more about the process and how to control it by using the negative-positive process.

If your main requirement is for colour transparencies – either for projection or for selling your pictures for reproduction (colour prints are rarely used for this) – then you should use transparency film. Although it is possible to make slides from negatives there is an inevitable loss of quality.

When you have decided on the type of film, the next consideration is speed. Your choice depends mainly on the lighting conditions you intend to shoot in.

You should also remember that image quality and sharpness are much greater with a slower, fine-grained film than with the high-speed variety. The difference between Kodachrome 25 for instance and, say, an ISO 400/27 film is very noticeable indeed, so in normal circumstances do not use a faster film than the lighting conditions require.

Above This architectural detail was illuminated by bright sunlight and an exposure of 1/125 second at f8 was possible even with ISO 25/15 Kodachrome.

Right A fast film is often an unavoidable choice for subjects which combine a need for a fast shutter speed and a low light level such as this surfer.

Q Is there much difference between similar types and speeds of transparency film from different makers?
A There can indeed be and it is wise, if you are a beginner, to experiment with a few different makes to determine which gives the most pleasing rendition.

Q Is it always best to use a fast film in dull light?
A Not necessarily. If your subject is static and you are able to give longer exposures, with a landscape for instance, then it can be better to use a slower, fine-grained film since the extra image quality and often greater contrast can give a lift to softly lit scenes.

Q What is film speed?
A Film speed indicates the relative sensitivity of the film to a given light level. A film which has twice the speed will need half the exposure to produce the same result.

Q Why is film speed important?
A Because if you don't know the speed of the film you cannot determine the correct exposure. You must set the film speed number on the camera or exposure meter before it can give a relevant exposure indication.

Q What does ISO mean?
A The ISO rating combines two separate methods of measurement, DIN and ASA. ISO 100/21 is the same as 21 DIN or ASA 100.

Q What is DIN?
A This is the European system. Doubling of film speed is indicated by an increase of three, so that 21 DIN is twice the speed of 18 DIN, and so on.

Q What is ASA?
A This is the American system. Doubling of the film speed is indicated by doubling the number. So 100 ASA is twice the speed of 50 ASA and so on.

Q Can film be uprated in the camera?
A Yes, since the decision is not made until the film is processed. You cannot, of course, alter the speed of individual frames, so the speed must be set to the new rating before you start shooting.

Q What is 'pushing' in the processing stage?
A This involves using increased development time or special developers which increase the sensitivity or speed of the film beyond that which is marked on the packet.

Q Are some films more amenable to this treatment than others?
A Yes. Colour transparency more than colour negative and fast films more than slow.

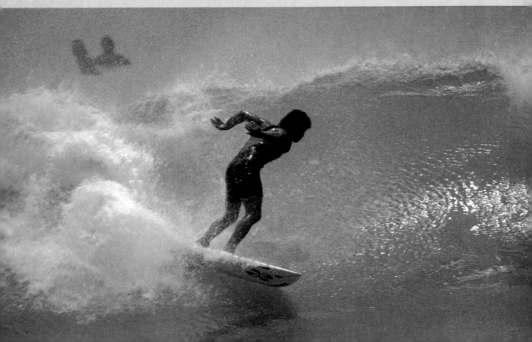

54 A TRAVELLING OUTFIT

A good case is understandably one of the most important items in travel photography, since it can make both carrying and using your equipment much more convenient. Personal preference is obviously a decisive factor, but it is advisable to avoid cases which are ostentatiously 'photographic', since this will invite theft as well as making it difficult to be unobtrusive. However, the large silver or matt black suitcase types are useful for basic transportation as they afford good protection and they can be used to offload equipment to a lighter and smaller case for day-to-day use. Always choose a case that has more capacity than you think you need, since an adequate case when neatly packed can become too small when in use.

Don't be tempted into taking more equipment than you need as this can simply become a burden when you are travelling. It is surprising how many different subjects can be tackled with just a standard lens and a medium wide angle and telephoto, three or four filters and a tripod and small flash. Anything more than this should be made to justify itself. A second camera body or a spare camera should, however, be considered vital on an important trip. Always ensure that you have a good supply of fresh, spare batteries.

It is also a good idea to carry some cleaning aids such as a selvyt cloth and some lens tissues and a brush. Black polythene bags are useful for exposed films and litter as well as for protecting your equipment when on a beach or in the rain.

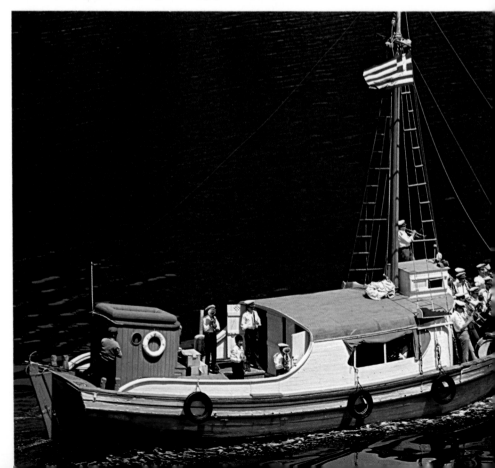

Right These two illustrations show the two basic types of outfit case, the rigid suitcase style above for basic transportation and maximum protection and the soft type below for more convenience in carrying on the shoulder.

Below A typical shot of a holiday celebration!

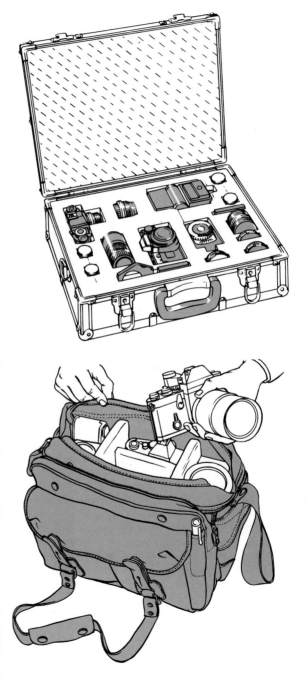

Looking after your equipment is important at all times, but especially when you are travelling, since it tends to be subjected to more rigours, and it is always on occasions like these that the gremlins choose to strike. You should make a daily routine of both cleaning and checking your equipment. Dust and grit are particularly harmful to the operation of the camera and a smeary lens can produce poor-quality images. Compressed air or a blower brush should be used to remove dust from the lens, mirror screen and interior surfaces of the camera. The latter can accumulate small fragments of film in the film-winding mechanism. It is also important to make sure that electrical contacts are kept clean and free from grease by cleaning with a lens tissue or cloth. Remove all surface dust from lens and mirror surfaces before wiping gently with a selvyt cloth or tissue.

As well as cleaning your equipment, you should also develop the habit of checking that it is working properly. When you have unloaded a film, with the camera back open make certain that the shutter is opening and closing and that the automatic iris is stopping down correctly. Film, too, needs to be cared for both before and after exposure. It should not be subjected to heat or humidity, as this can cause deterioration.

Right Conditions like these, on the island of Grand Canaria, can cause serious camera problems and even breakdowns unless a little care and thought is spent on protection and maintenance.

Q What can I do if sand gets into the lens or the focussing ring?
A Unless it can be removed by gently brushing or blowing with a dust-off spray, take the camera to a repairer.

Q Does air pressure have any effect on film or the camera?
A Not to my knowledge: cameras are used on the moon. However, low temperatures can cause battery failure, and a rapid change of temperature can cause condensation.

Q Can extreme cold affect the film or the camera?
A Low temperatures can create static problems with film and it should be wound on gently to prevent an electrostatic discharge fogging the film.

Q Do some countries object to photographers?
A It is always a good idea, if in doubt, to ask the advice of the relevant tourist office or embassy as to the existence of any legal or social embargoes.

2 UNDERSTANDING COLOUR

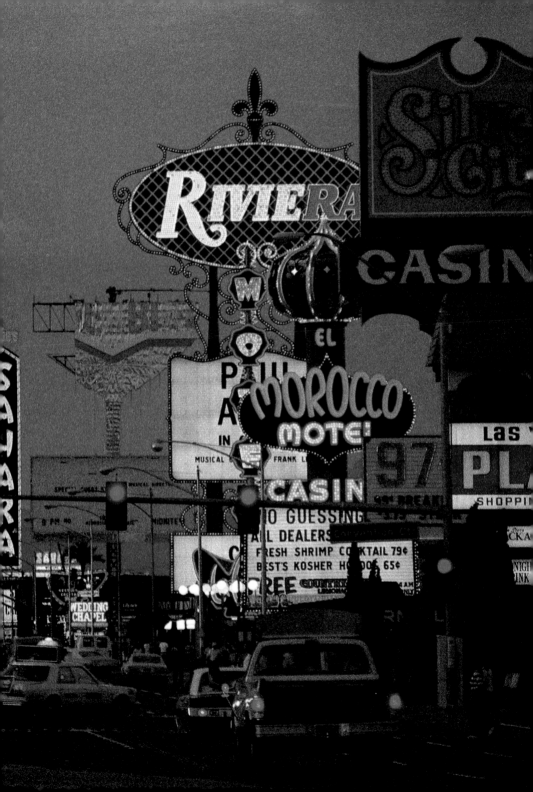

60 COLOUR AND LIGHT

Sunlight, or white light, is a mixture of all the colours in the visible spectrum. It is, in fact, a range of wavelengths of electromagnetic radiation, the shortest being violet and the longest red. These wavelengths are measured in nanometres — one millionth of a millimetre — and only the narrow band between about 400 and 700 nanometres can be seen by the human eye. Shorter than 400 is ultraviolet, which, although invisible to us, can affect colour film. Longer than 700 is infra-red, which again, although undetected by our eyesight, can be recorded by specially sensitized film.

The colours in the visible spectrum are red, orange, yellow, green, blue, indigo and violet. However, it can be conveniently divided into just three primary colours, red, green and blue. If three lights of equal intensity are fitted with a red, green and a blue filter and are projected onto the same spot the result will be white light. All the other colours can be produced by mixing the primaries in varying quantities.

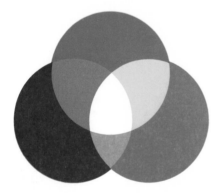

Above This schematic diagram shows how white light is formed from three primary colours adding to each other.
Right The familiar miracle of a rainbow clearly demonstrates the make-up of daylight. The droplets of water in the atmosphere act like a prism and split the white light up into its component colours.

Q How is a spectrum such as a rainbow created?
A When white light passes through a prism the different wavelengths are refracted at different angles, splitting up the white light into its component colours. Rainbows are formed when the light is split up by drops of rainwater.

Q How do we see coloured objects?
A When white light falls onto a coloured surface, a green leaf for instance, it reflects only the wavelengths in the green area of the spectrum. All the other wavelengths are absorbed and converted into heat.

Q Why do some things appear to be a different colour when viewed under different lights?
A Because some light sources, such as fluorescent tubes and mercury vapour lamps, do not emit all the wavelengths that are present in sunlight.

Q Why can sunlight sometimes vary in colour, such as at sunset?
A Because the Earth's atmosphere filters out or absorbs some of the wavelengths. The degree of absorption depends on weather conditions in the atmosphere and the direction of the sunlight. In the late afternoon, sunlight hits the atmosphere at a more acute angle than at midday and so has to pass through more of the atmosphere to reach us.

62 HOW COLOUR FILM WORKS

Colour film works on the same basic principle as black and white film: a light-sensitive emulsion creates an image according to the intensity of the light falling on it. The difference is that in a colour film there are three separate layers of emulsion, one sensitive to only red light, one to green and the other to blue. At a particular stage in the processing, these individual images are dyed to the appropriate shade and combine to reproduce the full range of colours present in the original subject.

There are two basic types of colour film, transparency (for slides) and negative (for prints). A negative film records light areas in the original subject as a dark tone and vice versa. It also shows the colours in reverse so that anything red will appear as a mixture of green and blue, which is called cyan, anything green will record as a mixture of red and blue, called magenta, and anything blue as a mixture of red and green, which is yellow. These are known as the complementary colours. To make a print, the colour negative must then be exposed again to a similar emulsion on a paper base to convert the tones and colours back to those of the original subject.

With a colour transparency film, all of this process takes place – including the reversal of tones and colours – when the film is developed.

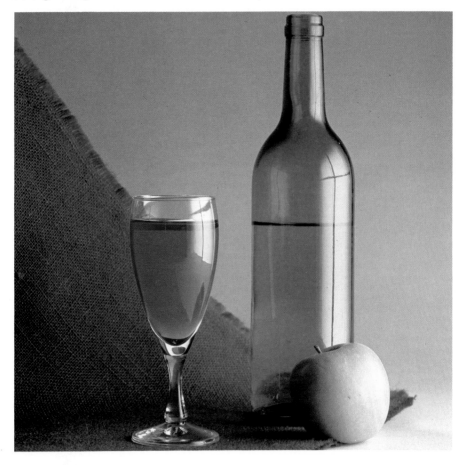

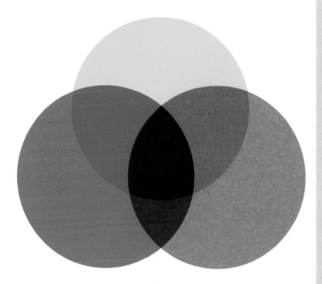

Above *A schematic presentation of primary and secondary printing colours.*
Left *An accurate reproduction of the original colours of the subject.*
Below left *The subject printed in one primary colour – cyan.*
Below right *The same photograph printed in two primary colours – cyan and magenta.*

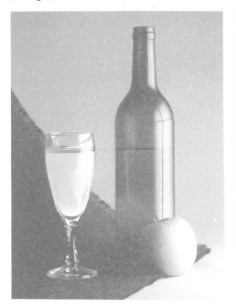

Colour film is very sensitive to even slight changes in the colour quality of the light. Unfortunately, we tend only to notice when there is a drastic variation because the brain makes adjustments for what we see; a piece of white paper will almost always appear to be white, regardless of the colour of the light used to illuminate it, simply because we *know* it is white. We are very rarely aware of any changes in the colour quality of daylight, yet it varies considerably and colour film will faithfully record such variations. This accounts for many of the surprises – and disappointments – which you may experience when you see your processed film for the first time.

The colour quality of light is measured in degrees Kelvin and is known as *colour temperature*. Most daylight-type colour films are designed to give a correct balance of colour when the light source is approximately 6000° Kelvin. However, the light from a rising or setting sun can be as low as 3000° and as high as 8000° from a hazy or overcast sky. When you consider that a variation of only 200° will be quite noticeable when recorded on colour film, it is easy to understand how sometimes a photograph can be quite a different colour from the scene you thought you saw.

Above *Marrakesh market after sundown. This scene shows how film can record the cool blue quality which is a result of a high colour temperature.*

Right *The warm glow of this Maltese harbour scene was created by the light of a late afternoon sun. Much of the blue wavelengths of light had been absorbed by the atmosphere.*

Q Can I use daylight film when taking flash pictures?
A Yes provided you are using either electronic flash or blue tinted flash bulbs, which are specially balanced to match daylight film.

Q Can I use colour correction filters with both colour negative and transparency film?
A As a general rule it is not necessary to use correction filters in daylight conditions when shooting negative film since the correction can be made at the printing stage.

Q Why do distant views often have a bluish quality?
A Because more ultraviolet light is usually present in such situations. Atmospheric haze compounds the effect. This is particularly noticeable at high altitudes.

66 DAYLIGHT AND COLOUR

When you are working with a light source of a substantially higher colour temperature than that for which the film is manufactured, the resulting photographs will have a bluish colour cast. This is commonly seen on pictures taken on cloudy, overcast days. When the light source is of a lower colour temperature the result is a reddish cast, which is seen frequently on pictures taken in evening light. The former is known by photographers as a cool cast and the latter as warm. You can buy a special meter, similar to an exposure meter but designed to measure colour temperature, but for most purposes this is not necessary. It is perfectly possible – and fun – simply to teach yourself to become aware of these colour casts and anticipate the problems. As a general rule, a slight warm cast is quite acceptable, but a bluish or cold cast can be rather unpleasant and is best avoided. In most circumstances colour correction filters will compensate for the colour cast – a bluish filter to balance a warm cast and a reddish filter to offset a cool cast. Sometimes a colour cast can contribute to the atmosphere and effect of a picture, and you should always consider this before you attempt to counteract it.

In addition to the variations caused by the colour temperature of the daylight itself it is also important to be aware of two other potential hazards. One is the presence of the invisible ultraviolet radiations which can create a blue cast on colour film. The other is the possibility of a colour cast produced by light being reflected from brightly coloured surfaces near the subject. A common instance of this is the bluish light reflected from the sky when taking pictures in open shade.

Right Ultraviolet lights in this mountain scene has resulted in the picture having a marked bluish cast, more so than would have been apparent to the eye.

68 DAYLIGHT AND COLOUR

Probably the most difficult conditions under which to take successful colour photographs are the very ones that most inexperienced photographers favour – a bright sunny day. While such lighting can produce good pictures, it needs more than a little care to avoid the pitfalls.

Bright sunlight unfortunately tends to create a much higher contrast than the film can accommodate, with strong highlights and dense shadows. Pictures taken in the close to middle distance in particular will tend to have a harsh and unpleasing quality unless care is taken to control the angle and direction of the lighting. Our eyes are able to adjust to extremes of contrast and it is easy to forget that the film's latitude is being exceeded. A useful trick to help judge this factor is to view the subject through half-closed eyes. Sometimes the difficulty is easily overcome. When photographing a friend, for instance, it is a simple matter to ask them to move to a different position where the lighting is less harsh. In other cases more favourable lighting must be achieved by the choice of camera viewpoint.

It is important to avoid situations where the distribution of highlight and shadow in the subject is equal, since such pictures will inevitably contain large areas where highlights are burnt out and shadows are dense and lacking in detail. Choose a viewpoint where the subject is either predominantly in shadow or the shadows are very small, and calculate the exposure accordingly.

Right *This shot of schoolchildren was taken from a position where the major part of the subject was in shadow and the exposure calculated accordingly. The small area of resulting overexposure is insignificant.*
Far right *The position of this man's head and the camera viewpoint were selected so that, although lit by direct sunlight, the shadows cast were minimal and did not create an unpleasant effect. This type of lighting is often more effective for a weathered, tanned skin than for a pale, smooth one.*

Q What use is the lenshood in these circumstances?
A A lenshood prevents bright light striking the lens and causing flare. Anything which casts a shadow over the camera lens – your hand for example – will have a similar, sometimes better effect than a lenshood, providing it does not encroach on the picture area.

Q Must the sun always be behind the photographer?
A By no means. The position of the sun relative to the camera and the subject should be considered in terms of its overall effect and the nature of the shadows it casts.

Q Can heat affect film?
A Yes. Apart from light, heat is the most damaging thing to film. Don't leave your camera in the sun.

Artificial light can be provided by a number of sources suitable for colour photography, but, like daylight, there are some variations in the relative colour temperatures. Most films designed for use in tungsten light are balanced to give optimum results with a colour temperature of 3200° Kelvin, the temperature produced by a floodlight bulb or a tungsten halogen lamp. An overrun bulb such as a photoflood produces a slightly higher colour temperature and a normal domestic bulb a slightly lower one. If you wish to use photoflood bulbs for your colour slide photography, buy the tungsten type A film, which is designed for the slightly bluer quality. The type B film is balanced for the warmer studio bulbs and can also be used in normal room lighting.

It is possible to use daylight type film when shooting with tungsten lighting, provided you use the appropriate compensation filter. However, this will require an increase in exposure and it is preferable to use the correct film for the light source whenever possible.

Other types of artificial lighting should be avoided where critical results are required, such as portraits. Fluorescent tubes, whether the so-called daylight type or the warm light, will produce a heavy colour cast when used with either daylight or tungsten type film because they do not emit all the wavelengths of the visible spectrum and require quite heavy filtration to produce an acceptable result.

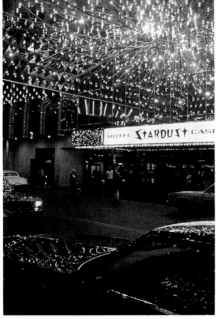
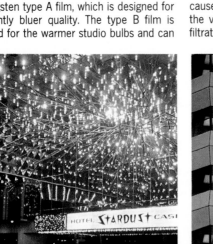

Above left Urban glitter illuminated solely by artificial light and taken on artificial light film, resulting in a fairly accurate rendition.
Above right This detail of an office block photographed in daylight on daylight type film shows clearly how the white fluorescent lights inside the offices have recorded – distinctly green.
Right The Casino at Baden-Baden was photographed on daylight type film. The predominant tungsten light has created a pronounced orange cast.

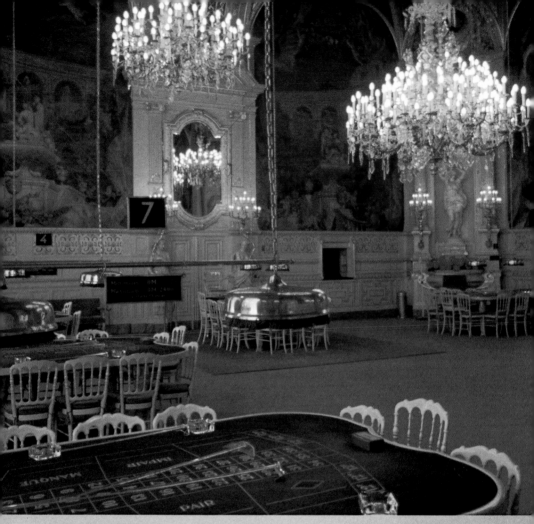

Q What type of film should I use for street scenes at night?
A It will depend to a great extent on the nature of the predominant street lighting. Sodium or mercury vapour lamps, for example, are virtually monochromatic. Sodium lamps produce primarily the yellow wavelengths, making tungsten film a best choice. Mercury produces mainly the blue-green range and daylight film will give a more pleasing result.

Q What should I use if I do not know what the light source is?
A If in doubt use daylight film, since a warm cast will create a more natural effect than a blue cast.

Q What is an overrun bulb?
A It is a bulb which is designed to produce a higher intensity of light for its wattage in exchange for a shorter life – a few hours instead of several hundred for a conventional bulb.

Q Should I use artificial light film when photographing something like a rock concert?
A It is almost impossible to judge the quality of the constantly variable lighting used for stage effects and consequently the film type used is usually not at all important. Many photographers prefer to use daylight type film in these circumstances.

Although film manufacturers conveniently divide film types into daylight and artificial, in real life things are not so neatly arranged. Two or more different sources are often used in the same picture. The decision as to which type of film to use under these conditions should normally be based on the predominant light source. For example, if you are taking a portrait using tungsten light to illuminate your model, but there is a small amount of daylight visible through a window in the background, then your choice should be tungsten type film since this will create natural looking skin tones and the small area of bluish daylight would be quite acceptable. However, if the scene was lit predominantly by daylight and only a small area of it was illuminated by tungsten light, then daylight film should be used.

In some circumstances, it is possible to use colour filters or acetates over one of the light sources to balance them. You could, for instance, fit a yellowish daylight to tungsten conversion filter over an electronic flash gun so that it could be mixed with tungsten lighting. You can also buy sheets of blue-tinted acetate which can be placed over artificial light sources so that they can be mixed with daylight. Do not, however, overlook the atmospheric effects of mixed lighting. Sometimes the 'wrong' choice of film can enhance this: for example, an illuminated building photographed at dusk would, for a correct result, require the use of tungsten type film, but the warm glow created by using daylight type film may well produce a more atmospheric picture.

Right *The rich colours of this Las Vegas sign were enhanced by shooting at dusk and by using daylight type film. This has helped to create the blue cast of the background as well as adding to the effect of the tungsten light.*
Far right *The glow of candlelight has created a distinctly warm cast on this woman's face, although the room itself was lit by tungsten lighting and tungsten type film was used. It could have been corrected by the use of a filter, but unfiltered it contributes to the mood of the picture.*

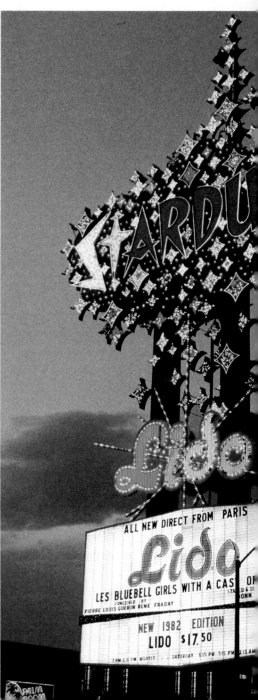

Q What film should I use if daylight and artificial light are evenly mixed?
A In most circumstances, daylight type film is the safest choice simply because as a general rule a blue cast is less pleasing than a yellow cast.

Q Why is it not possible to buy colour negative film for use in tungsten light?
A Because for most normal purposes it is possible to correct the colour balance at the printing stage. You can, however, buy a type L colour negative film for use with the longer exposures often needed when shooting in artificial light.

Q Is it best to use colour negative or slide film when shooting with mixed lighting?
A Colour negative film will give you the opportunity to decide on the final balance of colour at the printing stage, whereas once you have exposed slide film it is not possible to alter it substantially.

Q Are some slide films better than others for mixed lighting scenes?
A As a general rule, the faster films such as the Kodak ISO 400/27 are more tolerant of variations in colour balance than slower films such as Kodachrome.

74 EXPOSURE AND COLOUR

Deciding on the right exposure is one of the most important considerations in producing consistently good quality pictures. Most modern exposure meters if used sensibly will produce an acceptable result under most conditions. With a subject of normal contrast, that is to say within the latitude of the film, a correct exposure is one that records adequate detail in both the darker and lighter tones of the image. However, in many situations the subject contrast is often higher or lower than the norm and in these cases 'correct' exposure becomes a more subjective decision. Even when a scene has an average contrast range, the exposure that will create the most pleasing effect is not necessarily the correct one.

If less exposure is given than that indicated by the exposure meter, the immediate effect is to produce a denser transparency than normal or a thinner negative. In addition, there will often be an increase in image contrast and the colours will be more saturated. With a softly lit subject the effect will be to create a more low key, sombre image and with a contrasty subject the result will be a more dramatic quality, with dense shadows but full detail in the high-lights. A degree of underexposure often suits subjects where there is a bold element of texture in the lighter tones of the subject, such as the weathered skin in a portrait of an old man. It can also give emphasis to pictures where the shape of the subject is an important element by creating a slightly silhouetted effect. Where there is a dramatic sky or a colourful sunset, less exposure than normal will create richer tones and stronger colours.

Giving more exposure than the meter indicates will have the opposite effect. It will produce a lighter transparency than normal and a colour negative will be more dense. There will be a loss of detail in the lighter tones of the subject and a gain in shadow detail; colours will be softer and more pastel; there will usually be a lowering of image contrast, and the overall effect will be to create a picture with a more delicate and gentle mood than that of a normal or underexposed image. A degree of overexposure is often an advantage in portraits where you wish to minimize the effect of skin texture, such as a glamour shot for instance, or where romantic mood will enhance the picture, such as a misty landscape.

Above A bracketed exposure in which additional exposures are made each side of that calculated to be correct. In this case half a stop under and half a stop over.

Right This close-up of peppers on a market stall was underexposed by about half a stop to ensure that the colour was fully saturated.

Q Is there any other way of varying the exposure without bracketing?
A If you use colour negative film, it is possible to make the print slightly lighter or darker without loss of quality. With colour transparencies, it is possible to shoot a whole roll of film on a similar subject, such as a portrait for instance, and to cut off one frame from the end and process it as a test. The remainder of the film can then be adjusted during the processing. Most transparency films can be made at least half a stop darker and up to two stops or more lighter.

Q What is the best way of taking an exposure reading?
A For a subject of normal contrast most TTL meters will give an accurate reading. So will any other type of separate meter, such as a handheld one, provided you make sure that it 'sees' only the area you are photographing and any large light or dark areas such as sky are excluded.

Q How do you take a reading for a high contrast subject?
A You can either take a close-up reading from a mid tone in the subject, or you can take an average of readings from the lightest and darkest areas.

Q How can I bracket exposures with my automatic camera?
A By simply altering the film speed setting: if you are using an ISO 100/21 and you set your film speed dial to ISO 50/18, you will be overexposing by one stop; if you set it to ISO 200/24 you will be underexposing by one stop, and so on.

Q Can disasters be rescued at the processing stage?
A If you know that you have over- or underexposed a roll of film, by setting it to the wrong ISO for instance, it can be pushed or held back in processing to a degree.

The most effective way to learn how to control the quality of your pictures by the use of exposure is to *bracket* your exposures wherever possible. This involves making three or four exposures of a subject at half stop intervals each side of the setting indicated by the exposure meter. In this way you will be able to see just how much a particular subject can be improved by giving more or less exposure than normal. At the same time you can familiarize yourself with the characteristics of the film you use and be able to predict your results more accurately.

Above *Extreme overexposure has been used in this portrait to achieve the bleached effect, the skin recording with no detail. In this case one and a half stops extra exposure was given.*
Right *The dramatic effect of these backlit rocks has been created by underexposing by one stop. The shadows have recorded as a rich black, the texture is emphasized and the highlights accentuated.*

3 COMPOSING
A PICTURE

80 EXPLORING THE SUBJECT

One of the main reasons for disappointing pictures is lack of thought. A great many inexperienced photographers see a potential picture and simply snap it straight away, with no thought as to exactly why they want to take it or indeed whether they are taking it from the best viewpoint.

The classic mistake – a tree growing from the top of someone's head – is a result of the photographer simply not having studied and explored his subject fully before taking his picture.

It is vital to be aware of the reason why a particular scene appeals to you before you can decide how to go about taking it. You may for example stop your car along a road because you have seen a nice view. Before even taking your camera out you should study it carefully: is it the church in the valley which appeals to you, or the dramatic sky, or the field in the foreground, or the distant rolling hills? It may be all of these things or only one of them, but you must explore the possibilities so that you may then decide how to frame your picture and whether a different viewpoint may avoid unwanted details or improve the composition.

These three pictures of the same scene demonstrate how the nature and composition of the picture can be altered by fully exploring the potential of the subject and by the considered choice of viewpoint. There is very rarely only one way of taking a subject and to explore all the possibilities will not only help to produce better pictures but will also help you to develop a 'photographer's eye'.

Q Is there a way of learning to *see* pictures in this way?
A The best way is to train yourself to see a potential picture with a frame around it. Use the viewfinder of your camera, for instance, or even your hands formed into a rectangle, like a film director. Then look carefully at *everything* inside that frame and see what happens when you move it around to exclude some things and add others.

Q What do you do if you cannot take the picture from a different viewpoint?
A You can *always* find a different viewpoint. You may be surprised just how much a picture can be improved, often by a change of only a few centimetres or so higher, lower or to the left or right.

82 THE CENTRE OF INTEREST

A successful picture always has an identifiable centre of interest, a part of a scene or an object within the frame to which the eye is more strongly drawn. In some instances this may be quite obvious: a person's face in a portrait or a fishing boat on an horizon. In other cases, it can be less easily determined. In a view, for example, it may be just a group of trees or even only a highlight or a shadow. It is essential to find such a point so that you can decide how to frame the picture and create a balanced and harmonious composition.

The position within the frame which the centre of interest occupies will depend on the other elements of the image and on the effect you want to create. Many inexperienced photographers tend to aim their cameras as if they were aiming a gun with the subject 'sited' in the centre of the viewfinder. This rarely creates a pleasing picture. You should always adjust the framing of the picture in order to determine where the centre of interest will be most effective.

Q Why should you not place the centre of interest in the middle of the picture?

A Because as a rule this tends to create a rather static and symmetrical composition. It also makes it difficult to include other objects in a balanced way.

Q Where is the best place to position the centre of interest?

A Imagine the picture divided into three equal parts horizontally and vertically, rather like a noughts and crosses chart. The strongest positions for the subject are considered to be the points where the imaginary lines intersect.

This series of landscape shots demonstrates how the effect and composition of a picture can be radically altered by the position of the centre of interest within the frame. The lone tree (left) is placed at the intersection of thirds, usually considered to be the strongest point. However, the other pictures prove that there is often more than one solution, and that it can be worthwhile to experiment with the framing of the image to see how the mood and impact of the final shot may be most effectively achieved.

84 EMPHASIZING THE SUBJECT

There are a number of ways in which you can make sure that the subject of your picture is clearly and boldly defined.

The way the image is framed is the first consideration. You should also check that you are in fact close enough to your subject and that a closer viewpoint would not improve the picture by making the subject bigger and excluding unwanted details. This simple approach would improve a great many disappointing photographs.

The second consideration is to make certain that the subject is well separated from the background and does not blend into it. One way to do this is to arrange that there is a bold contrast in terms of either colour or tone between them. A light-toned subject for instance, should be posed against a dark-toned background, and a coloured subject such as a red flower against a contrasting colour like green or blue. Other techniques which will also help to create separation are backlighting and differential focussing, which will be helpful if there is insufficient tonal difference between subject and background.

Q What is differential focussing?
A This is when you use a wide aperture or a long focus lens to throw the background out of focus, leaving the subject in sharp relief.

Q How can backlighting help?
A It can create a rim of light around the subject which will help to isolate it from the background. In some circumstances it can help to subdue background details.

Far left Differential focussing has been used for this portrait to help separate the subject from the background. The use of a wide aperture has restricted the depth of field, throwing the background out of focus.
Left A strongly lit background and a dark-toned subject have created a bold tonal contrast which effectively isolates this relaxing Spaniard.
Above Tight framing, which focusses the attention on the subject and excludes irrelevant details, is one of the most effective methods of emphasis.

One major cause of disappointing pictures is attempting to include too many elements. A picture which has a number of different points of interest jostling for attention will invariably produce a fussy and confusing image. You must learn to be very selective.

The simplest approach is to limit your pictures to a quite close-up image of the subject with a simple and contrasting background. Of course, this would be very restricting and in many cases it is necessary to include more details either to add interest to the picture or to provide more information about the subject. The solution is to make certain that there is a balance between the elements of the picture with the main point of interest acting as a pivot, and the secondary interest leading the eye towards the subject rather than drawing attention from it. This can be done by making sure that the subject occupies the most dominant position in the frame, that it is larger or closer to the camera than the secondary elements or that it has a more assertive shape, tone or colour.

Above *This shot can almost be divided into two halves. It has two points of interest, but your attention is drawn more strongly to the man in the foreground.*
Top *The two equally important elements of this picture are placed at opposite sides of the frame so that the eye tends to travel back and forth between them.*

Right *In this shot of a Copenhagen quayside the main subject has been placed towards one side of the frame, enabling the more distant and smaller secondary interest to be included without creating an imbalance.*

Q Is there a good way of learning this technique?
A Probably the best way is to experiment with arranging a still life set-up consisting of a small group of different objects. Observe how you can change the balance between them by altering their relative positions.

Q How can you change the balance between objects in a picture?
A With the exception of subjects such as still lifes and portraits, where you have direct control, this must be achieved by choice of camera viewpoint and in the way the image is framed.

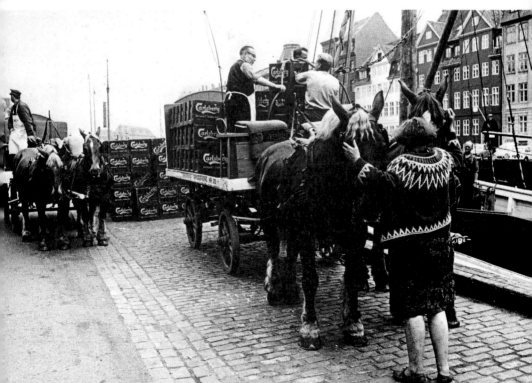

88 CHOOSING A VIEWPOINT

Choosing the best viewpoint is one of the most important factors in taking good photographs. With some subjects, such as a portrait or a still life, you are able to control the composition and framing of the picture by actually adjusting this position of the subject. With most pictures, however, this is not the case.

When you have a number of objects in a scene on different planes – a foreground, a middle ground and a background – even a quite small change in the camera position can produce a significant difference in their relative positions and the balance between them. If you move your camera to the left, the foreground object will appear to move to the right in relation to the middle ground and the background and vice versa. Moving closer will make the foreground appear larger and a more distant viewpoint will make it smaller. Even a higher or lower viewpoint can make quite a dramatic difference to the composition of a picture.

In addition the lighting will often be influenced by the choice of viewpoint and this will also affect the composition, since strong highlights and shadows can be a dominant part of the image.

Above and right These two shots of the same scene show how radically the composition of a picture can be altered by a change in camera viewpoint. In this case it was a matter of about 20 paces, but the two shots could hardly be more different.

Right Shot from the gallery of the Pompidou Centre in Paris, this picture gives an interesting and unusual view of the city square below. The structure in the foreground emphasizes the impression of height.
Far right A very close and low viewpoint has emphasized the lofty quality of this giant redwood tree. A wide angle lens was used to reinforce the effect of perspective.

Q What is the best viewpoint for portrait pictures?
A As a general rule, just above the subject's eye level, since this tends to create the most natural and flattering appearance.

Q Is this also the best for full-length pictures?
A No. This will tend to foreshorten the subject and a viewpoint on a level with the subject's waist or chest is preferable.

90 USING PERSPECTIVE

Perspective is the effect created by the apparent reduction in size as objects are viewed at increasing distances from the camera. It is a factor in creating an illusion of depth.

Perspective is most easily understood by imagining yourself looking at someone standing, say, 20 metres from the camera. Behind them, at the same distance again, is a tree. From your position, they will appear quite tiny in relation to the tree, but if you walk closer to them they appear to become progressively larger until, when you are only a metre or so away, they seem to be much larger than the tree. It can be seen from this that the effect of perspective is

considerably increased when there are both near and faraway objects in the frame, and so foreground interest can be a very effective way of creating an impression of depth in a picture. On the other hand, if it is important to show a subject in a more true representation of its scale in relation to the background, then you should choose a more distant viewpoint.

In addition to the variation in size of objects the perspective effect also tends to create an impression of lines in the image which recede towards the horizon. This too can help to create an impression of depth as well as being an important element of the composition.

Below The diminishing size of these shadows emphasizes the presence of the perspective in this shot, at the same time enhancing the effect of depth and distance.
Right A distant viewpoint combined with a long focus lens to isolate a small area of the scene and exclude

foreground details has resulted in a picture with compressed planes and little impression of depth.
Far right The effect of perspective has been exaggerated in this harbour-side shot, underlining the size of the net mender's task. A wide angle lens has accentuated the effect.

Q Does a wide angle lens alter the perspective?
A No, but because it enables very close as well as distant objects to be included in the picture, it does exaggerate the effect.

Q Why do portraits look odd when taken from close up?
A Because the perspective effect works even at quite small distances, so a person's nose or chin can be made to look much larger than it is if it is photographed from too close a viewpoint.

Q Why do the sides of buildings appear to converge when you aim the camera upwards?
A Because the base of the building is much closer to the camera than the top, and consequently appears larger. The sides of the building progressively dwindle the further they are from the base. In photographic terms, the top end of the building is not higher, just further away.

92 USING THE FOREGROUND

In many pictures the subject itself is the nearest object to the camera. The image exists only on two planes, subject and background. Yet it can often be effective to make use of foreground interest in a picture. As well as helping to create an impression of depth and distance, a strong foreground can make an important contribution to the composition of a photograph.

In some cases the foreground can be used to lead the eye towards the centre of interest, such as a river in a landscape picture, for example. Even just the lines created by the effect of perspective can be used in this way, such as the furrows in a ploughed field.

Another way in which the foreground can be used to aid the composition is to use it as a frame around one or more edges of the image. This can help to isolate the subject and prevent the eye straying away from the centre of interest. It is a device commonly used in landscape photography, where a close foreground detail such as a field gate or an overhanging tree can contain the image as well as helping to establish an impression of depth. In some cases you can use a frame to completely surround the subject by shooting through a doorway or window, for example.

Above Shooting through a window and including it as foreground interest has provided a compositional frame.
Below The dry stone wall leads the eyes to the centre of interest.
Right The tree branch provides an effective additional element to the composition.

Q Will the exposure be affected when shooting the outside through say a window as in the top photograph?
A Yes. You should exclude foreground details to avoid over-exposure.

Q Is a wide angle lens best for this type of effect?
A Not necessarily, although it will intensify the feeling of depth and enable you to include more foreground. A normal or long focus lens can be used quite successfully.

Q Does it matter if the foreground details are not sharp in this type of picture?
A Not necessarily. In some cases it can be an advantage if they are unsharp, since this will prevent the foreground from becoming too distracting.

94 EMPHASIZING THE TEXTURE

The camera has a quite extraordinary ability to record the texture of surfaces. It can do so in such a way that a photograph can even stimulate the same tactile response as the real thing. This is a crucial factor in the way a camera can create a sense of three-dimensional reality in two-dimensional terms. In addition, a picture with a strong textural quality usually has considerable visual appeal and impact.

The direction and quality of the lighting is one of the most important elements in emphasizing texture and this will largely depend on the nature of the surface. A subtle texture such as a fabric like canvas or leather needs quite a hard and acutely angled light which will glance along its surface to reveal the subtle relief of its fibre. A coarser texture such as the bark of a tree or the stonework of an old building needs a softer and less directional light to avoid the formation of hard and dense shadows and the loss of details.

Good camera technique is also vital, since the image must be razor sharp and the exposure spot on to record the fine detail and subtle range of tones upon which the quality of texture depends.

Above The soft but directional light of an overcast day was sufficient to record the rugged textural quality of this Alpine hut.
Right The tanned and weathered skin and rough textured clothes of this elderly Arab have been effectively revealed by the hard, strongly directional light of the sun.

Far right A low sun skating over the surface of this footpath has revealed every tiny indentation in its surface. Shooting towards the light has emphasized the effect.

Q What is the best type of film to use for texture shots?
A A slow, fine-grained film is best to maximize the fine detail. Too much grain would diminish the effect.

Q How can I arrange the right lighting when shooting outdoors?
A You can shoot subjects like landscapes early or late in the day when the sun is low to emphasize texture. You can also choose your viewpoints to maximize the effect.

Q How can I ensure maximum sharpness for this effect?
A Use a tripod to eliminate camera shake, a small aperture to obtain maximum depth of field and a slow, fine-grained film.

96 DISCOVERING PATTERN

In photographic terms, a pattern is created by the apparent or implied repetition of shapes or colours within the image. Pattern can have a powerful effect on a picture since it tends to create a reassuring, sometimes almost hypnotic quality.

This type of pattern can be found literally all around us. Nature is particularly rich in patterns readily observable by a perceptive eye. Simple objects like plants, trees and natural formations have an element of pattern which can be easily overlooked but can produce compelling pictures.

In addition to the existing patterns created by nature or man there is also the transient type of pattern which is conjured out of nothing by a temporary juxtaposition of random objects, like the wind rippling the surface of a lake, or by a trick of the light.

Looking for patterns can be an effective way of increasing your visual awareness and developing a photographer's eye. At the same time it is important to realize that a pattern alone will seldom create a satisfying picture. It must be an element in a composition, rather than the sole reason for it.

Above Tight framing and the perspective-flattening effect of a long focus lens juxtaposes these old houses in Alsace so to imply the presence of a pattern.
Above right This stack of drain pipes is a created pattern which needed only to be photographed. The presence of the conflicting shapes added interest and a focal point to the composition.
Right The choice of viewpoint and the framing of the picture has revealed the element of pattern in this shot of guardsmen.

Q How can you use a pattern as an element of composition?
A Since a pattern creates an expectation of continuity, it can also create an effective background or foil to a subject which breaks the pattern. For instance, the pattern created by a box of green apples could make a dramatic foil to just one red apple in the composition.

Q How does colour affect pattern?
A An inherent pattern is diminished by the presence of mixed and contrasting colours, so a black and white picture, or a subject that is essentially monochromatic, may be more effective.

Although a brightly-coloured subject is the one that is most likely to attract a photographer's attention it is not always the best basis for a good colour photograph. Such images tend to be fussy and confusing, with the different colours each competing for attention. A subject which contains a more limited range of colours that harmonize and blend with each other will usually result in a more balanced and simple composition, as well as giving atmosphere.

Colours tend to have a softer, more harmonious quality when they come from the same part of the spectrum – the green and blue of a summer landscape, for example. This quality will be further enhanced when the colours are not fully saturated but are darker and subdued or lighter and pastel in tone.

The main way to take such pictures is to frame the image and choose your viewpoint so that any distracting and discordant colours may be excluded from the picture. Lighting and weather conditions can also help to create this type of image by reducing the contrast and limiting the colour range, so do not leave your camera at home if it is raining. You may miss some impressive shots.

Above The autumn colours of this woodland scene combined with the warm, mellow lighting have helped to produce a picture with a harmonious and atmospheric quality.
Above right Soft lighting and mist have reduced the bold colours of this Hawaiian landscape to a subdued and low-key image, giving a very different impression to that which would have been evident on a bright sunny day.
Right Careful framing has created a picture in which one colour predominates, emphasizing the quiet pastoral modd of the photograph.

Q How can the lighting create this quality?
A A very soft light, on an overcast day for instance, can produce a very low subject contrast and colour saturation. Lighting which creates a colour cast such as evening sunlight can also help to make colours harmonize.

Q What sort of weather conditions will have this effect?
A Mist, fog and rain will all help to subdue and restrict the colour range as well as creating atmosphere and mood.

Q Can I create this quality artificially?
A To a degree. It is possible to reduce colour saturation by under- or overexposing. You can use colour correction filters to *create* a colour cast. A fog or pastel filter can also be effective in some circumstances.

100 USING BOLD COLOURS

While a mixture of bright colours in a photograph seldom creates a pleasing image, the impact of a brightly coloured subject can nevertheless be considerable if the picture is framed and composed in a controlled way.

The simplest and often the most effective way of using colour in this way is to isolate one or two bold colours in the subject and to shoot them against a plain, contrasting background. This effect will be strongest when the subject colour is in direct contrast to the background, that is to say when the two colours are complementary to each other. However, an effective contrast will be created as long as the colours are well separated in the spectrum, or even when a bold colour is seen against a neutral background such as white or black. The greatest impact will be obtained when the colours are fully saturated and the picture is composed so that the bold colour also occupies the strongest position in the frame.

Q Is bright sunlight the best for creating bold colours?

A No. As a general rule, a softer light is more effective since bright sunlight will create strong highlights and dense shadows which will diminish the effect of the colour. In bright sunlight you should choose subjects that are in open shade, or in some cases a softer light can be achieved by shooting into the light. A dull or hazy day is often best for shooting bold coloured subjects.

Q Are there ways of increasing colour saturation?

A Yes. A slight degree of underexposure will usually intensify colours. A polarizing filter will also often increase saturation by eliminating scattered and reflected light.

Q What do you mean by complementary colours?

A The primary colours are red, green and blue. Their complementary colours are a mixture of the other two: the complementary colour to red is a mixture of green and blue called cyan; that of green is a mixture of red and blue known as magenta; and the complementary to blue is a mixture of red and green, which is yellow.

Left *Although the greater area of this picture is neutral, the presence of a single bright colour in a strong position creates a quite bold effect.*
Below left *The bold colour effect of this shot is due to the predominance of a single strong colour. This, together with soft lighting and the use of contrasting shapes gives the picture a graphic simplicity.*

Below *Tight framing and the exclusion of extraneous details has emphasized the bold contrast between the shutters and the wall in this Mediterranean street.*

One of the most fascinating things about photography is its ability to record an accurate image of a scene in a split second. It is this 'slice of life' quality that has made photography such a unique medium and the ability to take pictures at what Henri Cartier Bresson calls 'the decisive moment'.

The most obvious way in which the timing of the exposure affects the image is in subjects like sport and action photography, where the most significant and dramatic moment occurs only once and then very briefly, such as a footballer scoring a goal. However, judging the best moment can also be a crucial factor in less active and dramatic situations. The best expression during a portrait session, for instance, may well be something that exists as briefly as a goal-scoring kick. Unless you are prepared for it and can react quickly enough, it will be lost.

Even with subjects like landscape photography, the moment at which the exposure is made can be equally important – to capture a fleeting cloud formation perhaps or to shoot when the lighting reveals a particular quality in the scene. The key factor in acquiring such an ability is to be completely familiar with your equipment so that you are able to concentrate fully on the subject.

Above *The impact of this shot is largely due to the spontaneous yawn of the weary tiger. Such a fleeting expression is often the secret of a picture's success.*
Above right *The break in the cloud in this seascape combined with the moment at which the ship moved into position created a situation where the decisive moment was as critical as with an action shot.*
Right *In this picture the camera was framed and prefocussed at a point where the horses would round the bend. The exposure was made the moment they came into focus.*

Q How can I learn to operate my camera quickly?
A Simply by practice. Follow a set routine of operations: check exposure, frame, focus, shoot, wind on. Keep doing it until it becomes a subconscious act.

Q Is a motor-drive an advantage for this skill?
A No. A very precise movement is more likely to be captured by anticipation than by the random use of a motor-drive.

104 AVOIDING CONFUSION

Today the vast majority of pictures taken by amateur photographers are in colour. In one sense, colour photography is easier than black and white. The film is exposed, then usually sent to a processing laboratory and the results appear with little further effort. In many ways it is too easy. The depressing result is that for all the colour film that is consumed, only a minute proportion of really good colour photographs is produced. The rest are just a jumbled confusion of colour, at best a poor record of an event or a scene. This is because colour is a very powerful element in an image and unless care and thought is given to the way it is organized and selected in a picture, the result will invariably be disappointing.

It is also an unfortunate fact that the very scenes that attract the inexperienced photographer are invariably those which are most unlikely to produce a satisfying photograph. Favourite disasters are vividly colourful scenes in bright sunshine with every colour in the rainbow indiscriminately scattered throughout them. Such situations require a very perceptive eye and a highly selective composition to produce an appealing image. A subject which contains only one or two boldly defined areas of colour against a neutral or contrasting background is far more likely to produce a prizewinning picture.

Above The impact of this picture depends on a highly selective approach. The only strong colour is red, the background is almost white and the image is framed tightly around the centre of interest.

Right Although more is included in this shot, it has been framed in such a way that neither the colour nor the elements of the subject compete for attention, but work together.

The first step in taking a photograph – having seen something which appeals to you – is to identify the main point of interest. Many unsuccessful pictures are the result of the photographer simply not having made this basic decision. It may be something quite obvious like a person's face in a portrait, or an element a little more difficult to identify, such as a particular tree in a landscape picture perhaps.

In a good picture, the eye will be led to this main subject. In order to achieve this you must make sure that it is sufficiently isolated from the surrounding details of the image. The simplest way to do this is to move close to your subject so that irrelevant details are excluded or relegated to the background. Not being close enough to the subject is one of the commonest causes of disappointing pictures, particularly of subjects such as people and animals.

The second step is to make sure that your main subject stands out quite clearly from the background. This can be done in several ways. One is to arrange that there is a bold tonal or colour contrast between them. Pose a dark subject against a light background or shoot a bright subject on a dark background – a flower set against a foil of green leaves for example. Another effective method is to use differential focussing, which requires the subject itself to be in sharp focus but the background to be out of focus.

Lighting can also help to isolate the subject. A bold highlight around its edge for instance can often be achieved by shooting into the light.

Right *Tight framing has ensured that the attention is fully focussed on the tuba player in this picture, although other identifiable elements are visible.*
Far right above *Differential or selective focussing has enabled this old lady's face to be recorded in sharp relief and clearly isolated from a potentially fussy background.*
Far right below *A plain contrasting background has been used in this shot to ensure that the subject is in bold relief and clearly defined, and that there are no distracting elements to confuse the image.*

Q What is depth of field?
A It is the distance in front of and beyond the point at which you have focussed a lens which still appears acceptably sharp.

Q How can I be sure that my background is out of focus?
A First ensure that there is as much distance as possible between the subject and the background and then use a wide aperture to limit the depth of field. If possible use a long focus lens to emphasize this effect further.

The temptation in colour photography is to always respond to the subjects which contain boldly defined colours. However, there is considerable scope in subjects that have a very restricted colour range, either because of a combination of muted colours or because they are essentially monochromatic. Pictures of this type are invariably able to convey mood and atmosphere more successfully. Subjects which are dependent on dominant elements such as shape, pattern, texture and form are likely to have more impact when this is not confused by an excess of colour. Some of the most successful pictures of this type are in fact almost black and white with only a suggestion of colour.

This type of photograph can be achieved in two basic ways. The first is when the subject itself is restricted in colour, such as a landscape in shades of green, for instance, or a carefully arranged still life in which all the ingredients have been selected because of their common colour values. The other way is to light a subject which itself contains a variety of colours in such a way that they appear muted. Weather or atmospheric conditions reduce the strength and saturation of the colours to create an impression of one colour. Mist, fog and rain can often achieve this and shooting into the light can produce the same effect.

Above *Careful framing has ensured that there are no bold contrasts in this picture. The lack of obtrusive colour has helped to emphasize the pattern.*
Right *Although this shot is almost monochromatic the slight hint of colour gives it a subtle, textural quality.*

In many photographs the colour content of the image is largely a secondary element. The subject itself is the main point of the picture and the colour is an element of the composition. Yet colour itself can be an effective subject for a picture, other elements such as shape, form or texture and the subject itself being subordinated to a relatively minor role.

Such pictures can be created in a variety of ways. The most basic is to move in very close to your subject or to frame it tightly with a long focus lens so that the picture is literally filled with colour, like a close-up of a pile of fruit on a market stall for instance. Another way is to use a very small but bold area of colour set against a large area of contrasting colour or neutral toned background, like a tiny, red-sailed boat on a wide expanse of blue sea.

The essential point is that there should be a dominant colour in such images so that when someone looks at the picture they will immediately see that colour above all else. To look for pictures of this type is an excellent way of teaching yourself to become colour conscious and to learn how to isolate and control the element of colour in your photographs. You can experiment for example with making the area of colour in the image as small as possible while still remaining the dominant element or seeing how much of one colour you can use before the picture becomes meaningless or boring.

Above *Although the element of colour in this picture is tiny, it has a powerful effect. It has been placed in a strong part of the image and it is contrasted against an unobtrusive background.*

Right *Yellow is the immediate impression of this shot. A careful choice of viewpoint and framing has allowed the bright yellow umbrellas to dominate the composition with colour.*

Q Are there any techniques that will help to make colours more dominant?
A A small degree of underexposure will often help to make colours record as a richer hue. You should avoid lighting that creates strong highlights.

Q Can filters be used to make colour more dominant?
A In some situations it is possible to use a colour correction filter of the same hue as the dominant colour to give it more emphasis. A polarising filter can also emphasize colour.

Q Are some colours naturally more dominant?
A Yes. The warm colours, red in particular but also orange and yellow, tend to be more dominant. A fully saturated colour is more dominant than a weak colour.

Perhaps the most difficult subject to photograph satisfactorily is one that contains a mixture of bright colours. Yet it is unfortunately the one to which the inexperienced in particular are most attracted. When a variety of bright colours are massed together they tend to clash with each other, creating discord, and to fight for attention, producing a confusing and unbalanced image. This does not mean that you should not attempt to tackle such subjects or limit your photography to subjects with only two or three different colours, but rather that you should learn to be more disciplined and selective in your approach to this type of picture.

One way of controlling a mass of bold colours in a picture is to frame it with an area of a fairly neutral tone or colour. A mixed flower border, for instance, would look more pleasing if you moved back with your camera to allow, say, the dark green of the lawn to surround it rather than more mixed colours of other flowers. A multicoloured subject will often work well when it can be set against a very light or dark surrounding area.

In some instances it is possible to impose a feeling of order on a random riot of colours simply by the careful choice of a viewpoint and selective framing. Differential focussing is an effective way to reduce a fussily multicoloured background to a more neutral tone by throwing it out of focus.

Above The white background provided by the snow in this colourful picture of skiers has helped to contain and organize the bold mixed colours of the subject.

Right Tight framing and the element of pattern has created a sense of order from this display of Mexican paper flowers. Without care, such a subject could easily become a jumble of colour.

114 COLOUR AND MOOD

Colour can have a very considerable effect on our feelings and moods. Modern marketing techniques make full use of the psychological effects of colour, from the decor of shops to the design of packaging. An understanding of the relationship between colour and mood is just as important to the photographer, who is concerned with producing expressive and atmospheric pictures.

The spectrum in fact expresses a range of moods as well as colours. Red, for instance, is a colour which we connect with warning and danger and as such it is the most dominant colour in the spectrum. Orange and yellow have a much less threatening aspect and their warm qualities tend to create an inviting or cosy atmosphere, like the amber glow of a log fire, for example. The cooler colours of green and blue are the predominant colours of nature and evoke a restful and reassuring response. Indigo and violet on the other hand have a much more sombre and subdued quality.

In addition to the colours themselves their degree of saturation and the way they are combined will also affect the mood they create. Full-blooded colours have a bright and lively quality, whereas soft pastel colours have a more gentle and romantic nature. Darker toned colours, like brown for instance, induce a rather serious or sad mood. For these reasons it is important that the colour quality of your pictures enhances the mood you wish to create. A picture of a lively group of children playing, for example, would be enhanced if they were wearing brightly coloured clothes and diminished if they wore drab and dull colours.

Q How can you control the colour and the mood of a picture?
A The main way is by choosing viewpoints and by framing the picture so that the most effective colours are emphasized and ones which spoil the mood are excluded. With some pictures, such as portraits or still lifes, you can actually select colours so that they contribute to a particular mood.

Q Can you use filters to control colour and mood?
A In some circumstances you can use colour correction filters to create a colour cast, such as a warm evening light, so that it adds to the atmosphere of a shot. Soft focus attachments and fog filters can be used to make colours paler and softer to create a more romantic mood.

Q Are there any exercises to train my eye?
A Look at advertisements, films and paintings and observe how they use colour to establish mood.

Left The peaceful mood of this landscape is emphasized by the subtle colour quality of the shades of green. The gentle contours have also contributed to the atmosphere.

Below The rather low-key quality of this picture combined with the subdued colour range of purple and brown adds emphasis to the flower lady's expression and the sombre mood of the picture.

4 UNDERSTANDING LIGHTING

118 SUNLIGHT

Although bright sunlight makes the world look a more appealing and attractive place, it is not necessarily the best conditions for taking photographs. On a sunny day when the sky is a deep blue, the shadows cast by the sun will be very dense and will have sharp, hard edges. Unless care is taken in the choice of viewpoint and in the framing of the image, you will produce very disappointing pictures.

Film has only a limited ability to record extremes of brightness, and the bright highlights and dense shadows created by strong sunlight can easily exceed the brightness range, resulting in pictures with no detail in the shadows and burned-out highlights. The best way to avoid this problem is to choose your viewpoint and frame the picture in such a way that these extremes of brightness are excluded. Avoid pictures in which there is an equal mixture of highlight and shadow and try to arrange it so that the image is either predominantly in shadow, and expose for this, or choose a viewpoint from which the shadows are very small.

Above *Equal amounts of highlight and shadow in this image mean that the contrast is too great for adequate detail to be recorded in both areas.*
Right *For this old-timer, viewpoint was chosen so that the majority of the picture area was in shadow and the exposure was calculated accordingly. The small amount of overexposed highlight was acceptable.*
Far right *The viewpoint for this beach picture was chosen so that the shadows created by the sunlight were least intrusive and minimized the contrast.*

Q How can I tell if the contrast is too great for the film?

A Use your exposure meter to take a close-up reading from the lightest and darkest areas of the subject. If this exceeds eight stops, you will lose detail in one or the other.

Q Why is it that sometimes the contrast looks all right to the eye but the pictures are too contrasty?

A This is because our eyes are much more accommodating than the film, and make allowances for the extremes. One way of overcoming this is to view the subject through half-closed eyes.

120 CONTROLLING CONTRAST

Even on a bright sunny day it is possible to reduce the brightness range of the subject to bring it within the limit of the film.

The surroundings in which you take your picture will have a considerable effect. If they are essentially light in tone, a beach scene, for example, then a large proportion of the sunlight will be scattered and reflected back into the shadows making them lighter. If you are taking a picture of a person, you can move him or her to a position where there is more reflected light.

Another solution is to move your subject to an area of open shade, under a tree for instance, sheltered from the direct light of the sun. When the sky is blue, however, open shade can create a cool blue cast on colour film and you will need to use a colour correction filter, such as a skylight or an 81A to overcome it.

Another method with relatively close-up subjects, such as a portrait, is to use an artificial reflector. Place a piece of white card close to the model on the shadow side and angle it to reflect the sunlight back into the shadows. Even something like a handkerchief or the pages of a book can be useful if placed close to the subject. It is possible to buy specially-made white fabric reflectors which are supported on a collapsible metal frame. Alternatively, you can use a small flash gun to fill in the shadows instead of a reflector.

Right *The contrast problems of shooting on a sunny day can often be overcome by placing or looking for subjects in an area of open shade, as this portrait of a Neapolitan lady demonstrates.*
Top right *When subjects are illuminated by bright sunlight the problem of excessive contrast is often reduced if the subject is in light surroundings. The shadows in this picture have been partially 'filled in' by light reflected from the whitewashed walls around the subject.*
Far right *This sunlit portrait was shot with the aid of fill-in flash to reduce the density of the shadows and to bring the brightness range of the subject within the tolerance of the film.*

Q How do you use a flash gun to fill in shadows?
A You must first establish the correct exposure for the subject, ignoring the dark shadows. Suppose this to be, say, $\frac{1}{125}$ second at f5.6: you then calculate the correct exposure for the flash according to the distance it is from the subject. Let us assume that this also requires an aperture of f5.6: since you only want the flash to supplement the daylight and not to completely eliminate the shadows, you should aim to underexpose the flash by about two stops. This means setting your aperture to f11, which in turn means resetting the shutter speed to $\frac{1}{30}$ second to compensate for the smaller aperture.

Many inexperienced photographers do not even consider taking pictures unless the sun is shining. Yet the soft light of an overcast day can have some positive advantages, and many subjects will benefit from this type of lighting. Brightly coloured subjects, for instance, are usually more effectively photographed in soft, even lighting than in the harder, harsher light of a sunny day, which will create dark shadows and strong highlights detracting from the colour content of the subject. Subjects that have an inherently high contrast, an abundance of detail or a bold pattern are also likely to make better photographs when illuminated with a softer light. The lighting quality of pictures taken on a dull day is less likely to be affected by a change of viewpoint. Consequently this type of lighting is often preferable for shooting subjects which are on the move.

One problem that can occur when shooting in colour is a blue cast on the film as a result of the higher content of ultraviolet light in dull conditions. It is advisable to use a skylight or 81A filter to counteract this.

Above In this shot the soft light and the lack of shadows has helped to accentuate the simple shapes and textures of the image.
Above right Shot just as a storm approached, the heavy sky has created a soft but interesting light which has produced an atmospheric picture of the Vosges mountains.

Right The bright colours of this fishing boat on a Normandy beach have been emphasized by the soft light of an overcast day.

Q Why is it that pictures I have taken on a dull day are often rather dark and murky?

A Probably because the sky is often the brightest part of such scenes. If you include too much sky when taking an exposure reading you will underexpose your picture.

Q Should I use a fast film on a dull day?

A Not necessarily. Unless you need to use fast shutter speeds such as when taking sports pictures, the slower, fine-grained films can often give a little more 'bite' to pictures taken in soft light. The grain of the faster films will show up more in a low-contrast image.

124 USING A SOFTER LIGHT

Even on a sunny day, the quality of the lighting can vary quite considerably. The light of a bright unobscured sun in a deep blue sky for example will create a much more contrasty lighting than when there are a number of large white clouds around or when there is a slight haze. When the sun is lower in the sky the shadows may be larger but they are also less dense and the light is usually softer and mellower. The surroundings, too, will affect the quality of the light. Where your subject is in an essentially light-toned setting – on a beach for example – there will be a considerable amount of the sunlight scattered and reflected into the shadow areas, reducing the brightness range.

Open shade is also an effective way of finding a softer light on a sunny day, since the subject will be shielded from the direct light of the sun and will be lit only by reflected light. When taking a portrait, for instance, you can position your model in the shade of a building or a tree. A problem in this situation is however that since the subject is being lit predominantly by light reflected from a blue sky, there will inevitably be a blue cast on the film unless a colour correction filter such as an 81A or B is used.

The softest light is created when the sky is overcast or when there is mist. Inexperienced photographers often put their cameras away on such days, yet these conditions can produce an ideal illumination for very colourful subjects, especially where a more subtle mood is required.

Above The mood of this Italian lake scene was largely created by shooting in the soft light of dusk. It appeared quite different earlier in the day in bright sunlight.

Right Even in the harsh light of the sun, it is still possible to find a softer light by shooting subjects in open shade as in this shot of a market. An 81A filter was used.

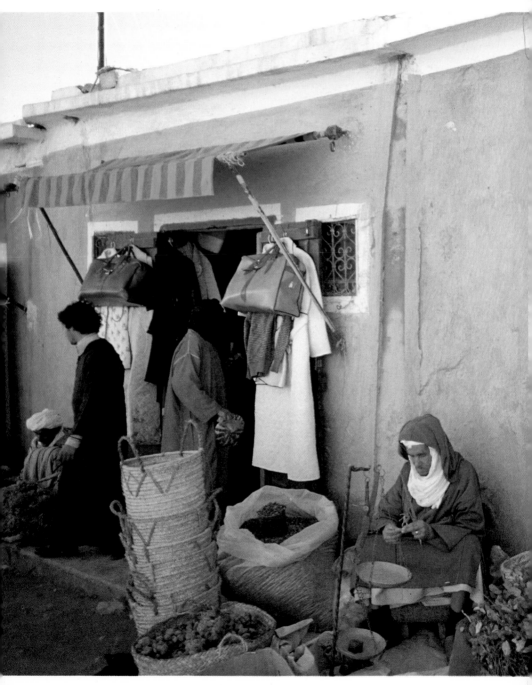

The nature and the quality of daylight can vary considerably. One of the most important variables is the effect of the time of day. At noon the sun is at its highest point in the sky and if there are no clouds the shadows it casts are very small and intense. In the early morning and evening, when the sun is close to the horizon it produces much longer and larger shadows. In landscape photography, for instance, the light of a midday sun can often create a rather flat effect, with little impression of form and texture. The same scene photographed in, say, evening light is frequently transformed, with the contours of the landscape thrown into sharp relief and the impression of texture greatly enhanced. Even a portrait can be affected by this change in the lighting. Often noon sunlight creates a very harsh and excessive top light with dense shadows under the eyes and chin, whereas when the light comes from a lower angle a more pleasing and flattering effect is created.

Do remember that the *colour* of the light changes during the day as well as the quality, and early and late in the day it will be more red than at noon.

Left *The low angle of the sunlight in this evening shot has emphasized the shapes and texture of the image as well as creating a warm, atmospheric quality.*
Below *The textural quality of the hillside in this landscape shot has been created by the late afternoon sunlight, which literally skates across its surface picking out almost every blade of grass.*
Right *Noon sunlight has created a quite stark quality emphasizing the harsh, hot quality of this Moroccan landscape.*

Q How can you correct the reddish cast created by evening sunlight?
A By using a colour correction filter in the Wratten 82 range. The 82A is the weakest, and the 82B and 82C progressively stronger.

Q Should you always use a colour correction filter when shooting early or late in the day?
A By no means. The warm cast created by this light is often contributory to the atmosphere of such pictures.

Q What pictures need to be corrected?
A Portraits can look unpleasant with a strong colour cast because skin tones in particular make the effect more noticeable.

Without light photography is of course not possible. It is not just the existence of sufficient light that is important to a photographer but also its quality. The different effects of lighting can reveal and emphasize different elements of a subject, but one factor which is almost completely dependent on the lighting quality is mood. Sunlight creates bright highlights and crisp shadows. This tends to promote a lively often happy mood in a picture. The soft light of an overcast day tends to produce images with neither strong highlights nor positive shadows and the effect is more subdued or sombre. The tonal range created by the lighting is also an important factor in creating atmosphere. A picture consisting of mainly light tones, for instance, will have a peaceful and gentle mood, whereas one dominated by large areas of dark tones or shadows will have a more mysterious or dramatic quality.

It is important to be aware of the effect of lighting on the mood of your pictures, since the wrong type of lighting can just as easily destroy a picture as the right lighting can enhance it. A portrait of a lively, happy child would have far less impact if lit with sombre, low-key lighting than if it had bright highlights and a full range of tones.

Above This shot of a fairground merry-go-round contains a full range of tones with bright highlights. This tends to create a lively atmosphere, in keeping with the subject.
Above right Mist and falling rain have created a very soft light and masked background details, producing a very high-key image which conveys a delicate and tranquil mood.
Right The predominance of dark tones in this stormy landscape picture has created a low-key image emphasizing the sombre mood of the scene.

Q What is meant by low-key lighting?
A This is a term used to describe an image which consists primarily of tones from the darker end of the scale.

Q What is meant by high-key lighting?
A High key is the description of a picture which contains mostly the lighter tones in the scale.

Q What is meant by soft and hard lighting?
A Soft lighting produces an average to low brightness range in the subject and creates weak shadows with diffused edges. Hard lighting creates a high brightness range and dense shadows, with a sharply defined edge.

Outdoor photography does not have to be restricted to daylight hours. Indeed many interesting and unusual pictures are taken after the sun goes down. Even a simple camera can be used for this type of picture, provided it has a time or B setting on the shutter speed dial and you have a tripod to support the camera. A camera with a fast lens, such as an f2 or an f1.4, can be used to take handheld pictures in many situations such as a city street as long as a fast film such as ISO 400/27 is used.

The main problem with pictures after dark is that of high contrast. This is particularly true of artificially lit subjects such as floodlit buildings, and scenes under street lighting. You must appreciate that the intensity of the light will diminish rapidly away from its source and when a large area is photographed the result can be small pools of light in a black void. One answer is to choose a viewpoint and to frame your pictures in such a way that both the light sources themselves and large areas of shadow are excluded from the image. Another way is to take your pictures before it is completely dark and there is still some light in the sky. You must also take care over exposure readings since both the light sources themselves and large areas of shadow can give misleading readings.

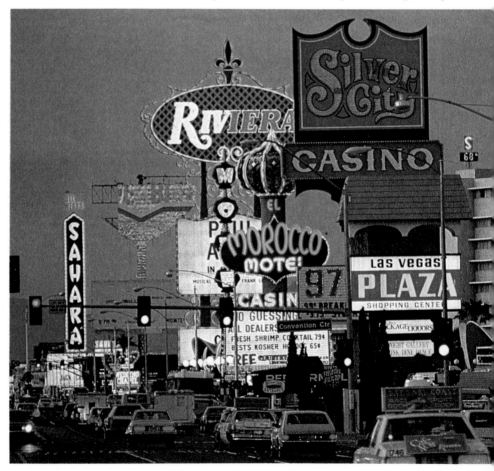

Q What is the best way of taking an exposure reading for this type of picture?
A Take a close-up reading from the most important part of the subject, making sure that you exclude light sources from the meter's view.

Q What if I can't get close enough?
A The best solution is to take an average from the highest and lowest readings.

Q Are there any special problems with long exposures?
A You must make sure the camera does not move or vibrate during the exposure. A cable release will help to prevent this. You must also allow for reciprocity failure.

Q What is reciprocity failure?
A This happens because film becomes less sensitive to exposures longer than about half a second. A film rated at ISO 100/21 may, for example, be only ISO 50/18 with a five-second exposure. The effect varies from film to film and you should make tests.

Above *This picture was taken long after the sun had gone down when there was just a little light on the distant horizon. It needed an exposure of 20 seconds, twice that indicated by the meter, to allow for reciprocity failure.*
Left *Taken just after sunset this shot of The Strip in Las Vegas still shows detail in the unlit areas and the sky, without the illuminated signs being overexposed.*

Many photographers simply put their cameras away when the light level drops below a point at which they can safely handhold their cameras, and the slower shutter speeds of their cameras are never used. This is a great pity, since many interesting and atmospheric lighting effects are created when the sun has gone down or the light is poor.

A firm tripod is an invaluable accessory. It can greatly increase your picture-making opportunities by enabling you to give longer exposures and make use of low light levels. City streets at night, illuminated buildings, dusk and moonlight pictures are well within the scope of even a simple camera on a tripod.

There are two main pitfalls to be avoided on this type of shot. The first is the very high contrast that night shots in particular tend to have. Care is needed to avoid pictures with large areas of black void and burnt-out highlights. With subjects like illuminated streets and buildings, for instance, it is best to take pictures before it is completely dark so that some ambient light remains to illuminate the sky and retain some detail in the shadows. The other factor to be aware of is exposure. Extreme contrast can mislead the meter, so a good method is to take an average of readings from the darkest and lightest areas and to avoid actual light sources like street lamps. You must also allow for *reciprocity failure* when giving exposures longer than about half a second or so.

Above An exposure of one second was needed for this shot of a circus tent at night, using ISO 400/27 film with the camera mounted on a tripod. The exposure was calculated by the averaging method.

Above right This picture, taken well after the sun had gone down, required twice the exposure indicated because of reciprocity failure.
Right The moon rising over Yosemite. The exposure was calculated by taking a reading from the sky above the camera.

Q What is reciprocity failure?
A It happens when the film becomes less sensitive in proportion to the increase of exposure time. Most films begin to show signs of this with exposures in excess of about half a second. For example, a film may be rated at ISO 100/21 but at one second exposures it may drop to ISO 64/19 and at five seconds to ISO 32/16 and so on. The effect varies from film to film. It is sensible to do some tests with your usual stock at various exposure times as the colour balance can also shift and you may need to compensate with colour correction filters.

Available light photography simply means making do with what is usually a low level of existing light without using flash or studio lights to supplement it. Even in the brightest artificial lighting there is a dramatic reduction in the brightness level compared to daylight and the main difficulty is that of adjusting your technique to cope with this.

Fast film and wide aperture lenses are obviously very helpful, but even so you will still probably be using much slower shutter speeds than when shooting outdoors and the danger of camera shake is much greater. It is always advisable with shutter speeds of less than ⅟₆₀ second to use some additional support for the camera. If you don't have a tripod then try to find an existing support such as the back of a chair or a doorframe to help brace your camera. You will also find that focussing needs to be more critical when using wide apertures and in low light levels the rangefinder type of focussing can be an advantage.

Even if you are using a fast film you may find it necessary to uprate to a higher speed in very poor light, particularly when you are shooting a moving subject and need to use faster shutter speeds. As with shooting after dark, you must also look out for problems created by light sources and high contrast.

Right This picture of London's Berwick Street market was taken using daylight type ISO 400/27 film, enabling an exposure of ⅟₁₂₅ second at f2 to be given. *Far right* Tungsten light film of ISO 160/20 uprated two stops was used for this shot of circus performers. This enabled an exposure of ⅟₆₀ second to be used at an aperture of f4. A long focus lens was used.

Q How do you uprate film speeds?
A For black and white films you can buy special speed-increasing developers such as Acuspeed. Or you can extend development times in conventional developers such as D76.

Q Can you uprate colour films?
A Yes. Most fast colour films can be uprated to two or three stops more by increasing the first development time.

Q What if I don't process my own film?
A Most professional laboratories offer a speed increasing service at a small extra cost. You simply mark clearly on the film at what speed it was rated and they will modify the processing time accordingly.

The small flash guns which fit into the camera's accessory shoe are a very convenient and highly portable means of additional lighting. However, unless used with some care, they can easily produce disappointing results.

As with any light source the illumination from a small flash gun when aimed directly at the subject will decrease rapidly the further it travels. This means that if the exposure is set for a subject at, say, three metres from the camera, objects further than this will be under-exposed and objects closer will be over-exposed. The solution is to make sure that the subject and the background are on a similar plane and that nothing is much closer to the camera than the subject.

Another technique which can be effective when shooting in a confined space, such as a living room, that has light walls or ceiling is to aim the flash gun at one or both of these surfaces so that the light is 'bounced' off onto the subject. This creates a much softer and more even light, but you will need to give more exposure to compensate. When shooting in colour the surface must be white to avoid a colour cast.

Another effective way of using a flash gun aimed directly at the subject is to use a slow shutter speed instead of setting the dial to the flash speed setting. This will allow any ambient light to record as well as the flash and will improve the atmosphere of the picture as well as the lighting quality.

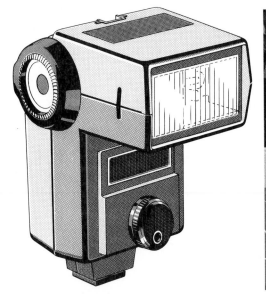

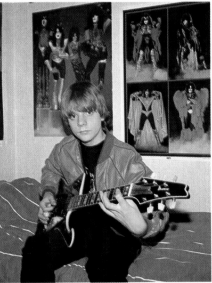

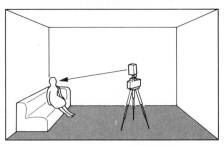

Above *A typical portable flashgun. It is usually powered by small batteries or a rechargeable nickel cadmium cell. The head can be angled to bounce the flash to the subject from the ceiling, and the gun is fitted with a sensor which provides automatic exposure control.*

Above right *The picture above was taken by using direct flash close to the camera. The effect of a dark background has been avoided by placing the subject close to it, so that both were illuminated with a similar level of brightness.*

Q How do you calculate what shutter speed to use for this technique?

A You should use a shutter speed one or two settings faster than that indicated by a normal exposure reading at the aperture required for the flash exposure.

Q How can I avoid the red highlights in the eyes when taking portraits or photographing animals?

A Red-eye is caused by the flash gun being too close to the lens. That is why it is often a feature of family snaps taken with a flash cube mounted on the camera. It can be prevented by holding the flash gun at least 30 centimetres above the level of the lens.

Q How can you calculate the extra exposure when using bounced flash?

A Measure the distance from the flash to the ceiling and then to the subject. Use this to find the correct aperture and then open up one stop if the surface is white, more if it is darker.

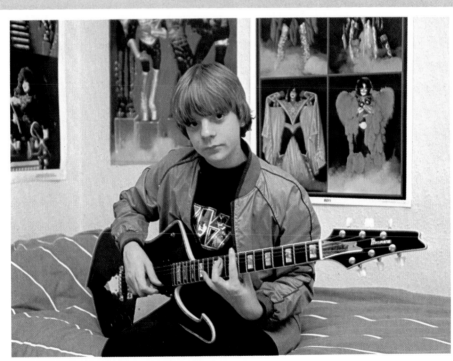

Above This shot was taken by using bounced flash in the way shown in the illustration. The effect is rather softer than that of the picture on the left hand page but with more modelling in the boy's face. This method required an increase in exposure of three stops over that of the direct flash shot.

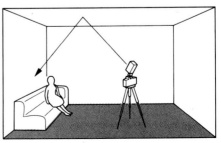

138 USING DAYLIGHT INDOORS

Daylight can be an ideal source of light for indoor photography. The essential thing is, of course, a good-sized window or skylight. If this is exposed to the direct light of the sun, you will need some means of diffusing it, a large sheet of tracing paper, for example, taped across the glass or even just a white net curtain.

Since the only way of controlling the direction of the light is to move your subject and the camera in relation to the window, you will also need to have a moveable background for subjects like portraits and a table or bench for still life pictures. When you set up your camera with the window behind it the result will be a frontal light with few shadows and little modelling. With the subject and camera arranged so that the window is to one side, the effect will be a more directional light with greater modelling and quite pronounced shadows. Since this will tend to create excessive contrast, you will also need a large white reflector which can be placed close to the subject on the shadow side and angled to reflect the window light back into the shadows. This can be a piece of white card or polystyrene simply propped against a chair. Mirrors can also be used to create a stronger effect.

A tripod will be particularly useful for indoor work. It will help to avoid camera shake at the inevitable slow speeds you will need. You can also use it to support the camera, set up and ready to shoot, leaving you free to study lighting effects at your leisure and make any necessary adjustments.

Above *Taken inside the clown's caravan this portrait was lit by windows on each side and at the rear to provide a white background.*
Above right *For a more dramatic effect, the model in this portrait was positioned almost at right angles to the window, creating a quite strongly-lit profile with dense shadows.*

Right *Soft but directional daylight from a window provides a light which has effectively emphasized the textural quality of this simple still life.*

Q What is the best background to use.
A You can buy from professional photographic dealers large rolls of cartridge paper in a range of colours. These can be supported by threading a piece of wooden dowelling through the core and resting each end on two light stands or similar supports.

Q Can fabric be used as a background?
A Yes, but it must be crease free, otherwise it can look very unattractive and distracting.

Q Is indoor daylight suitable for colour photography?
A Yes, certainly, although you may find that you will need to use a faster film because of the lower light level and with a north facing window, or one that is illuminated by the sky, you will probably need to use a filter such as an 81A to offset a possible blue cast.

Provided you have a reasonably large window or skylight, daylight can be an ideal light source for colour photography indoors as well as outdoors. Subjects such as portraits, still lifes and nudes can be lit very effectively indoors with the aid of a reflector or two to help control the lighting contrast. A north-facing window will provide fairly constant quality of light throughout the day, but a window which admits direct sunlight will need a net curtain or tracing paper screen to diffuse the sunlight.

Since your light source, the window, is in a fixed position you must arrange your camera and subject so that they can be moved in relation to each other to control the angle and direction of the lighting. With a still life, for instance, you can set up the elements on a small bench or table which can then be turned to adjust the lighting. With a portrait you will also need to be able to move the background as well as the model.

If you set your subject up facing the window and the camera in front of it the result will be frontally lit with little modelling and minimal shadows. On the other hand if the window is to the side of the subject the lighting will be much more directional with strong shadows on the other side. The density of these shadows can be easily controlled by using a large piece of white card or other material as a reflector on the shadow side and moving it closer or further from the subject to adjust the lighting contrast.

Right A lady with her cat photographed in a bay window. The window has created a white background as well as providing light for both sides of her face, diffused by net curtaining. A reflector was used to fill in the shadows from the front.
Far right A small, white-painted room was the setting for this shot of a girl. The reflected light has created quite a soft quality, minimizing the shadows and creating an almost high-key effect.

Q Do you need an exposure meter or will TTL do?
A Either is satisfactory, but a hand meter can be more convenient for taking close-up readings when the camera is mounted on a tripod.

Q What film speed is best?
A Since the light level is likely to be substantially lower than when shooting outdoors, a medium speed or fast film is preferable to a slow one.

Q Is a wide angle lens helpful?
A Not really for portraits or still lifes, unless a distortion of perspective is required, or you need to incorporate a large expanse of the room as background, or you want to take a full-length portrait in a confined space.

Q What kind of film is best?
A As a general rule, a fast film is best. If the subject is static and you can use a tripod to prevent camera shake at slower shutter speeds, a slow film will be all right.

Q What speed?
A It depends on a number of factors. A good general-purpose film for low light levels is ISO 400/27, which could be push-processed one or two stops faster if necessary.

Q Can shots be made inside a large building without flash?
A Yes, by making use of the available light and giving a longer exposure. In fact, a small flash gun is virtually useless in a large interior such as a church. At best, all it would do is illuminate the immediate foreground.

When you are shooting black and white pictures there is no problem about mixing light from different sources, but with colour film this can cause a noticeable effect. For instance, if you are taking a picture indoors using daylight, but you also use some tungsten lighting to boost the daylight, one or other of these sources will create a colour cast. If you shoot on daylight film, the area illuminated by daylight will record naturally, but the part of the subject lit by the tungsten light will have an orange cast. If you shoot on artificial light film, the area lit by the tungsten light will appear normal, but the details illuminated by the daylight will have a blue cast. The answer is to choose the film type to match the colour quality of the predominant light source and to make sure that they are not evenly balanced. As a rule, the effect is more acceptable when there is a warm cast than it is when there is a blue cast, so daylight type film is the safest choice.

If you are using a small source of mixed light, such as a flash gun, with tungsten light you can fit a colour conversion filter over the flash gun so that it matches the colour quality of the artificial light.

Above Tungsten light film was used for this picture. Although the illuminated room appears almost correct in colour, the residual daylight has produced a blue cast.
Above right This interior was lit with an almost equal mixture of tungsten light and daylight. It was photographed on daylight type film, resulting in a warm cast where the artificial light is strongest.
Right Tungsten light film was also used for this street scene. The sodium vapour lighting has created an orange cast, although the unlit areas are blue.

Q Can you mix fluorescent light with daylight?
A No. Although they appear similar, and some tubes are called daylight type, they are quite different to daylight and will produce a strong colour cast, usually green, unless filtered.

Q What sort of filter should I use for fluorescent light?
A There is considerable variation in the different types of tube. However, most fluorescent tubes are lacking in red, and with daylight type tubes using daylight type film a 30 to 40 magenta filter will usually produce an acceptable result. Where possible a test exposure is advisable.

Although you can take pictures using available light indoors, there are many subjects where a great deal more control over the quality and direction of the light is needed to produce the best results. Indeed, even daylight has limitations in this respect. Any photographer who is interested in subjects like still life, close-ups and portraits will eventually feel the need to have at least a modest studio set-up.

A home studio need not be expensive. A quite adequate arrangement can be made using two or three reflectors on stands, fitted with photoflood bulbs or quartz halogen. A few basic accessories such as a white reflector, a diffusion screen and some pieces of black card will give you a range of effects.

A little more outlay would provide you with a portable studio flash outfit, consisting of two or three flash heads on stands and a choice of different types of reflectors and attachments such as snoots and honeycombs. The advantage of this equipment is that you are able to shoot on daylight type film and the flash is so brief that you do not have to worry about camera shake or subject movement.

You will also need a background and the arrangement suggested in the pages dealing with daylight indoors (pp 84-85) is ideal. Paper rolls are very useful for full-length pictures because the paper can be draped onto the floor in a gentle curve to avoid the formation of an ugly line between wall and floor.

Left A basic portrait lighting set up. The key light is provided by one of the lamps reflected from a white umbrella. The second lamp is fitted with a snoot to provide a tightly controlled beam of light to highlight the hair. The white reflector prevents the shadow areas from becoming too dark.

Right A typical portable studio flash kit. Each lamp has its own flash generator. Lightweight collapsible stands are included, with a choice of reflectors. The white or silver umbrella is a convenient and portable means of providing a soft, broad flood of light.

Above *The effect of this still life was produced by very simple means. A single diffused light was directed from one side with a reflector to fill in the shadows, a piece of plain coloured paper provided the background and the textured effect was created by stretching a piece of cheesecloth over a wooden frame in front of the vase of flowers.*

Q Are there any disadvantages with a flash outfit, apart from the extra cost?
A Flash has a limited power output and so the choice of aperture is limited according to the distance the flash is from the subject. With tungsten lighting you can simply give a longer exposure. This makes a low-power flash outfit less suitable for subjects where you might want to use small apertures for extra depth of field, such as still life.

Q What is a snoot and a honeycomb?
A They are attachments which fit onto the reflector to limit the spread of light. They give an effect similar to a spot light.

Q How do you calculate exposure with a flash outfit?
A You will need to buy a special flash meter which is designed to read the brief duration of the flash.

Q Can you use ordinary domestic bulbs instead of photoflood bulbs?
A Yes, but they are of lower intensity and you will need to use longer shutter speeds or faster film. They also have a warmer colour quality than that for which artificial light film is balanced, so if you are shooting colour pictures you will need to use a bluish colour correction filter.

As with outdoor photography, the most useful light for most subjects in colour photography is one that is fairly soft. Hard, undiffused lighting such as a spotlight has its uses, but for subjects like portraits, nudes and still lifes the most effective source of illumination is created by a fairly large diffused source.

There are a number of ways of achieving this quite simply. The most basic is to bounce a small flash gun from a white ceiling or wall. This method produces a far more pleasing light than when the flash is aimed directly at the subject. However, this is not always possible.

Ideally, at least two lights are required to give a reasonable degree of control of effects and at least one large white reflector. Either tungsten or electronic flash can be used satisfactorily, with the correct film of course, but unless your flash is fitted with modelling lights, tungsten makes it easier to judge the effect of your lighting as you arrange it. Your diffused main light can be produced either by making a large tracing paper screen which can be positioned between the light and your subject, or by bouncing the light from a large, white, movable reflector. Alternatively, an umbrella type reflector can be fitted to most lamps, but this will not give quite such a soft light as the methods described. The density of the shadows can be controlled by the use of a white reflector, and the second light source used for rimlighting or illuminating the background.

Above *A single diffused light source, at 45° to the camera, was used to illuminate this abstract. A tracing paper screen was placed between it and the subject to create the diffusion.*

Right *This shot was taken using one undiffused light source at right angles to the camera. Highlights were created by a mirror placed close to the subject. A white reflector in front filled in the shadows.*

Q Can daylight be mixed with studio lights or must it be excluded?

A When shooting in colour, daylight can be mixed satisfactorily with electronic flash, but not with tungsten light since tungsten light balanced film will produce a blue cast when exposed to daylight.

Q How big need a home studio be?

A You can take head and shoulder portraits or small still lifes in an area about three by four metres. For full-length pictures you would need half as much again, although more space would obviously be better.

Q Can ordinary domestic bulbs be used for studio photography?

A Yes, although their relatively low intensity will mean that you will have to use a longer exposure and/or a faster film. As they have a slightly warmer colour quality than photographic bulbs they will require the use of a bluish colour correction filter such as an 82A.

The secret of good lighting technique is never to use more lights than is necessary. Start with only one, adding others as and where required. This first light is called the key light and is responsible for revealing the form of the subject and establishing the basic effect of the lighting.

For subjects such as portraits and still lifes and where a natural look is required the key light needs to be quite soft. You can either diffuse through a tracing paper or fabric screen, or reflect from a fairly large white surface. The umbrella type reflector supplied for flash lamps is a convenient way of achieving this. The key light must be positioned at an angle to the subject which will reveal both modelling and texture but will not create ex-

cessively large or unpleasant shadows. Naturally this depends on the kind of subject you have, but on the whole an angle of about 45° to the camera, and just above eye level if it is a portrait, will be a good starting point from which to make a finer adjustment. If the shadows that this light creates are too dense, and they probably will be, then you must use either a second light or a reflector to add light to them. Do not try to eliminate them as this will destroy the modelling as well. If you use a second light for this purpose be careful that it does not itself create shadows, as this can look unpleasant.

In addition, one or two other lights can be used to illuminate the background or to backlight the subject, or both, to add interest and to separate the subject from the background.

Above A single diffused light at right angles to the model was used to produce this effect, in which the texture of the subject's face has been accentuated.
Above right A diffused light from close to the camera was used as a key light for this shot, with a reflector to fill in the shadows. A second light from behind the model was also used to create highlights on her hair.

Right An undiffused light from about 45° to the camera position and just above the model's head was used to create strong modelling in this portrait.
Far right The high-key effect for this portrait was produced by a single soft light from close to the camera position, with a reflector close and to the left of the model, and another lamp directed at a white background.

Q How do you calculate exposure when using several lamps?
A It is best to switch off the secondary lamps when taking an exposure reading, since these are only for additional effects and might mislead the meter. It is the key light which is crucial.

Q Should I use an ordinary reflector for backlighting and lighting the background?
A As a rule it is best to use a snoot or even a piece of black card to limit the light to the area you want, particularly in a small room. Stray light from these lamps can be scattered indiscriminately and alter the balance of your main lighting.

Most pictures are taken with the sun somewhere behind the camera. On occasions it can be an advantage to shoot with the sun behind the subject so that your camera is aimed towards it. This has the immediate advantage of creating an image which is rather different in quality to most other photographs imbued with an exciting degree of impact and drama. It can also be an effective way of providing a softer and more flattering light for portraits when shooting on a sunny day, since the light which illuminates the front of the subject is indirect reflected light from the sky rather than a squint-inducing frontal glare. The backlighting can also create a pleasing halo of light around the edges of the subject. This type of lighting can also be an effective way of subduing unwanted background details and simplifying a fussy and confusing image.

There are two problems associated with this technique. One is the danger of the sunlight falling onto the lens and creating flare. This will produce a pale, flat image. It can be avoided by shielding the lens with an efficient lens hood, or by positioning the camera within an area of natural shade. The second common fault with this type of picture is underexposure.

Above Shooting against the light has provided a quite soft frontal light for this portrait of a girl.
Right Although the sun is included in this shot the risk of flare has been minimized by partially masking it with the tree's branches.
Below Shooting into the light has created a dramatic effect with this seascape.

Q Why will backlighting cause underexposure?
A Because the bright highlights created by this type of lighting will mislead the exposure meter and give a higher reading than is really correct.

Q How can I avoid this problem when taking an exposure reading?
A The best way is to take a close-up reading from the most important part of the subject, being careful to exclude any bright highlights from the meter's range.

Q What can I do if I can't get close enough to do this?
A You can increase the exposure indicated by a general reading by about two stops.

Most pictures taken on a sunny day are with the sun somewhere behind the camera. This will help to ensure that the subject will be at least adequately lit and will also simplify exposure calculation. For the majority of pictures, this is the most satisfactory way.

However, shooting into the light – with the sun behind the subject rather than the camera – can on occasions create a far more interesting effect. It can, for instance, produce a pleasing halo of light around the edge of the subject which can help to isolate it from the background. It can also provide a softer lighting for the subject since this will now be reflected rather than direct sunlight. Shooting against the light can in addition help to subdue unwanted background details either by creating a bright area of light tones or by causing the background to become a shadow area. When the sun is fairly low in the sky, it is also possible to emphasize the textural quality of, say, a landscape picture by shooting towards it.

There are a number of pitfalls that must be avoided when using this technique. Exposure meters, for instance, can be very misled by this type of lighting: a reading taken in the normal way will usually produce an underexposed result. It is best to take a close-up reading from a mid tone in the subject, or, if this is not possible, to increase a normal reading by approximately one and a half to two stops.

Another problem inherent with shooting into the light is that of flare, an effect which is induced by the sunlight falling directly onto the lens and causing internal reflections. An efficient lenshood will help to prevent this.

Above Shooting against the light has helped to separate the marchers from the confused background. One and a half stops extra exposure was given over the meter reading.

Right Shooting against the light has resulted in a soft frontal light for this picture. The picture was slightly overexposed to keep the image fairly high key and romantic.

Q Can filters help?
A A graduated filter can be used to reduce the intensity of, say, a bright sky or the sun in the picture area.

Q Will a UV filter help?
A Yes. It will help to prevent a blue cast when the subject is lit by a blue sky, in open shade for example, but a stronger filter such as an 81A is likely to be preferable.

Q Is a polarizing filter worth using?
A Yes. It can help reduce glare from reflecting surfaces.

With most pictures, it is sufficient that the lighting should simply create a pleasing and balanced effect without becoming a noticeable element of the composition. However, there are occasions when to add interest or drama to a picture or to help establish a mood it is an advantage to allow the lighting to become more dominant and to use it in a rather more contrived way.

The most commonly used technique is probably rim lighting. A lamp is positioned immediately behind or slightly to one side of the subject and directed towards the camera. This creates a rim of light around the subject. It is often used in portraiture to highlight a model's profile or hair. A second light can also be used to make a plain-coloured background more interesting, either by using a snoot to project a pool of light behind the subject or to cast a shadow pattern onto it.

Lighting can also be used to create mood. A low-key effect can be established by using mainly backlighting, which creates a few small areas of highlight but leaves most of the subject in shadow, producing a sombre or more dramatic mood. Alternatively, a very soft frontal light can be used so that the subject is lit without shadow. If the subject is essentially light in tone this will produce a high-key effect and a more gentle, romantic mood.

Right Only one light was used for this high-key portrait. The model was positioned close to a white background, a single diffused light placed close to the camera and two white reflectors added very close to her on each side.
Far right The low-key effect of this three-quarter shot was produced by placing one light source, diffused with a tracing paper screen, almost at right angles to her from the left of the camera. Another light fitted with a snoot was directed at the background to create a pool of light.
Above right The rim light effect on the model's hair in this shot was produced by placing a light fitted with a snoot above and behind her, suspended from a boom stand. The key light was placed in line with the direction of her head and a reflector was used to fill in the shadows.

Q What is the best way to light a glass object?
A The way to emphasize its translucent quality is to place it in front of a well-illuminated white background. Use only a small amount of frontal lighting, just enough to create a few highlights.

Q How should I light a very reflective object like a silver bowl?
A The best way is to completely surround the subjects inside a 'tent' of translucent white paper or fabric. Leave only a small hole through which to aim the camera and light the tent as evenly as possible from the outside.

5 COLOUR TECHNIQUES

A sunset is a subject which few photographers can resist. Yet a surprisingly large percentage of sunset pictures are disappointing. There are a number of reasons why this should be so, since it can be a more difficult subject to capture on film successfully than it might at first seem.

The first mistake that many people make is to think that the sunset alone is sufficient to make an interesting picture. This is rarely the case and even when other elements such as foreground interest are included in the image, the exposure which will record the rich tones and colours in the sky will inevitably result in considerable loss of detail in these areas. One solution to this problem is to find some foreground interest which will be effective in silhouette, such as an interestingly-shaped tree for instance. Another technique is to choose a viewpoint which includes a reflective foreground, such as an expanse of water, to continue the tones of the sky. A third technique is to use a graduated filter to reduce the exposure in the sky area without affecting the foreground details. These can also be used to add colour to the sunset.

The calculation of exposure can also be a problem. One method which will give a satisfactory reading in most circumstances is to take a reading from the area of sky immediately above the camera. It is advisable to bracket exposures as the effect of the sunset will vary considerably according to the exposure and the best is difficult to predict.

Above *Sunset in Death Valley. The soft, subtle colours were the result of shooting after the sun had gone down. A common mistake in sunset pictures is to take them too soon.*

Right *A 600mm lens was used to create this dramatic juxtaposition. Since no detail was needed in the silhouetted foreground figures, it was possible to select the best exposure for the sunset.*

160 COLOUR CLOSE-UPS

Colour photography lends itself particularly well to the close-up techniques. This is largely because there is an abundance of potential subject matter all around us that appears unremarkable until we take a closer look at it. Simple everyday objects such as fruit, flowers, ornaments and utensils and even small creatures can reveal an infinite variety of textures, patterns and colours when photographed in close-up.

Most cameras, apart from the very basic, will focus down to about half a metre. This can be adequate for some subjects, but you will give yourself much more scope with a close-up lens, which reduces the close focussing distance of the camera lens even further. For SLR owners a set of extension tubes, a bellows unit or a macro lens offers even more potential, enabling lifesize or even magnified images to be obtained.

A tripod is another vital accessory for close-up work, because the depth of field reduces drastically when the lens is focussed at close distances and you will need to use a small aperture and longer shutter speeds. With the tripod you can also set up, frame and focus your camera accurately and make small adjustments easily. You will often find it easier when shooting close-ups to focus by moving the camera closer to or further away from the subject rather than altering the lens focussing ring.

Do not forget when you are using extension tubes or a bellows unit to give more exposure to allow for the extension.

Right An extension tube was used for this close-up of a flower. Soft lighting has enhanced its colour, and a medium aperture was used to ensure that the flower itself was sharp while the background remained out of focus.
Far right A supplementary lens was used to move in close and emphasize the texture of this piece of dockside machinery, creating an almost abstract image. A small aperture was used to ensure adequate depth of field.

Q How do I calculate the exposure increase needed when using extension tubes?

A You must increase the exposure in proportion to the square of the increase in the distance the lens is extended beyond its focal length. For example, if a 50mm lens is extended so that it is 100mm from the film plane (ie twice the distance) then you must increase the exposure by four times. The formula is:

$$\left(\frac{\text{Total lens extension}}{\text{focal length of lens}}\right)^2 = \begin{array}{l}\text{increased}\\ \text{exposure}\\ \text{time}\end{array}$$

So taking the above example we have:

$$\left(\frac{100}{50}\right)^2 = 2^2 = 4$$

Q Will I need a small aperture for close-up work?

A As a rule, yes, since the depth of field is much less with close-ups.

Q Will I need a cable release?

A A good idea. This is very useful when using slow shutter speeds as it prevents the camera being jarred when the shutter is released.

There are three essential ingredients for a successful portrait photograph: the model must be comfortable and relaxed, the lighting must create a pleasing effect and the background must be uncluttered and unobtrusive. Many portraits are spoiled because the model has been asked to stand and smile into the camera. This is almost guaranteed to produce a stiff and self-conscious response. It is much better to let your model adopt a comfortable and relaxed position of his or her own accord, if necessary making slight adjustments to it in an indirect way, and simply carry on a normal conversation whilst you shoot the pictures so that the expressions are quite natural.

The ideal lighting for a portrait is a fairly soft source from an angle of about 45° to the camera to model line. This will produce a good degree of modelling on the face but will not create excessively dense shadows or accentuate skin texture. Outdoors this can be achieved by shooting on a slightly cloudy day or on a sunny day by positioning your model in open shade.

If you wish to emphasize character rather than flatter your model you can afford to use rather harder, more directional lighting to create a more dramatic effect. Finally you should make sure that the background area is a fairly smooth and unobtrusive tone that acts as a contrast to the subject and helps to bring out facial features and expression.

Above A long focus lens (150mm) was used to enable a quite close-up image to be obtained without having to use a close viewpoint. The soft lighting was from an overcast sky.

Right A clown shot against the side of the circus tent, which provided a plain, contrasting background. In soft light, patience and a quick response captured a spontaneous expression.

Q How do you get the model to relax?
A Have everything prepared. Be relaxed and confident yourself and thoroughly familiar with your equipment. Carry on a normal conversation while you work. If you like it, music can be very helpful.

Q Why do I have more problems with colour in portraits than with, say, my landscape pictures?
A Because we tend to be more critical of a colour cast when it affects a skin tone and even a slight variation will be quite noticeable.

Q Why is it often recommended to use a long focus lens for portraits?
A Because if you move the camera too close to the subject in order to fill the frame it will produce an unpleasant perspective effect in which the model's face will appear to be slightly distorted.

The type of view to which most people respond readily, the postcard vista of a summer landscape on a sunny day, is the one that is most difficult to translate successfully into an effective photograph. Our eyes are able to sweep over such a scene like a panning movie camera, building up an impression of it rather than making a factual record. But a factual record is exactly what the camera will record: usually there is no effective centre of interest and the result is an unsatisfactory image with no sense of order and composition.

It is essential to find or create a point in a landscape picture to which the eye will be led, such as a tree or a building. This can often be done by isolating a small area of a scene rather than attempting to include it all, and to frame it so that the other elements of the picture create a balance around the main point of interest. Where a broad view is essential a cohesive quality can often be created by introducing some foreground interest. This will help to create an impression of depth as well as leading the eye into the picture.

Lighting is a vital factor in landscape photography. Often an otherwise unremarkable scene can be transformed into a powerful image by a sudden change in the light. Shooting early or late in the day will help to create such situations when the low, slanting angle of the sun will reveal rich textures and patterns in the countryside. The light that occurs just after a storm can also be ideal for landscape photography.

Below left *The elegant shapes of these bare trees create an impression of pattern which helps to make an effective composition. A long focus lens was used to isolate a small area of the scene.*
Below *A distant view is one of the most difficult subjects for a landscape picture. This shot was taken with a long focus lens to concentrate on a specific area of a wider view.*

Q Do seascapes need a different technique?
A Not really. However, bear in mind the possibility of misleading exposure readings due to large areas of reflected light and highlights, and a possible blue cast resulting from ultraviolet light.

Q What is the best way of creating a feeling of distance in landscape shots?
A This can be done by including close foreground details in the frame to enhance the impression of perspective. This effect can be increased by using a wide angle lens.

Q Where is the best place to position the horizon in a landscape shot?
A As a general rule it is best to avoid a centrally placed horizon as this can create a picture which is too evenly balanced, about one third of the way from the top or bottom of the frame is effective.

In most cases a colour photograph is intended to give a fairly faithful record of the subject with perhaps a slight modification of the image to emphasize a particular quality or to create a more dramatic effect. There are, however, many ways in which the subject can be used only as a basis for the final image and the photographic process used as a means of changing and distorting it to create a more subjective and personally expressive image. Many of these techniques are relatively simple and can be done inside the camera, without recourse to the darkroom, simply by using and combining the characteristics of the film, lighting and filters. The following photographs demonstrate some of these effects.

Above Infra-red Ektachrome was used for this surrealistic landscape. Its effect is not completely predictable, since it depends upon the invisible infra-red radiation. Kodak recommend the use of a starting point for experiments, but different filters and different exposures can produce a variety of effects. This shot was taken using a Cokin sepia filter with an exposure of 1/125 second at f8 in bright sunlight.

Above right This seascape was taken with the aid of an orange filter designed for use in black and white photography. Heavy filtration of this type can often be effective with the right subject. In this case, although the lighting was pleasing the unfiltered picture had a rather muddy, grey appearance and the filter added a degree of impact. This is an ideal way to use up stale or suspect film.

Right Soft focus is one of the simplest ways of creating a slightly different image quality. Used with the right subject, it is most effective. This shot was taken through strips of Sellotape (stretched) across the lenshood opening, leaving a clear spot in the centre. As well as the special attachments which can be bought as part of a filter system, there are many other ways of achieving this effect.

Q I hear that some professionals use Vaseline on the filter for a soft focus technique. What is the effect?

A If it is smeared around the edges of a filter leaving a clear spot in the centre, it creates a soft focus effect combined with an attractive streaking of highlights. This can be controlled by teasing the jelly around with your fingertip. *Never* put Vaseline directly on the lens.

Above The strange colour quality of this still life shot was produced by illuminating the subject with ultraviolet light, sometimes called black light. In this case, sheets of fluorescent paper were illuminated by the ultraviolet lamp and reflected in a sheet of mirrored foil upon which the glasses were placed. This picture required an exposure of four seconds at f11 on ISO 200/24 daylight type film with a Kodak 2A UV filter to eliminate any scattered UV light.

Left The effect of this image was created by making three separate exposures – each through a tri-colour separation filter – red, green and blue, onto the same piece of film. Make an exposure through the red filter in the normal way. Without moving the camera or film, make an exposure through the green filter, giving one and a half stops extra, and another through the blue filter, giving two stops extra.

In most cases the camera settings are selected to create an image which is as sharp as possible. The shutter speed is fast enough to prevent camera or subject movement and the aperture small enough to ensure adequate depth of field. Yet the effect of blur can create quite powerful and attractive images in colour photography and you should consider the possibilities of using this quality as part of the composition when taking a picture.

Out of focus details can be created quite simply by using wide apertures and focussing the lens at a particular point of a subject and by framing the picture in such a way that objects much nearer and/or further are also included. This effect will be further emphasized by using long focus lenses.

Blur created by movement can be even more effective and can be achieved in a number of ways. With a subject that contains both a moving and a static element, such as a waterfall, the camera can be set up on a tripod and a slow shutter speed selected. This will record an image in which the static elements are sharp but the moving parts are blurred. With some subjects such as sports it is also possible to pan the camera with a moving subject and use a fairly slow shutter speed. This will produce an image in which the moving element is recorded sharply and the static part of the subject is blurred.

For those that like to experiment it can also be interesting to use a controlled camera shake combined with a slow shutter speed to introduce movement to a completely static subject.

Above *Controlled camera shake created effect. An exposure of 1/8 second was selected, the camera was wobbled carefully in a regular manner and the shutter released while it was moving.*
Left *For this shot the lens was adjusted so that it was completely out of focus. It was set at the closest focussing distance with the subject at infinity.*
Right *The slightly ghostly quality of this landscape picture was achieved by mounting the camera on a tripod and using a two-second exposure in poor light.*

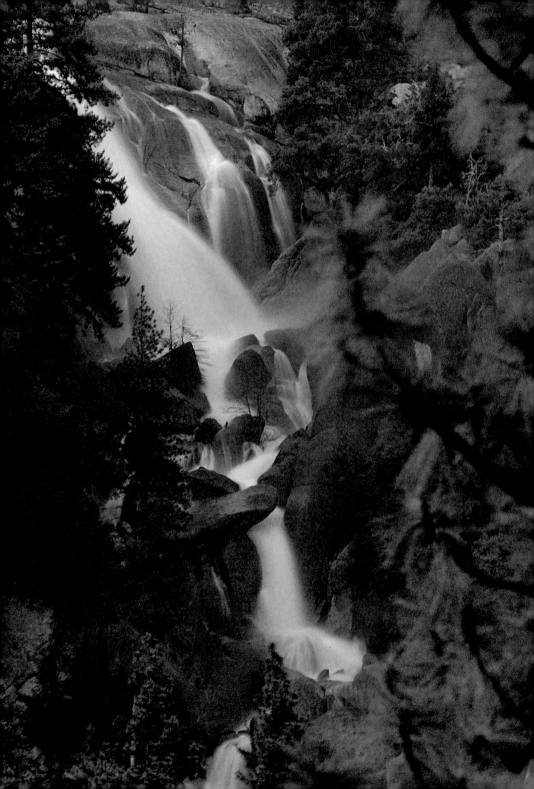

Most cameras have a device which prevents the accidental exposure of two images on one piece of film. Such double exposure however can be used to create interesting and unusual pictures if done in a controlled way. You will either need a camera which enables two or more exposures to be made without advancing the film or to be prepared to wind the film back and re-expose it after having carefully marked the starting position.

The success of this technique lies in the juxtaposition and balance between the individual images and this requires that the final image is carefully planned. You must remember that as you are in effect reusing the film in the second and subsequent exposures that the lighter areas of one image must not be juxtaposed with light tones in the other. This will result in both being lost. The simplest way of ensuring success is to have one image basically dark in tone with the second image superimposed over it. To make it easier, you can underexpose the first or background image by as much as two stops or more. In most cases you will need to slightly underexpose the second image as well, as there is a cumulative effect and two or more normal exposures will produce an overexposed final picture.

This type of picture is usually most successful when one image predominates and the other acts more as a background.

Right *The textured effect of this portrait was created by making an exposure of a piece of woven bamboo, lit to accentuate its texture, and then photographing the girl, who was placed against a black background, onto the same piece of film. The background shot was underexposed by two stops and the portrait by half a stop.*

Far right *Three separate exposures were used for this shot. The girl's profile was rim lit with a spotlight so that only a selective area was illuminated. The rest of the image is completely black, enabling three normal exposures to be made.*

Q What is the device that prevents double exposure?
A It is an internal mechanism which prevents the shutter from being released until the film is wound on.

Q How do you mark film for position for re-exposure?
A When you load the film, before closing the camera back and winding on to the first frame you must make a small mark on the film to line up with a precise point inside the camera, such as the edge of the film gate.

Q Can you make more than two exposures on one piece of film?
A Yes. You can make as many as you like, bearing in mind that the exposures will have a cumulative effect.

Q What is a slide duplicator?
A Basically it is a close-up device in which a slide is placed at the business end with a piece of Perspex behind it to diffuse the light. The inexpensive versions are used in place of a camera lens on an SLR.

A slide sandwich is in effect the opposite of a double exposure, since the images are added together with dark tones building up against an essentially light background. There is the added advantage that you can also manipulate and judge the effect the images are creating as you do it.

Although eventually you will probably want to take shots specifically for an image you have visualized, to begin with it is a good idea to practise and experiment with slides you have already taken. It can be an economic way to use up not very successful slides. You will need a selection of rather overexposed slides, sorted into categories before you start. This type of picture, like the double exposure, works most effectively and easily when you have one image providing a fairly even background element, such as a pattern or a texture, and the other with a more boldly defined subject with a prominent shape or design. You could for instance have a silhouetted image of a tree sandwiched with, say, a picture of reflections in rippled water.

You will need some sort of light box or viewing screen so that the slides can be manipulated while you view the effect. When they are juxtaposed in the most effective way they can be taped together along one edge and fixed into a mount. In this form they can be shown in a projector or for a more permanent display.

Above *This sandwich was the result of combining two unsatisfactory pictures of the same scene to make one good one.*
Right *A transparency of a mountain reflected in a lake was contacted with a close-up picture of raindrops on a window.*

One of the pleasures of travel is that as well as encountering different people and places you are also likely to find a different variety of wildlife. This can add an interesting and important element to the record of a trip.

The prime requirement for this type of photography is patience, since there is little possibility of control over your subject and it is largely a question of waiting until the subject moves into the right position. A long focus lens is almost a necessity for this type of picture, as in many cases you will not be able to approach your subject too closely. A standard lens would give you an excessively small image.

The success of animal and bird photography is dependent on quite tightly framed pictures of the subject which emphasize its features, combined with uncluttered and contrasting backgrounds which enable it to be clearly isolated from its surroundings. A long focus lens used with wide apertures will usually ensure that background details are kept well out of focus and will prevent them from becoming distracting.

Do not overlook the possibility afforded by less exotic creatures. There are often domesticated and semi-tame animals that are easier to approach and can create just as appealing pictures when photographed well. A local wildlife park or zoo can provide a rewarding few hours.

Above This tightly framed shot gives no indication of the animal's captivity, although taken from behind a mesh fence. The use of a wide aperture and a long focus lens has rendered the cage invisible.

Right A long focus lens was used to create a close-up image of this bird from a distant viewpoint. The use of a wide aperture effectively separates it from the background.

6 PHOTOGRAPHING PLACES

Although postcards are seldom the most exciting photographic images, they are a useful source of information as to the photographic potential of a town and provide some suggestions and indications of lighting and viewpoint. Of course, a slavish duplication of the postcard view would be both pointless and unsatisfying, and your purpose should be to allow something of your own feelings and thoughts about a place to be visible in your pictures.

The most common method that people use to personalize a view is to place a companion in front of it, but this is almost always an unsatisfactory compromise, producing a mediocre picture of both subjects. It is far better to put your own stamp on the picture by the choice of viewpoint, the lighting and the way in which you frame the image. The aim of the picture postcard is to create a timeless image of a place, whereas it is that very sense of time that is important to your picture, since the way a place appears at a particular moment in time is unique. A market in front of the cathedral perhaps, a sunset, or even rain – it is elements like these that will affect your response to a place and will enable you to produce a more personal interpretation in your photograph.

Right *Taken after a sudden and intense downpour, this picture of the Champs-Elysées shows it in a less familiar context without its crowded pavements and busy cafés.*
Far right *Most postcards and pictures of San Francisco's Golden Gate Bridge show it in its setting, with the city's skyscrapers soaring in the background. A dense fog accompanied my visit, but it has nonetheless produced a more personal impression of the sight.*

182 AVOIDING THE CLICHES

One of the disadvantages of the ease and popularity of modern travel is that it has made what were at one time exotic and faraway places almost too familiar. Nowadays it is even possible to have a sense of anticlimax when visiting some famous places for the first time. This is largely because the images that the media use to promote and record these places have become clichés, and we often subconsciously feel a sense of disappointment if we are not able to see or photograph the same things when we go there ourselves. This is a great pity, since it can cause us to close our eyes and minds to what is there and the opportunity to see a place with a fresh eye and adopt an individual approach is wasted. It is not an unfamiliar sight to see a coachload of tourists literally queuing up to photograph one of these clichéd sights, and many of them will probably look no further.

You should learn to develop the habit of exploring every aspect of a place. Have a look to see what the other side of a building is like, for example, and visit the places that are not marked on the tourist map. Sometimes the simple expedient of using a different lens or a special effects attachment such as soft focus can avoid the clichéd image even from the popular viewpoints.

Right In this shot the picturesque château of Saumur on the Loire has been relegated to a small area of the picture. The river and the boats dominate the image, creating a less obvious and more evocative view.
Far right The Place du Têrtre in Paris is renowned for its colourful artists. This picture shows the artists' view instead of a view of the artists themselves, resulting in a less familiar image.

Q Why are pictures like these called clichés?
A It comes from the French for negative, implying that the same situation gives rise to copies.

Q Surely there is no harm in taking clichés?
A No. Clichés are actually often in demand for travel brochures.

Q How can you discover interesting places when they are not in the tourist literature and you only have limited time?
A By asking. There will be all sorts of people living and working in popular tourist areas who are just dying to tell visitors about less exploited corners of their town or locality.

Choosing a viewpoint is a vital factor in deciding the nature and composition of a photograph. One of the most common causes of disappointing pictures is the failure to consider the camera position carefully. Inexperienced photographers often simply take their pictures from the place they first see the subject without fully exploring the possibilities.

Most pictures consist of a foreground, a middle ground and a background. By altering the position of the camera, the relationship between these different planes and the objects on them can be changed. The quality and the direction of the lighting can also be varied.

The inclusion of an interesting foreground can often add considerable impact to a picture, as well as helping to create a more effective composition, and often this can be achieved by simply moving the camera position a few metres. For this reason it is always a good idea to look behind you when you see a suitable subject to see if by moving further back you can include a more effective foreground.

Don't overlook the possibility of using both higher and lower viewpoints. Most people take their pictures from eye level. It can be surprising how much difference can be created by shooting from ground level, or finding a high

viewpoint – from a window in a nearby building for instance. Many people also overlook the possibilities of simply moving much closer to or further from the subject, so that details can be emphasized or the subject can be shown more in relation to its setting.

These three shots demonstrate how the nature and composition of a picture can be altered by the choice of viewpoint. The relationship in terms of both the position and the scale of the elements in this boatyard is completely different in each shot, and yet the change in camera position for each picture was only a few metres.

186 CONTROLLING PERSPECTIVE

The choice of viewpoint also affects another important element of an image and that is its perspective. Perspective is created by the apparent reduction in the size of objects in a scene the further they are from the camera. It is this which is largely responsible for creating an illusion of depth and distance in a two-dimensional image and it is vital to be aware of this effect when positioning your camera.

When an object is very close to the camera it will appear much larger than distant objects. In this way a person may appear to dwarf a building, for example. At the same time, the impression of depth and distance will be en-hanced. However, as the camera is moved further away the two objects will begin to appear much closer to their true relative scales and the impression of depth and distance will be diminished. In addition, the reducing size of more distant objects in the image creates the impression of convergent lines. This too can be an important element of composition as well as contributing to the three-dimensional quality of the picture. If the converging lines are used as a foreground, for example, they can often very effectively lead the eye towards the subject – shooting down a street, for instance, with a more distant building as the subject.

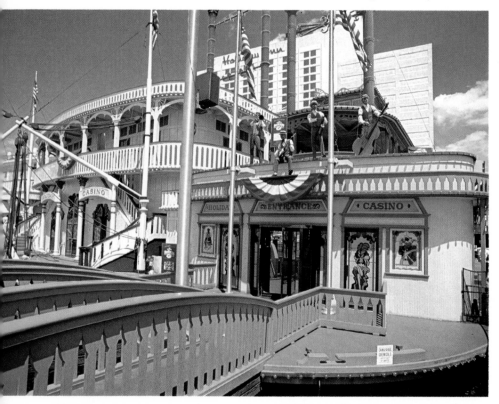

Above A wide angle lens combined with a close viewpoint has resulted in an exaggeration of perspective in this shot, producing a strong three-dimensional impression.

Right The compressed perspective effect of this picture of a street in San Francisco is the result of using a long focus lens combined with a distant viewpoint.

Q How does a perspective control lens avoid the problem of converging verticals?
A Because it is constructed in a way that enables the optical axis of the lens to be raised, decreasing the amount of picture area at the base of the image and adding it to the top, without you needing to tilt the camera upwards.

Q Why do the verticals converge when pointing a camera up at a tall building?
A Because the base of the building is much closer to the camera lens and therefore appears larger than the more distant parts.

Q Why does a telephoto lens sometimes appear to distort perspective?
A Because it shows a distance scene as if it were much closer. Therefore you would expect the objects to diminish in size.

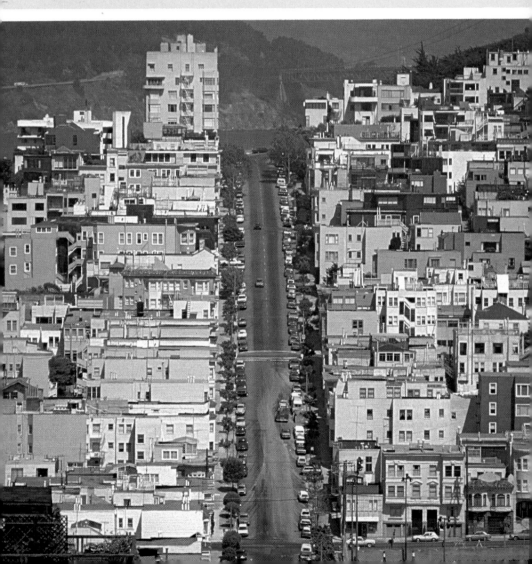

188 USING A WIDE ANGLE LENS

A wide angle lens is particularly useful for shooting in towns and cities for the simple reason that in these circumstances the choice of viewpoint is usually more restricted and confined. The more obvious quality of a wide-angle lens is that it enables more of a subject to be included in the picture without the photographer having to move further back. This can be a real problem when shooting large buildings, for example. However, a wide angle lens can also present problems in this respect. Because it enables pictures to be taken from close viewpoints, it exaggerates the effect of perspective. Close foreground details will appear to be much larger in proportion to more distant objects, and this often creates an unnatural and distorted appearance. This is most commonly seen when the camera is tilted

upwards to include the top of a building. The result is converging verticals and the building appears to be toppling over. This is caused by the fact that the base of the building is much closer to the camera than the top. It can only be avoided by ensuring that the film plane of the camera is kept perfectly parallel to the side of the building. This may well mean moving further back and including a larger area of foreground or finding a higher viewpoint, from a window in a building opposite, for example.

Although converging verticals can look unpleasant if allowed to occur accidentally, they can be used to create a quite dramatic effect when used as a part of the composition. In this respect, it is often best to exaggerate the effect further by moving even closer to the base of the building and tilting the camera up.

Above These two shots of Victorian houses in Los Angeles show what happens when you use a perspective control lens. The first was taken with a conventional 28mm lens, requiring the camera to be tilted upwards to include the top of the house, whereas for the second shot the camera was held level, but the shift mechanism of the lens was used.

Right above A 20mm wide angle lens was used to include a large area of this formal garden from a quite confined space and limited viewpoint.
Right This shot of the campanile in Florence shows how the effect of tilting the camera upwards is considerably accentuated when using a wide angle lens.

The very familiarity of well-known places and landmarks often makes it more difficult to produce pictures that have particular impact. Often when this does happen it is due to an unusual circumstance such as a dramatic lighting effect. However, it is often possible to create a more interesting and appealing picture by allowing the composition of the image to become a more dominant element.

Inexperienced photographers often make the mistake of simply centring the subject in the viewfinder. This rarely produces a pleasing, let alone dramatic, composition. It is usually far more effective to frame the picture so that the subject is placed somewhere between the centre and one of the corners of the picture. In this way, it is possible to use other elements of the scene to act as a lead in to the subject, or as a balance. For example, where you have an interesting foreground, you can place the subject quite near the top of the frame and use a large area of foreground as a lead in. When this is combined with a strong perspective effect, the result can be quite dramatic. Alternatively, if there is an interesting or dramatic sky, you can include a large area of this and place the subject and the horizon quite low in the picture.

Another effective way of using the foreground is to create a frame by shooting through a doorway or by using flowers or foliage close to the camera. This will also enhance the impression of depth in the image.

Above The placing of the centre of interest almost at the edge of the frame in this shot, together with the inclusion of a large area of foreground has resulted in a bold image from a fairly unexceptional subject.
Right above The low viewpoint and the dramatic lighting have produced a picture which relies for its effect on a juxtaposition of bold shapes, emphasized by the exaggerated perspective.
Right This picture uses a number of elements such as frames within frames, contrasting shapes, and bold lettering to produce a photograph with a strong sense of design.

It is important to appreciate that buildings are seldom an isolated concept. The architect has usually related the shape and design of the structure, and often its colour and texture, to the setting in which it is built. This is something that should be considered when taking photographs.

Although the immediate reaction of most people is to choose a viewpoint which is far enough away to 'get it all in' but still close enough to show its details clearly, there is often a good case for moving much further away, so that the building becomes a relatively small element of an image in which the surroundings also play an important part.

In towns and cities in particular finding such a viewpoint can be quite difficult. One method which is usually effective is to stand near the building you want to photograph and look around at distant landmarks that you can see clearly. Once you have found your way to one of these spots, it will provide a clear view of your subject. Since the purpose of such pictures is to convey some of the atmosphere of both the building and its environment, it is often possible to make use of lighting conditions in which maybe the details of the structure are not seen clearly but the mood is enhanced. A good example of this technique is to use a building with an interesting or characteristic shape as a silhouette against a dramatic sky or a sunset.

Above *A quite distant viewpoint has enabled the river to be used as both an interesting foreground and as an element of mood in this shot of the Alnwick Castle in Northumberland.*

Right above *A feature of many castles is that they dominate the skyline. Even though only the outline of Dover Castle is visible in this shot, this and the* dramatic sky help to create a picture with considerable atmosphere and interest.

Right *This picture of the cathedral in Segovia was taken from a hill on the edge of the city. I discovered it by standing by the building and looking around for a suitable vantage point.*

Q Is there any way of overcoming the problem when a distant view of a building includes unattractive foreground details?
A One solution is to find a very close detail, such as some flowers which you can use as an out of focus screen.

Q How do I deal with floodlit buildings?
A They are best photographed before it is completely dark using daylight type film.

As opposed to moving further away from a building to show its surroundings, it can also be effective to choose a very close viewpoint in order to isolate and emphasize individual details of its construction and decoration. Indeed, a series of close-up pictures of this type can often give more information than one picture.

This approach can often create images of considerable beauty and impact by revealing textures, patterns and shapes that would probably be unnoticed by the more casual observer. A long focus lens is an advantage with this type of picture, since it will enable you to frame your picture tightly without having to approach the subject too closely. Where this is not possi-

ble, with high-level details, for example, a tripod is also an advantage, since it will enable you to frame and focus the picture accurately and eliminate the possibility of camera shake. Such pictures need to be very sharp to record the fine details upon which texture and pattern depend. For this reason it is best to use a slow, fine-grained film whenever possible. Lighting is a vital factor in this type of picture, particularly where texture is important, and you must choose your viewpoints with this in mind. A hard, directional light may be effective in revealing the subtle texture of weathered stone, for instance, but could easily lose the detail of an intricate woodcarving.

Above The element of pattern combined with the perspective effect of shooting from a low viewpoint has produced a picture which accentuates the symmetry of this building.
Right above The mirrored windows of this building in downtown Los Angeles reflecting the brightly lit

structure opposite has created an abstract juxtaposition of shapes.
Right Obliquely angled sunlight emphasizes the textural quality of the tiles and woodwork of this country church. A long focus lens was used to isolate a small detail from a distant viewpoint.

Q Any advice on shooting stained glass windows?
A If they are the main feature of the picture then avoid having the sun shining directly onto them, and also avoid a deep blue sky behind the window. An overcast sky on a poor day would give you a soft, even and neutral illumination.

Q Any tips on photographing high-relief details?
A Details in high relief are best photographed with a soft but directional light. Avoid direct sunlight, as this will create dense shadows.

Quite often the interior of a building can provide a more effective subject than the exterior, and in addition it is a useful alternative when the weather or the lighting is poor. A wide angle lens is a very useful accessory for this type of picture, since you will invariably be shooting in quite confined areas. However, a standard lens can also be used in larger rooms and for photographing details. It is often an advantage to shoot from one corner of the room as this will give you a more distant viewpoint and will also give you a better perspective by including two or three walls. Be careful to avoid tilting the camera, especially with a wide angle lens, since although converging verticals can look effective sometimes in exterior shots they seldom do in interiors. A tripod is also a valuable aid as long exposures will usually be needed, although in a well-lit interior you can often manage by bracing the camera against some natural support.

In most cases you will need to make use of the existing lighting, as a small flash gun is inadequate for all but the smallest spaces. The main problem is to avoid the extremes of contrast that this type of lighting can create. In particular, you should avoid shooting towards windows or large light sources and frame the picture so that large areas of shadow are excluded.

Above This detail of a church interior in Israel was taken on a standard lens and the illumination was provided by light from the windows. An exposure of half a second was given, with the camera mounted on a tripod.

Right This picture of the vaults of St John in Acre was taken by the light of tungsten bulbs. Careful choice of viewpoint has minimized the amount of shadow and image contrast.

Q What is the best way to take an exposure reading for an interior shot?
A Ideally, take a close-up reading from a mid tone in the subject. Alternatively, take an average from the darkest and lightest areas, but be careful to exclude light sources from the meter's view.

Q Is a small flash gun no help at all?
A It can be if you use it simply to illuminate some foreground details in conjunction with a longer exposure to record the ambient light.

Q Is there any way around the problem of avoiding blurred people in busy interiors when fast shutter speeds cannot be used?
A Apart from asking them to stand still the best solution is to use very long exposures. By stopping the lens right down and giving an exposure of, say, a minute.

198 SHOOTING AFTER DARK

One way of creating pictures with a more unusual and interesting quality is to shoot after the sun has gone down. In some cases this can overcome difficulties such as poor weather or crowded and fussy surroundings, particularly with subjects like illuminated buildings. This type of picture is well within the scope of a quite simple camera provided it has a time exposure facility and you have a tripod.

Most after-dark situations create images with a high brightness range. This is the main source of difficulty, since it will usually be well in excess of the film's tolerance. To avoid harsh contrast with dense black shadows and bleached-out highlights you must choose viewpoints and frame the picture to exclude these extremes. With some subjects such as street scenes and illuminated buildings it is often best to shoot your pictures before it becomes completely dark. The small amount of residual daylight will add just a little detail in the darker areas; if you expose for the highlights, the impression will still be that of a night scene. You must also ensure that light sources such as street lamps do not influence the exposure meter, as this will result in underexposure. You must also remember to allow for reciprocity failure when giving exposures longer than about half a second.

Right The light trails in the foreground of this shot of David's Tower in Jerusalem were the result of cars passing during an exposure of several minutes.
Far right Shooting before the sky had become completely dark has resulted in the outline of the building remaining visible. The reflections in the water in the foreground provide additional interest.

Q What is reciprocity failure?
A It happens when the film becomes less sensitive when long exposures are used.

Q How can I tell which sort of light source street lamps have?
A Both sodium vapour and tungsten light appear to be reddish in quality and will photograph so on daylight type film if correction filters are not used. Mercury vapour and fluorescent appear white.

Q How can I get a moonlit scene to look convincing?
A The best way is to include the moon itself in the picture, and to slightly underexpose. An exposure of more than about 30 seconds will record it as unsharp.

200 AVAILABLE LIGHT

Capturing atmosphere is an important aspect of travel photography and lighting is often the dominant element in this respect. For this reason, there are many situations where although the light may be somewhat less than adequate in terms of its brightness level, it is preferable to manage with what is available rather than using supplementary lighting such as flash. As high-speed films and fast lenses make it possible to take pictures in most light levels bright enough to read by, even in colour, flash may destroy the atmosphere of a scene and be an unwelcome intrusion.

Since you will be using both wide apertures and relatively slow shutter speeds, one of the greatest problems is likely to be obtaining a sharp image. Precise focussing, a firm camera hold and a smooth release are vital in this respect and with shutter speeds of less than, say, $\frac{1}{60}$ second it is advisable to seek some means of supporting the camera if a tripod is not available.

Most fast films can be push-processed to increase their speed. An ISO 400/27 colour transparency film, for example, can be rated at up to ISO 3200/36 by increasing the first development time. Black and white films can be uprated by the use of special speed-enhancing developers such as Acuspeed. These techniques will increase the size of the grain and reduce the image quality, but this often has the effect of heightening the atmosphere.

Above This evocative shot of the long and winding road was taken at dusk using a fast film of ISO 400/27. A handheld exposure of $\frac{1}{15}$ second was made possible by resting the camera against the roof of a car. A long focus lens was used.

Right ISO 400/27 film uprated two stops was used for this shot of night-time street celebrations, allowing an exposure of $\frac{1}{30}$ second at f2 to be given.

With many photographic subjects the image consists primarily of a subject and a background, and the technique of composition is largely a question of creating a satisfactory balance between them. With a landscape picture, however, the image is often not so easily defined and it must be considered in terms of areas of tone and detail and the creation of balance and harmony within these elements. However, as with any other type of subject a successful landscape picture should still have a readily identifiable centre of interest, to which the eye is most strongly drawn and around which the other elements of the image play a supportive role. This may be something quite obvious like a building in a distant landscape. Very often it is more subtle, such as an area of texture or colour or a highlight or a shadow. Whatever it is, you must establish such a point within the image before you can decide how to frame the picture. One of the major divisions between areas of tone and detail in a landscape picture is invariably the horizon, and the position this occupies in the frame will have a significant effect on the nature and effect of the picture. As a general rule, you should not allow the horizon to divide the picture exactly in two as this can produce a rather symmetrical effect. It is usually more effective to place the horizon line so that it divides the picture into a one to two proportion.

Above Trees are often a dominant element in landscape pictures. In this shot a low, close viewpoint has isolated a single tree from its surroundings and emphasized the shapes and patterns created.
Right above In this picture the horizon has been placed towards the base of the image to emphasize the dramatic quality of the stormy sky.

Q Should you never have the horizon in the centre of the picture?
A No. As with all rules there are exceptions and when the image has a symmetrical quality which you wish to emphasize, then this can be effective.

Q Is it best to place the horizon line above or below the centre of the picture?
A If the sky is an important element of the image, then it will be more effective to place it towards the base of the picture.

Q When is it best to have the horizon line high in the frame?
A When there is an uninteresting sky or when you want to emphasize the foreground.

Left *A centrally placed horizon has accentuated the symmetrical balance of this seascape and the rock formation in the foreground.*

Above *This picture of a Kentish landscape has been composed so that the horizon is placed at about two-thirds from the base of the image, laying the emphasis on the textured fields in the foreground.*

204 LIGHT AND THE TIME OF DAY

The nature of the lighting is often the single most important element of a landscape picture. Quite often even a slight change in the quality and direction of the lighting can create a great picture.

In addition to weather conditions the time of day can have a dramatic effect on the lighting quality of a scene and the same scene can undergo a number of dramatic changes during the course of a day. At midday when the sun is overhead it creates quite dense but small shadows, with little modelling on the contours of the landscape, creating a minimal degree of texture. As the sun approaches the horizon at the beginning and end of the day, it creates much longer shadows and enhances both the impression of form and texture in the image.

The colour of daylight also changes quite dramatically during the day. At noon for instance it creates the quality for which daylight colour transparency film is balanced, but early and late in the day it has more red content and produces pictures with a warmer, more mellow quality. Combined with the more directional lighting, this can produce a very pleasing quality, particularly in distant views. It is one reason why many landscape photographers often prefer to shoot in the morning or evening light.

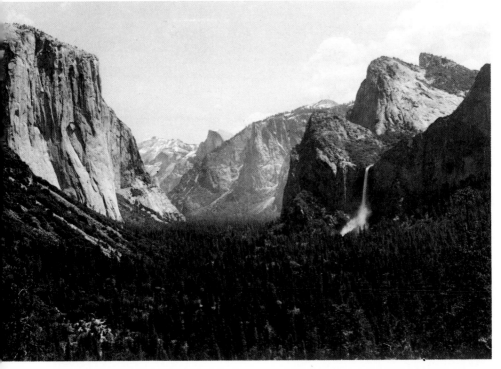

Above and right *These two pictures of Yosemite demonstrate just how much the quality and mood of a landscape can be affected by the time of day. In this instance, only a few hours separated the two shots, but the difference is quite dramatic.*

Right *The reddish light of early evening has accentuated the rich colours in this landscape picture, taken in the Negev Desert. The low angle of the sun has also revealed the contours of the land.*

Q Does this mean that you should not take landscape pictures at midday?
A By no means. You should judge each situation on its merits, but always consider how the picture may be improved if the lighting were from a different angle.

Q When might it be best to take pictures at midday?
A One situation could be in mountain scenery, where the more exaggerated contours could easily produce excessively large areas of shadow when the sun is lower in the sky.

206 USING A TELEPHOTO LENS

Although a wide angle lens may seem to be a more obvious choice for landscape photography and indeed is effective when the aim is to photograph a wide vista or distant view, a telephoto lens does make it easier to create well-organized and cohesive images. It also helps to avoid the most basic danger of landscape photography which is to simply include too much detail in the picture, creating images in which there are conflicting centres of interest. The long focus lens enables you to isolate specific areas of a distant scene and to concentrate the attention on individual details. In many instances, using the telephoto approach with landscape pictures will often result in you being able to find two or three effective pictures within one scene. In addition, while the wide angle lens creates a distorted impression of the scale of the objects within the frame, foreground objects, for example, appearing much larger than a distant mountain, the telephoto lens combined with a more distant viewpoint will produce images in which the objects within the scene appear much closer to their true relative scales. At the same time the impression of depth is diminished with such a lens. For this reason, a long focus lens is very effective in emphasizing the graphic quality of the image where the attention is focussed on the shapes, textures and colours.

Above A 200mm lens was used to isolate a small area of this lakeside scene, emphasizing the patterns and textures of the foliage and their reflections in the water.

Right above This shot was taken with a 600mm mirror lens and shows the typical compression of planes which a combination of a long focus lens and a distant viewpoint creates.
Right Careful choice of viewpoint and a long focus lens has enabled the shapes of these trees to be effectively juxtaposed to create a balanced composition.

Q Pictures I take with my long focus lens are often not as sharp as with my standard or wide angle lenses. Why is this?
A This is probably because you are suffering from a minor degree of camera shake. This is greatly increased with such a lens and you must use a faster shutter speed.

Q What is the best focal length of lens to buy for landscape pictures?
A A 150mm lens is a good compromise. If you don't mind the extra bulk and weight a 70 to 200mm zoom would offer a more flexible alternative.

Q Is there a guide to a safe shutter speed for lenses of different focal lengths?
A As a rough guide you shouldn't use a slower shutter speed than the reciprocal of the focal length, e.g. 200mm giving $\frac{1}{200}$th.

One very effective way of creating a centre of interest in a landscape picture is to include a human figure. Even a very small figure placed boldly within the image will attract the attention and create a focal point around which the other details of the scene can be balanced. In addition a human figure is an ideal method of establishing a sense of scale. The effect of a wide, lonely landscape would be heightened, for example, by the presence of one solitary figure. Since the eye is so strongly attracted to a human presence in a picture it is vital that it is placed at the centre of interest of the landscape itself. If it appeared at, say, the edge of the frame or at an opposing point in the composition the result would be a distraction or a picture with a divided interest. Although you can often find or wait for a local person to appear in the right position, this can be an effective way of including a companion in a holiday picture. Just by asking them to walk into the scene without looking at the camera, you can produce a much more pleasing result than a stilted, posed picture of them standing close to the camera with the view in the background. This is a technique frequently used by travel photographers since it adds interest to the picture as well as inviting the viewer to imagine him or herself in the same situation.

Top The figures in this alpine landscape provide a centre of interest as well as contributing to the peaceful atmosphere.
Above Although quite tiny, the two figures in this shot of Jerusalem attract the eye quite strongly and give a sense of scale to the setting.

Right This picture taken in a park already had a quite well-balanced composition and centre of interest without the figure, but the old lady and her reaction to the statue has added a degree of whimsy to the scene.

A photographic print or transparency is only a two-dimensional image and yet it can very effectively convey an impression of three dimensions. The ability to create the illusion of depth and distance in a picture is something which is important to a travel photographer in particular. Perspective is the factor which has the most influence on this quality since the apparent reduction in the size of objects as they become further from the camera is the main indication of their relative distance. The effect is reinforced when both close and distant objects are included in the frame. A distant view can often appear rather flat, since it is largely on one plane. However, if close foreground details are included in the picture the impression of depth and distance will be considerably heightened. Even more emphasis can be given to this effect if a wide angle lens is used, since it will enable even closer foreground details to be included and the reduction in size of receding objects will be even more dramatic.

Another factor which can effectively convey an impression of depth is what is sometimes called ariel perspective. This is created by the more distant planes in a picture becoming progressively lighter due to the increasing thickness of the atmospheric haze or mist. It is most effective when the subject has quite well-defined planes such as a receding range of hills or mountains and will not, of course, be very noticeable on a clear day.

Right *These two pictures demonstrate how the impression of depth can be heightened by the inclusion of foreground details even when taken with a long focus lens, as in this case. The foreground shapes have also provided an effective element of the composition.*
Far right above *Atmospheric conditions have contributed to a feeling of depth in this picture. The haze has resulted in the tones of the image becoming progressively lighter further from the camera.*
Far right *The inclusion of a foreground frame in this shot of Massada has emphasized the effect of distance as well as height. The use of a wide angle lens has accentuated it.*

Q Is there anything you can do to increase the effect of ariel perspective?
A With black and white pictures you can emphasize the effect by using a deep blue or green filter.

Q Are there any other ways of creating an impression of depth?
A Differential focussing can often create this effect. Focus sharply on a particular plane within the image and use a wide aperture. The resulting juxtaposition of sharp and unsharp areas within the image will often imply depth.

An interesting or dramatic sky is something which can add a considerable degree of impact to a picture. Although there is little that can be done to enhance the quality of a blank, grey sky there are a number of techniques that can effectively emphasize the tones of a cloudy sky. The effect of white clouds on a blue sky can be increased when shooting in black and white by using a filter in the yellow to red range. A yellow filter will have quite a subtle effect, orange will make the blue sky a dark grey and a red filter will create a very dramatic effect with the sky nearly black.

In colour photography, a polarizing filter can be used to make a blue sky a much deeper and richer blue and emphasize the white clouds, although the effect will depend on the position of the sun relative to the area of sky you are photographing.

Where there is no blue sky, simply a variation in the tones, such as with a sunset or a stormy sky, the effect must be created by exposure. As a rule, an exposure which is correct for foreground details will tend to create an overexposed sky and the most effective way of overcoming this problem is to use a graduated filter. This has a tinted area at the top (or bottom) which graduates off to clear glass or plastic, enabling you to position it so that it makes the sky area of the image darker, leaving the foreground details unaffected. These filters can be bought in a variety of colours as well as grey so that they can be used to emphasize, for instance, the colours of a sunset.

Above *A polarizing filter was used to create the bold relief between the white cloud and blue sky in this picture. A long focus lens was used to isolate a small area of the scene.*

Right *The sky effect in this shot was produced without the aid of filters but by simply underexposing about two stops. The low viewpoint has helped to make use of the interestingly shaped tree and the skyline in silhouette.*

Q Can you use a polarizing filter to make blue sky darker with black and white pictures?
A Yes. With a fairly deep blue sky at about 90° to the position of the sun the effect will be similar to an orange filter.

Q Can you use filters to emphasize the effect of a sunset in black and white pictures?
A Yes. A deep green filter will often enhance the quality of a red or yellow sunset.

Q Should I increase the exposure when using a graduated filter for skies?
A No. This will negate its effect. If you are using TTL metering, you should measure the exposure before fitting the filter.

Q Does a polarizing filter require extra exposure?
A Yes. Approximately one and a half stops.

Q How can you avoid the sky being overexposed when the subject is positioned against it and a graduated filter cannot be used.
A If the subject is relatively close to the camera you can do this using flash. Calculate the correct aperture for the flash to record the subject normally, and then select a shutter speed that will underexpose the sky to the degree you want at that aperture.

214 BAD WEATHER

In the early days of photography, when film was very slow and cameras less sophisticated, good weather was essential. For some people, things have not changed. A great many photographers do not even consider going out with their cameras unless the sun is shining. Yet in not doing so they miss many opportunities for pictures with a more interesting or unusual lighting quality. Even simply an overcast day can create quite beautiful soft effects and produce pictures with a more atmospheric quality than a bright sunny day. This type of lighting is also more effective when photographing brightly coloured subjects, when the dense shadows and bright highlights created by sunlight would detract from the effect of the colours.

However, even actively unpleasant weather can create effective lighting conditions. Mist and fog, for instance, can create images of bold simplicity, casting a veil over distant objects, suppressing fussy and confusing details and leaving the foreground subject in bold relief. Frost and snow are also conditions which can create strong graphic images by simplifying the subject and emphasizing shapes and lines. Exposure can be a problem in a snow-clad landscape because of the abnormal tonal range.

Q Is it possible to emphasize the effect of mist and fog?
A Yes. In black and white photography a deep blue filter will increase the effect.

Q Pictures I have taken in mist have often had a muddy grey appearance. Why is this?
A Almost certainly because of underexposure. The absence of very dark tones in the picture will cause the meter to indicate less exposure than is needed.

Q Pictures I have taken in snow conditions have had a strong blue cast. Why is this?
A Because of the presence of ultraviolet light, which, although invisible, affects the blue sensitive layer of the film. On sunny days, the shadows will be illuminated by the blue sky.

Q What is the best filter to correct this?
A A UV filter is often not strong enough. An 81A or even an 81B will be more effective.

Q How can I protect my camera when shooting in the rain?
A A polythene bag with an aperture cut for the lens and viewfinder window will be both effective and convenient.

Above The graphic simplicity of this alpine landscape has been produced by the light fall of snow subduing background details and revealing the shapes of the trees and branches.
Left A dark and stormy sky often produces an interesting and dramatic quality of light, as this moody shot of a Scottish loch demonstrates.

216 PHOTOGRAPHING WATER

Water has unique visual qualities which make it particularly photogenic. The presence of water in a picture invariably creates a degree of impact. The sky is principally responsible for creating the tones and colours in the surface of water, although in small areas such as lakes and rivers the surrounding details will also affect its appearance. This fact can be turned to considerable advantage when shooting sunsets, for instance, since the reflections of the rich colours and tones of the sky can be continued into the foreground by shooting over water, adding impact to the picture.

Movement is another factor which has a considerable effect on the appearance and impact of water. Still water can create an almost mirror image of the surrounding details or the sky, but even a slight ripple in the surface can reduce this to an abstraction of shapes and colours. When you are shooting moving water such as a river or a waterfall you should also consider the effect of the shutter speed. A fast shutter speed such as, say, 1/250 second will create an almost frozen appearance, whereas a much longer exposure of, say, a second or more will produce quite ethereal effects.

A polarizing filter can often be very effective in controlling the appearance of water by eliminating some of the reflections in its surface; the translucent quality and colour of a calm sea, for example, can be greatly enhanced with this attachment.

Photographing by natural light underwater is only practicable to a limited depth. Not only does the light level diminish rapidly as you go deeper, but the water also absorbs much of the shorter wavelengths of light, resulting in pictures with a strong blue cast. The practical limit is about ten metres and bright sunlight and clear water are essential. A fast film and red filter of about cc 20 or cc 30 are recommended for most situations. A wide angle lens is also an advantage for greater depth of field and ease of focussing.

Above Water can often be an effective element in a sunset shot because it reflects the tones and colours of the sky and continues them into the foreground. A long focus lens was used in this shot to create a tightly framed image.

Right In this landscape shot the still water of a small pond provides an effective element of composition, with the almost mirror image reflection of the trees.

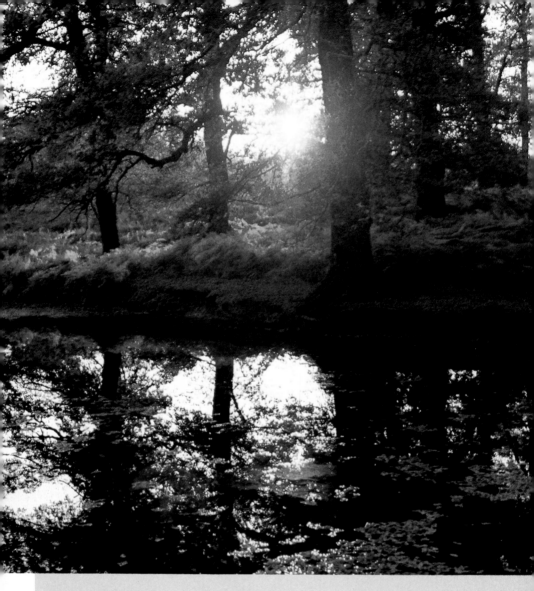

Q How can you give a long exposure of a second when photographing moving water in bright light?
A You can use a neutral density filter, available in a range of strengths to reduce the exposure by one, two or three stops and so on.

Q I took some pictures of a building reflected in water but they were not as distinct as they appeared. Why is this?
A It could be because you focussed on the surface of the water and caused the reflections to be out of focus, in which case you could have focussed at the more distant point of the reflected image or used a much smaller aperture for greater depth of field.

Q I have seen pictures of water where it has rainbow-like colours. How is this done?
A A colour burst filter or diffraction grating can be used to create this effect when there are bright highlights on the water's surface. It is also possible to make multiple exposures onto the same piece of film using a red, green and blue filter for each. The moving water will have coloured fringes.

A very large proportion of holiday travel includes at least some time beside the sea. It is a place which has great potential for pictures as well as its more obvious attractions. Quite apart from the pictures for the family album of the activities on the beach, there is also considerable scope for the more pictorial approach, ranging from seascapes to abstract images of rocks and sand.

The seashore is particularly rich in the elements of texture and pattern, which, when used as part of a composition, can impart a powerful visual quality to a picture. The evening light glancing across rippled sand, for example, or the effect of water erosion on rocks and driftwood. Subjects like these can often reveal even more potential when viewed through close-up equipment.

In addition there is the impedimenta of the holiday and leisure. At first glance this may appear to be garish and unphotogenic, but seen with a perceptive and selective eye there are many pictorial possibilities to be found amongst things like seaside piers, amusement arcades, deckchairs, beach huts and so on. Of course, the environment and mood of a seaside resort makes it an ideal location for those who collect human interest pictures. Do not forget to be particularly careful of your equipment, since sand and seawater are two of the most dangerous hazards for precision instruments.

Above *A careful choice of viewpoint and tight framing have emphasized the pattern element in this shot of beach beds. The restricted colour range also helps to enhance the pattern.*
Right *Reflections in the ripples at the water's edge provide an almost abstract image in this picture. A long focus lens was used to isolate a small area of the subject.*

Q Are there any technical problems when shooting at the seaside?

A Exposure calculation is likely to be the main problem since the highly reflective surroundings of sand and sea can mislead an exposure meter unless it is used carefully. It is best to take close-up readings from a mid-tone detail.

Q Can filters help with seashore pictures?

A When shooting in colour it is advisable to use a UV or 81A filter to offset the blue cast that can be created by excessive ultraviolet light, and in some instances a polarizing filter can be used to reduce glare and to increase the colour of the sea and sky.

Q What is the best way to protect my camera on the beach?

A Wrap each item in a plastic bag inside your holdall and make sure that every speck of sand is removed before replacing it. Seawater must be wiped off instantly with a soft cloth and sand must be blown or flicked away before wiping.

If there is one place where you can be assured of finding interesting and colourful subjects for your camera it is a harbour. In many cases the harbour itself will provide a photogenic composition, especially in a small fishing village where the boats and the jetty are part of the landscape or the community. This is indeed one of the most popular topics for calendars and cards. However, you will find it more satisfying to break away from the obvious and pretty approach and to look for viewpoints and angles which give a more personal impression of a place.

Even in the less decorative harbours there is plenty of opportunity for good pictures. Fishing boats have immense visual appeal. Often brightly painted and interestingly shaped, they can provide all the elements for strong compositions. You should learn to be quite selective and avoid the inclusion of too many conflicting colours and shapes within the same picture. A long focus lens can be useful in this respect, allowing you to frame the image quite tightly from a more distant viewpoint.

In addition to the boats themselves there is also plenty of opportunity for picture-making in the harbour-side equipment. Fishing nets, lobster pots, winches and machinery are all potentially effective subjects for pictures that emphasize elements like pattern and texture.

Above *The colours and shapes of fishing boats make them an ideal subject for the more abstract approach. This tightly framed shot emphasizes the colour, texture and lines created by a beached boat.*

Right *The evening light has created atmosphere and effectively revealed the contours and textures of the rugged landscape in this shot of the harbour at Ilfracombe. A long focus lens was used to get a tightly framed shot.*

Q Is it necessary to obtain permission to photograph in a harbour?
A Not in an area where there is unrestricted public access, although it would be courteous to ask anyone present before doing so.

Q Are you allowed to take pictures inside a commercial harbour of passenger and cargo ships?
A You must first ask permission of the harbour or port authority or from a security official.

Q What are the problems associated with taking pictures from a moving boat?
A You will need to use a quite fast shutter speed to ensure a sharp image, particularly if the water is choppy.

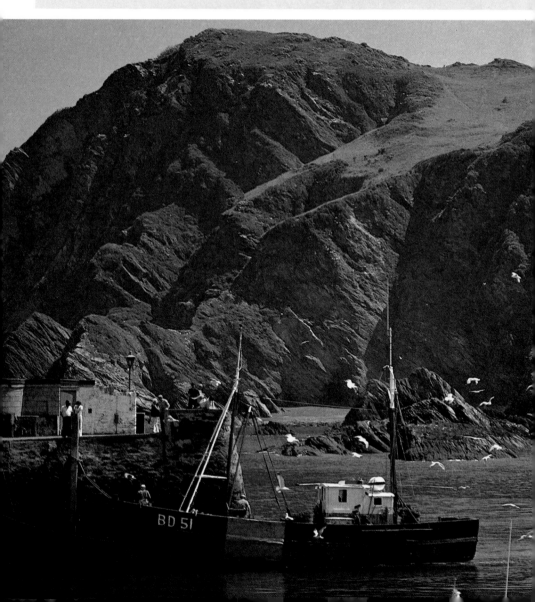

7 PHOTOGRAPHING PEOPLE

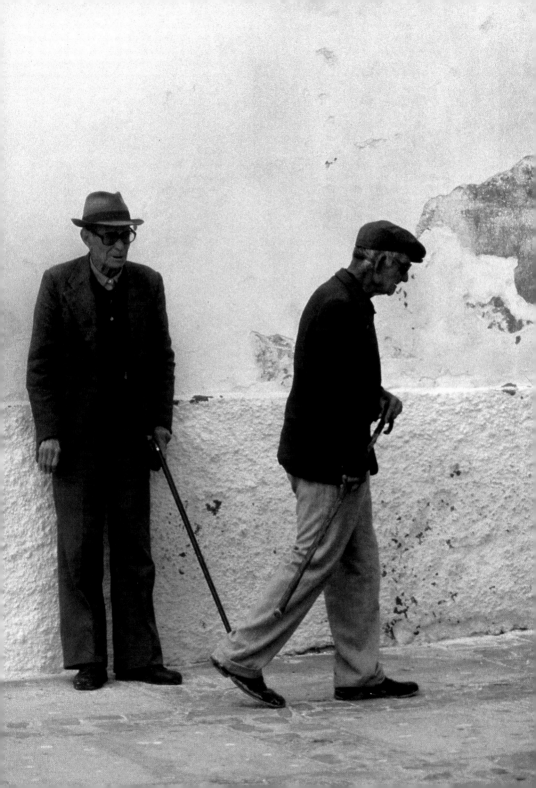

In both holiday and travel photography, the ability to take a pleasing portrait of someone with the minimum of fuss is very valuable indeed. It is by no means difficult. There are three essential ingredients: to have your subject comfortable and relaxed, to ensure that the lighting creates a pleasing effect, and that the background or surroundings contribute to the picture and do not distract. It is far easier to get your subject to react in a natural and relaxed way if they are comfortably seated or are supported in some way, leaning on something, for instance, rather than simply being asked to stand. And the best expressions will be created by talking to your models and waiting for it to happen as opposed to asking them to smile into the camera.

As a general rule, a soft light is most effective for portraits, such as that of a slightly cloudy day or in open shade on a sunny day. Direct sunlight needs to be used with discretion, since it can create hard shadows and excessive contrast. However, in some circumstances it can be effective to emphasize the skin texture of a fisherman's weathered face, for example. The best way of judging the effect of the lighting is to be aware of the nature and direction of the shadows and if these are not excessively large or dense the result is likely to be acceptable.

The best way of dealing with the background of a portrait is to keep it plain and simple and to make sure that it provides a good tonal or colour contrast to the subject. This will ensure that the emphasis is on the subject's face and expression and that he or she is well separated from the surroundings.

Right *Tight framing and the exclusion of irrelevant details has emphasized the rather sinister expression of the subject in this shot. A long focus lens was used to produce a close-up image without having to use a close viewpoint, so avoiding the possibility of unpleasant perspective effects.*
Below *In this picture of an Hawaiian storekeeper, the background is an important element of the picture but the man himself remains the focus of attention.*

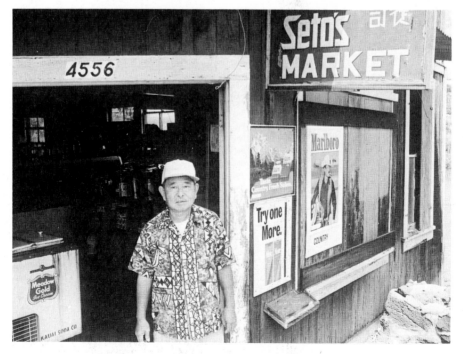

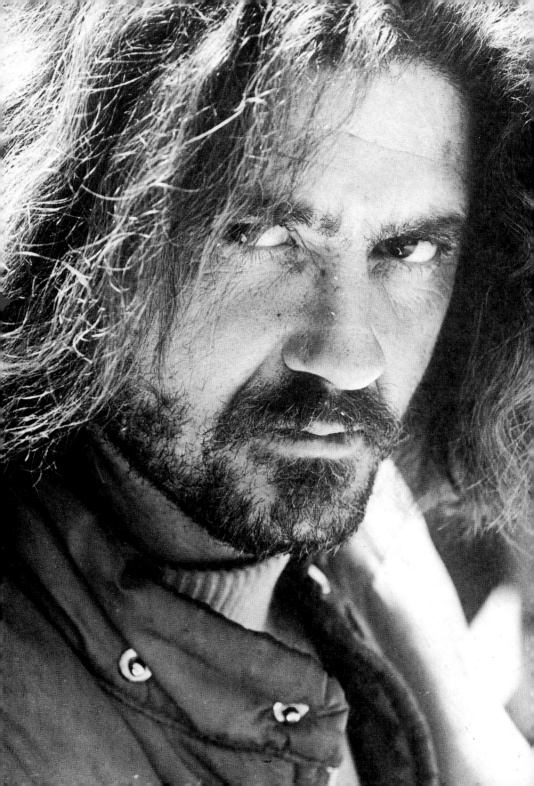

Although the posed and organized type of informal portrait is the best approach in some instances, there are occasions when it is better to photograph people when they are involved in some occupation, particularly in travel photography, where the purpose is to show people in the context of their environment. This approach has a number of advantages. It enables you to take less selfconscious pictures of someone who may otherwise be inhibited by the presence of a camera. It often creates a more interesting picture, and it helps to say more about the person you are photographing.

The main concern with this type of picture is to create a satisfactory balance between the identity of the subject of your picture and the surroundings and activity in which they are involved. If this is allowed to become too dominant the result is a confused image with conflicting interests.

Even when the surroundings are quite an important element of the picture it is possible to ensure that the person you are photographing remains the main point of interest by framing the picture in such a way that they are in the strongest part of the composition and that the composition of the image focusses the attention upon them. A wide angle lens is often helpful in this respect, since it enables you to move in quite close to your subject while retaining a relatively large area of background. The effectively greater depth of field of such a lens will help to obtain sharp focus throughout the image.

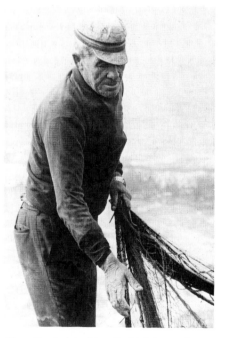
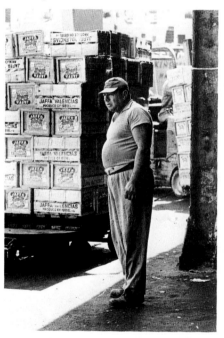

Above People doing things like this fisherman folding his net often create quite pleasing and uncontrived positions and shapes in a picture. The sea has provided a plain contrasting tone as the background.
Above right This picture was taken in the busy harbour of Haifa. Although no attempt was made to conceal the camera, the man remains quite unaware and unselfconscious because of his concentration on the job.
Right Pride and confidence in a craft or skill invariably make for a satisfying and unselfconscious quality in a picture. This man had spent his entire working life making wattle sheep hurdles from hazel saplings.

It is an unfortunate fact that a tourist or a stranger usually stands out like a sore thumb in a community. For a photographer interested in photographing people this can be a serious handicap, since although there are occasions when a picture can be effective because the subject is looking at the camera, quite often this can spoil an otherwise good photograph.

It is possible for most people to learn how to be unnoticed and to be able to shoot unobserved. Time is the first and most important factor. Even in the most alien of places the initial interest that your presence will inevitably attract will quickly diminish if you simply wait around until you become more familiar and less noticeable. It is certainly best not to start shooting pictures straightaway but to wait until the immediate impact of your presence has subsided. It also helps if you don't look too much like a photographer. Ostentatious silver or leather camera bags are a positive handicap. It is best to carry your immediate needs in your pockets or at least in a nondescript bag and to handle them as little as possible until you are ready to shoot. Find a quiet place around a corner to change lenses or load film. Wherever possible make exposure readings out of sight of your intended subject so that when you want to take your shot all you need to do is to raise the camera, focus and shoot.

It also helps to learn to judge camera angles and fields of view without the aid of the camera, so that it is only necessary to bring it into view for the briefest possible time.

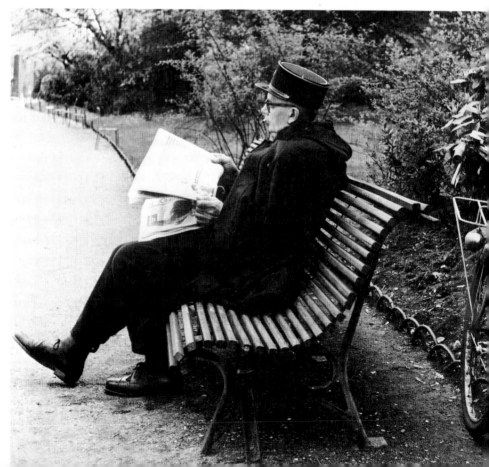

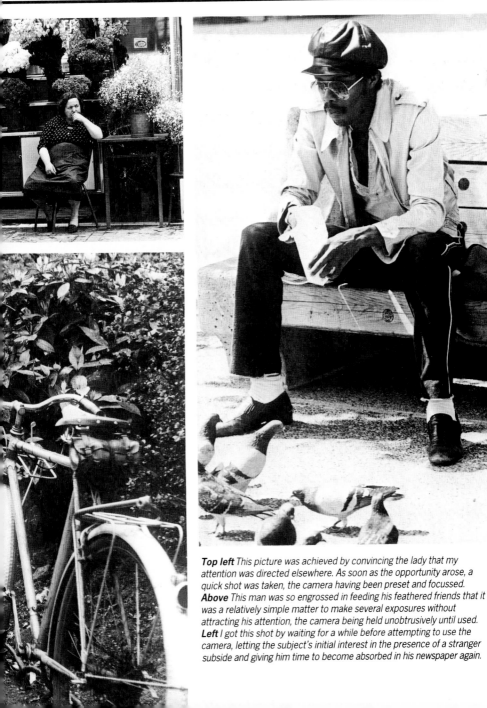

Top left This picture was achieved by convincing the lady that my attention was directed elsewhere. As soon as the opportunity arose, a quick shot was taken, the camera having been preset and focussed.
Above This man was so engrossed in feeding his feathered friends that it was a relatively simple matter to make several exposures without attracting his attention, the camera being held unobtrusively until used.
Left I got this shot by waiting for a while before attempting to use the camera, letting the subject's initial interest in the presence of a stranger subside and giving him time to become absorbed in his newspaper again.

One problem that some photographers who like shooting human interest pictures experience is simply that of finding a place where there is a combination of interesting people, varied backgrounds and activity and which is also accessible. The answer to this is often overlooked, largely because it is almost too obvious. Most streets fulfil these requirements and when you are staying in an unfamiliar place or travelling in a foreign country, even the most ordinary suburban street will allow you to take pictures of people in a way that will attract the minimum of attention and at the same time show something of the environment in which they live.

Street life can be extremely varied. In many hot countries much of the everyday life of a family takes place outside the home and the street becomes an extension of their living quarters. In this way the nature of the life in a single street can undergo considerable changes during the course of a day. While a long focus lens will give you the opportunity to shoot from a more distant viewpoint, from one side of the street to the other for instance, and will allow you to isolate small areas of the subject, you should not overlook the possibilities of shooting with a wide angle lens from a closer viewpoint. This will enable you to include more of the background and surroundings but still have a relatively large image of your subject.

The life and character of a particular street could in fact provide an ideal subject for a photo essay and this would help to give your picture-taking a more controlled and directed quality.

Right above *This picture, taken in the French town of Colmar, enabled a candid approach to be turned into an informal portrait because of the lady's spontaneous reaction to seeing the camera.*
Right *The atmosphere of an American street is effectively captured in this detail of a passing motorcyclist and contrasts vividly with the peaceful mood of the shot on the far right taken in a quiet street in Jerusalem.*

It is always worthwhile checking the calendar of events in a place that you are visiting to see if there is something interesting happening during your stay, such as a street festival or a special ceremonial. There are few major towns or cities that do not have some occasion worth photographing at any week during the holiday season. Even a regular tourist event such as the Changing of the Guard can provide some exciting picture opportunities.

If possible you should plan to visit the location a day or so before the event to select a good viewpoint, ask about the best time to arrive for a good position, and to discover the order of the proceedings. This will help you to anticipate the best pictures and viewpoints. A local policeman will often be able to give you this sort of information.

Remember to take into account the lighting as well as the action when choosing a camera position. Bear in mind that the site will be much more crowded on the day. A high viewpoint is often useful in this case as it will help to prevent you being obstructed by other people. A long focus lens is also a valuable asset.

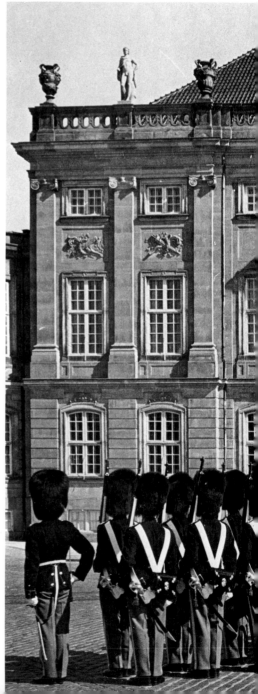

Above The spontaneous expression of this lady has helped to capture the mood of the occasion. A long focus lens was used to isolate her from the background.

Right The Changing of the Guard in front of Copenhagen's Palace has produced a picture in which the element of pattern has been used to emphasize the formality of the event.

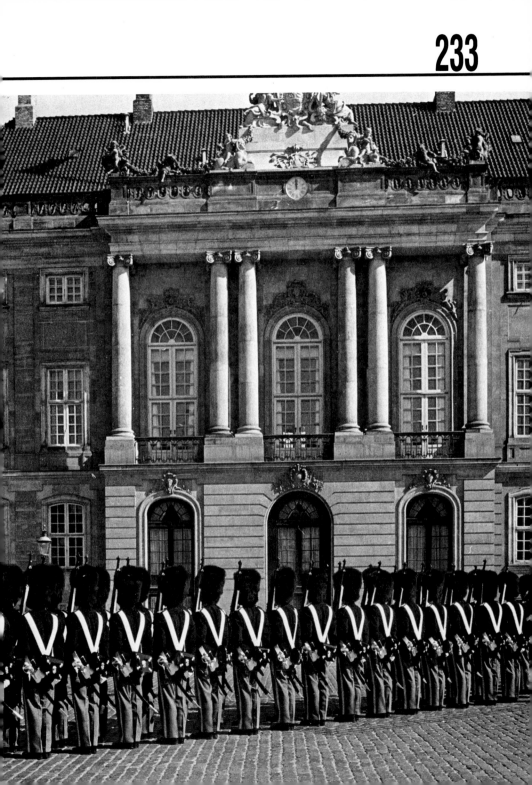

One of the places that invariably provides a wealth of interest and activity together with a great potential for human interest pictures is a market. Wherever you travel, it is unlikely that you will ever be far away from such a gathering, whether it is a fish market in a seaside village or a large permanent market dealing with more sophisticated wares, such as the flea market in Paris.

It is always much easier to shoot pictures unobserved in such places because there is plenty of activity and people are generally preoccupied with the business of wheeling and dealing. Market people themselves tend to have the more extrovert type of character, which provides good subject material.

The main difficulty in photographic terms is simply that of being selective. A market is a busy place in more than one sense, and it is easy to take pictures which contain too much interest and detail and become fussy and confusing. You must select viewpoints and frame your pictures in such a way that extraneous details are excluded and the attention is focussed firmly on the main subject of the picture. In this respect a long focus lens can be helpful to isolate a small area of the scene and will let you use the shallow depth of field to throw distracting background details out of focus. This is particularly useful when you want to single out a particular face from the crowd. However, a wide angle lens used with care can also be effective in photographing individuals in close-up while including interesting and relevant surroundings, which can be important to the mood or setting of the pictures.

Right above *A careful choice of viewpoint and tight framing has successfully isolated these ladies from the busy surroundings and emphasized their concentration on the work in hand. A long focus lens was used.*
Right *A quiet corner of the flea market in Paris provided an opportunity for a picture with a touch of humour. The composition uses an effective juxtaposition of the old lady and the brass plate.*
Far right *The appeal of this picture lies in the lady's spontaneous and unselfconscious reaction to the camera. A well-chosen viewpoint provides a plain contrasting background to emphasize her face.*

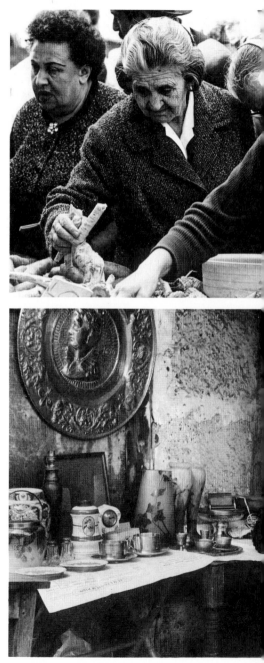

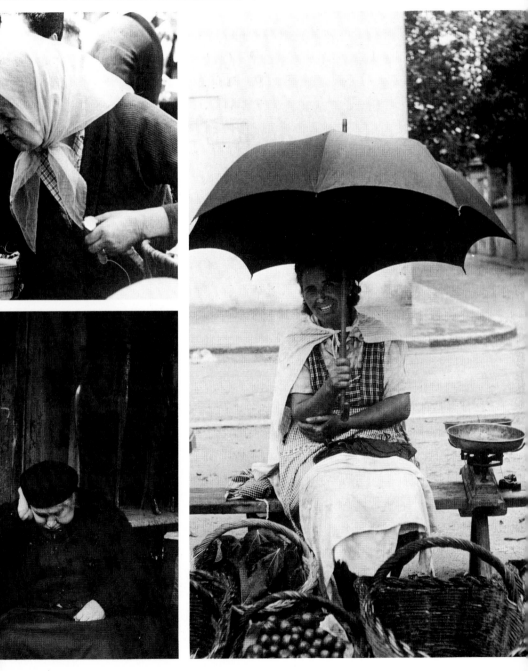

Many of us get a great deal of pleasure and amusement out of looking at photographs of children. A simple shot of a child's face laughing can induce a similar response from the viewer. You can either set up situations that you know will be humorous or you can look out for them when they occur. A young child with a cornet getting ice-cream all over its face may not see it as amusing, but is sure to raise a smile in the most dour of us. On the other hand, children may be making the humour such as pulling faces in a shop window or mirror while waiting for mother or father to make up their minds over some purchase.

Of course you could make a situation humorous by virtue of the angle you shoot from. For instance, by emphasizing with a low angle shot the height or size of, say, an elephant over a child. Or by selecting the correct viewpoint to make the elephant look as if it is shaking the child's hand with its trunk. At the circus or Punch and Judy show be on the lookout for the gleeful animated expression that says it all. Let humour take its natural course. Do not humiliate children into doing things that they don't want to do. The results could be worse than a bad photograph.

Far left Being quick and choosing the viewpoint carefully has produced this humorous shot of a young boy and his balloon.
Left Alertness was also essential to capture the fleeting expression of this child.
Above Often it is the children themselves who add humour to your shots by pulling faces or adopting funny positions.

There are many ways of creating mood in photographs. It could be location, lighting, expression or dress. It could be a combination of all of them. In some ways the occasion will set the mood. Take a shot of a mother breast-feeding her baby. If this were lit with harsh directional light the whole feel of the situation would be lost. A far better mood would be created by using a diffused light from a window that would reflect the softness and intimacy of the situation. On the other hand a group of teenage boys lit with a harsh light could look perfectly in keeping with the sullen, slightly aggressive look they may want to project. The mood created by expression is something you must always be on the lookout for. If you are shooting a head-and-shoulders portrait the expression that sums up the essential qualities of the child may come and go in a moment.

On an overcast day the light will neither have bright highlights nor strong shadows and the mood that this will create will be rather subdued, whereas a bright day is more likely to create a joyful sparkling mood. As well as the changing daylight, weather can emphasize mood. In winter weather a child can evoke a feeling of outside cold by quite simply looking snug in a snowsuit or hat with ear muffs.

Above *The impact of this photograph lies in the rather menacing expression of the youths. This would be greatly lessened if it were in colour.*

Right *The effect of the young boy, relaxed in his room, plus the shaft of light results in a pleasantly moody and rather private picture.*

Many photographs have that something extra which makes them special because the photographer employed a special effect. This does not mean that you need a lot of expensive equipment or your own darkroom. A great deal can be done with a little improvisation. For instance, many professional photographers, instead of using a special soft focus lens, shoot through Sellotape or smear petroleum jelly on a filter over the front of the lens.

You can get filters that will break up the image to give a prismatic effect or another which will send out rays from a strong highlight, such as the sun or a street light. Both these types of filters come in various strengths, i.e. varying the number of images or rays. Another technique which looks most effective is obtained by moving a zoom lens through its range while taking a shot. You need to use a fairly slow shutter speed to do this, but the result will have the appearance of speed lines, so, although the child may be sitting quite still on a bike, it will look on the finished photograph as if he or she is moving very quickly. For very slow speeds, you will need to support the camera on a tripod. You could also use the B setting on your shutter dial or the delayed action self-timer.

By using flash in daylight you can simulate night. If the daylight reading is $\frac{1}{125}$ second at f5.6 and the flash reading is f16 and you shoot at the flash setting then the background would be underexposed and therefore quite dark. You could also use this technique at sunset to fill in the foreground but retain the dramatic sky.

Q What is a graduated filter?
A Sometimes when there is a lot of sky in a picture it will require a different exposure to that of the foreground. With a graduated filter you will be able to match the two, and save having the sky burnt out or the foreground underexposed.

Q What is ring flash?
A A ringflash fits around the lens and produces almost shadowless lighting, but can make the subject's eyes look quite haunting.

Q Can I take stereoscopic pictures with my camera?
A You can buy an attachment that fits on the front of the lens which will enable you to take stereoscopic pictures, but you will need a special viewer to see them in stereo.

Q What is a split focus lens?
A This allows you to take close-up shots on one half of the frame while retaining the sharpness of the background on the other.

Q Why should I use delayed action at slow shutter speeds?
A When working at very slow speeds it is still possible to jerk the camera when depressing the taking button, even if the camera is supported on a tripod. If you use the self-timer, the taking operation is made that much smoother. You can also get yourself in the picture if you want.

Q What is the B setting on the shutter dial?
A When the shutter dial is on B and the taking button is fired the shutter will remain open for as long as the taking button is depressed.

Far left Moving a zoom lens through its range has created the effect of speed when in actual fact the boy on his bicycle was standing still.
Left Using flash in daylight can produce unusual and surreal effects. This shot was taken at midday.
Above A multi-image device fitted to the camera created this shot.

Playing is the most natural activity to children so it should be relatively easy to capture this aspect of their lives. You could be shooting in a busy adventure playground or with one child playing with a doll. If you are in a playground try to look for different angles. It could be at the bottom of a climbing frame looking up, or you could be on top looking down. Many people when photographing children on swings fail to get the shot sharp. This is because they try to focus on the child as they swing backwards and forwards. To get the picture sharp you should select a fast shutter speed, say $\frac{1}{500}$ second. Then get yourself into a position in front of the swing so that when it comes forward it fills the frame. Judge the distance of this point and set the camera accordingly. As the child swings take the shot when it reaches the optimum point. This technique of pre-focusing on a set point can also be used on other apparatus such as slides or roundabouts.

Whatever game is being played, your subjects will be dashing about and unlikely to stay in one position for long. It is therefore advisable to use a fast film and shutter speed to capture the action as it happens. A zoom lens could be an advantage in these situations as it will give you the freedom to frame the subject tightly without necessarily moving from your viewpoint.

Right These two lads in their tree camp were photographed from the ground. The low viewpoint has helped to emphasize the impression that it is definitely their territory.
Far right As well as creating strong perspective the slide has provided the opportunity for an action picture. A fast shutter speed was used and the camera prefocused on the leading child.

244 PHOTOGRAPHING GROUPS

When photographing groups of children try to place them in the viewfinder so that they make an interesting composition rather than a straight line. If you are photographing a sport try to get some action pictures that show the team spirit. A telephoto lens will be useful here, as with hockey or football you obviously will not be allowed on the pitch.

Of course, groups of children need not be restricted to the sports field. They could well be playing in the street. If this is the case you may want to show them in an environment that makes a statement about the lack of playing facilities or the danger of passing traffic.

If you want to isolate a child from the rest of the group this could be done by using a wide aperture so as to decrease the depth of field. Another idea would be to get the child to stand still while the others move about him. If you use a slow shutter speed, your subject will remain sharp whereas the others would be blurred. You will have to support the camera in some way otherwise you will get camera shake and lose the effect.

In an informal setting it may be an idea to let the children form their own group by telling them to all climb on a gate, for example, so they will make a tightly framed picture.

Above The charm of this picture is a result of tight framing and the happy participation of the boys.
Right When photographing any group, but especially children, it is wise to take more shots than usual as there is always the chance of taking the shot just when someone blinks or looks away.

8 PHOTOGRAPHING CHILDREN

248 TAKING HIGH KEY PICTURES

The term high key is used to describe an image that is made up of primarily light tones. An extreme example of this would be to photograph a pale-skinned, blonde-haired child against a pure white background using very diffused lighting. We could soften the shadow areas even more by using a soft focus lens attachment. Of course, it is possible even if the child has black hair to take a high-key photograph.

The reason for wanting to use such lighting is to enable us to create a certain mood or feeling. For instance, if you were photographing a very young baby, maybe with its mother, you may want the final image to have an ethereal quality. This would be impossible to achieve with harsh, one-sided lighting against a dark background.

As well as using high-key lighting to set the mood, you may want it to emphasize the delicate skin tones of some children, or to add importance to facial features such as eyes or hair.

When calculating the exposure for high-key shots take care not to underexpose those shadow areas that do exist, as this will just increase contrast.

Above Dressed in white night clothes these sisters were photographed in their bedroom.
Right A diffuser on the camera lens helped produce this high-key shot.
Far right Two flashes were bounced from the ceiling to create an even, soft light.

Q What is the difference between a high-key photograph and a high-contrast photograph.
A A high-key photograph is made up of tones from the lighter end of the tonal range, whereas a high-contrast photograph is made up of tones from the lighter and darker ends of the range.

Q What is the tonal range?
A This is the range of tones between the darkest and lightest areas of a photograph.

Q Can I only take high-key portraits with studio lighting?
A No. But as you have complete control of studio lighting, it is relatively easy to get this effect.

Unlike a high-key portrait that is made up of generally light tones, a low-key portrait is made up of primarily dark tones. This style of lighting can produce pictures with a very dramatic effect. At the same time, if not used carefully, it can be brutal and unflattering.

Many adolescents can feel isolated or just plain awkward when it comes to coping with the changes they are going through. As you may wish to portray this side of growing up, try photographing them alone in their room. Use the available light or daylight from a window. If you use an exposure to render the highlight areas as mid tones the result will be a picture consisting primarily of tones from the darker end of the tonal scale. If you use a fast or uprated film, the increase in grain can greatly add to the dramatic impact of the final photograph.

Another situation where a low-key effect may be applicable is when the child is asleep. This could be in its mother's arms or in its own bed with just a nightlight as the main source of illumination. Although the light in this case may be very weak, as the child is asleep, you will get a worthwhile shot by using a long exposure with the camera mounted on a tripod. In this case, watch out for reciprocity failure.

Right Low-key lighting is particularly suitable for conveying a moody atmosphere, as in this shot of an adolescent boy, lit by daylight entering a small window.
Far right With modern films, it is possible to record an image even in conditions of very low light. This portrait was lit by candlelight and shot on film rated at 3200 ASA.

Q What is meant by reciprocity failure?

A When taking pictures in poor light with long exposures, the stated speed of the film may decrease. Although your meter may give a reading of one second for the film being used, it may be necessary to use double that time. In cases of long exposure the colour balance of the film may also be affected.

Q Because low light often produces bright highlights from the light source combined with large areas of dark shadows, what is the best way of working out the exposure?

A Either by averaging the readings taken from the brightest and darkest areas or exposing for the most important feature of the subject.

In the early days of photography when films were very slow and therefore exposures took some considerable time, it was little wonder that subjects took on a rigid and formal appearance. Fortunately times have changed, and there is no reason at all why a 'formal' portrait should not have life in it. Maybe the occasion for the portrait is the winning of a competition or a race at school. If this is the case, then aim for the expression that will reflect the joy of winning. Take care with the light bouncing off the trophy or other highly reflective surface.

A family portrait consisting of several gen-erations may also be a reason for a more formal approach. Avoid the 'wedding photograph' approach with a long line of embarrassed people. Organize your subjects into a group that can be tightly framed. Some could be seated, others standing, one or two on the floor. As well as positioning them according to age or status, think carefully about what they are wearing so that you strike a pleasing overall balance. One of the advantages of the formal portrait taken regularly over a period of years is that it produces a delightful record of the child's or children's development.

Above *Although the uniforms are formal, the expressions of brother and sister give a slightly cheeky expression. As most children will be strangers to a studio, your ability to create a relaxed atmosphere will be very important.*

Right *By having one child sitting on his mother's knee while his sister embraces her, a feeling of togetherness has been obtained in this tightly cropped shot.*

For basic portrait lighting, the room should be large enough for the subject to be a minimum of four feet from the background. If you are using 35mm equipment with a lens of 80 to 120mm, there should be space enough for you to adequately fill the frame. Light coming in from windows or doors must be blacked out. If the room that fits these dimensions has an undesirable background, a heavily embossed wallpaper, for example, you will need a backdrop. If the room you use is decorated in a very pale style, attention will have to be paid to light bouncing back from walls or maybe a

mirror. A screen of dark material or paper will help overcome this.

Because tungsten lighting can be hot and uncomfortable for the child, I would recommend a portable flash unit. There are many of these available, some of which are no bigger than a suitcase when stored away. Apart from being portable, they can also be adjusted to the amount of power required and they have modelling lights that enable you to see how the light will fall on the subject. Some have a range of reflectors, diffusers and special effect filters, all of which could be added as you progress.

Above By simply diffusing the main light and adding a reflector to bounce light back into the shadow areas, a far more pleasing portrait has been created.
Above right Shooting with just one light has resulted in rather harsh shadows that aren't particularly

flattering to this young girl.
Right It was necessary to isolate the boy from the background to emphasize his concentration on a computer game. This meant using a single light slightly behind and above him, directed at a reflector.

Q How do I calculate exposure with several flash heads?

A Take a reading from the key light. Let us imagine this is f11. Your fill-in lights should be about two stops below this, about f5.6. If they are as powerful, or more so, as the key light, turn the power down or move them further away.

Q What is a slave unit?

A When using several flash heads you have to employ a method by which they will all synchronize. This is done with a light-sensitive cell known as a slave. The camera sync lead is plugged into the key light and the slaves into the others. When the key light is fired, the slave picks up the flash and triggers the other lights.

Q Can I use my exposure meter for calculating the aperture required with studio flash?

A Although there are one or two very expensive meters that can be used for daylight and flash the answer is no!

Having made the child feel relaxed and at home in the studio, let us set up a head-and-shoulders portrait. Unless you want the chair to feature in the photograph it should have a low back. Above all, the child should feel comfortable.

With the child facing the camera, position the light just forward of the camera line and at about 45° to the child. From this position, adjust its height and direction to best suit the qualities you want to emphasize. With this key light in position, you can now add further lights, reflectors, diffusers or screens as desired. The important thing to remember is always use the minimum amount of lights to set the mood that is required. Nothing can look worse than shadows created from independent lights thrown at various angles across the face.

With your key light in position, the shadows cast on the face will be quite harsh. These can be softened by adding a diffuser to the light. If you now add a reflector on the other side of the camera, light will be bounced back into the shadow areas of the child's face, giving a more high-key effect. Another light could be added slightly overhead to highlight the hair. Now it will be up to you to capture the expression that will make the photograph special.

Right Don't be afraid to go in close when shooting a head-and-shoulders portrait. Tightly framing the subject, as in this shot, has helped to emphasize the wistful expression on the boy's face.
Far right Try to be flexible when positioning your model. By turning the chair round and leaning forward on it, a far more relaxed portrait of this girl has developed.

Q What is a fill-in light?
A When you have your key light in position, the shadows it will cast will be quite harsh. Another light, the fill-in, is used to soften the edges of those shadows but retain the modelling.

Q What is a boom?
A A boom is like a large Anglepoise lamp. It is very useful in portraiture for lighting the model's hair.

Q What is a snoot?
A A snoot is put over the front of a light and reduces the beam to a very narrow circular shaft. This can either be used to highlight a small area or to create a lighting effect on the background.

Q I have seen lights with umbrellas. What are these used for?
A Creating a soft lighting effect. The flash is directed in the opposite direction to the subject into a reflective umbrella. This in turn bounces the light back onto the subject.

Q What is a window light?
A This is a light whose reflector, covered with a diffuser, will be at least two feet square. It gives a very even, soft light.

Q What are barn doors?
A These fit onto the front of a light and can be adjusted to alter the direction and width of the light path.

Close-ups of children can be extremely evocative. A tightly cropped picture of a child's head is an ideal way of capturing the intimacy of mood whether it be joy or sorrow. When taking close-ups, use a medium telephoto lens, 85 to 150mm. With lenses of shorter focal length a certain amount of facial distortion may arise. Also, by keeping a certain distance you will not make the child inhibited or break its concentration if involved with a game or model-making. You could also consider using other means of distancing yourself but not the camera lens from your subject, such as extension tubes or a macro lens.

If you are using daylight indoors or available light you will probably be working with a wide aperture. This will restrict the depth of field. If this is the case, focus on the dominant feature, usually the eye nearest the camera. When working with a rangefinder camera, allowance will have to be made for the difference between what the viewfinder sees and what the taking lens sees. This allowance is known as parallax correction and usually there is a line to compensate for this in the viewfinder. Close-ups need not be restricted to faces. Especially with very young babies, the discovery of their toes or hands, or clutching something for the first time, could be the basis for a very interesting, if abstract, photograph.

Q What are extension tubes?
A These are fitted between the camera and lens and allow close focusing, but will prevent focusing on infinity.

Q Can I use extension tubes in portrait photography?
A Sometimes you might want to fill the frame completely but find you cannot get close enough. A short extension tube will get over this problem, but it should be used with a lens of about 100mm focal length. The face will become badly distorted with a shorter lens.

Q What is a macro lens?
A A macro lens, like extension tubes, allows close focusing, but will also focus on infinity.

Q Can I take close-ups with a wide angle lens?
A Yes. But the area covered will be that much greater than for a normal lens.

Q If the child wears glasses, can I avoid reflections?
A Yes. Angle your main light so that from your viewpoint it is not reflected in the glasses. Or bounce the light off the ceiling. Be careful with reflections from the room itself.

Far left A close-up effect can be achieved by enlarging a small part of a photograph. Although this will increase the grain it need not detract from the final print.
Left This tearful child provided the ideal subject for a close-up picture.
Above A medium telephoto lens will allow you to be close to your subject without intruding.

Having decided what room to use to take your photographs in, what about the background? Most commercial studios use rolls of cartridge paper, which comes in many colours besides black and white. These rolls, which are nine feet wide, will probably be too bulky for the home studio, but an enquiry at a professional photographic dealer may result in you being able to purchase half-width rolls.

Another background could be made by using fabric. If you require a flat surface then stretch the material on a frame.

A large sheet of hardboard could also be used. You could paint it the desired colour, but if it were white it could double up as a reflector. The rougher, reverse side could be black to act as a screen. It would also provide a good surface for a textured backdrop, made by spreading plaster of Paris or any wall filler generously but unevenly over the hardboard and painting it when dry. Remember that a head and shoulders portrait only needs a background of about four feet, so many items found around the home will prove suitable as backgrounds.

Above When posing models against a background make sure they are far enough away from it to avoid casting a shadow.
Right To keep a white background white it will be necessary to light it separately.
Far right If your subject is close to the background and you want both lit evenly it would be best to bounce the light off the ceiling.

Q Why does photographic background paper come in such long rolls?
A When shooting full length, a continuous background avoids the ugly join between wall and floor.

Q What can I do about an unwanted background if I do not have a portable backdrop?
A If you are using flash and your subject is far enough away from a distracting background, the power of the flash will decrease, therefore underexposing the background.

If I do not have a portable background and the room I am using has an unsuitable decor is there anything I can do?
A If you position your subject far enough away from the background, with careful lighting it will be possible to darken the background by underexposure. It may also be possible to obscure the background by using a large aperture.

Many portraits will be enhanced by the use of props. Props is the name given to any items included in the photograph that add relevance and interest without detracting from the main subject, in this case the child. For this reason you should select and use them carefully. If the child is seated, the chair, in the correct setting, could act as a prop in itself. Including toys in the photographs could add the dimension of action or capture a thoughtful expression. A lolly, ice-cream or toffee-apple will provide colour as well as relevance.

A prop may also lend itself to a background. You may wish to photograph the child reflected in a mirror. Take care here not to include yourself, the light or other distractions. A more formal setting could be created by using a wall map as a background or having the child seated at a desk, with a globe, as in our old school photographs! For older children, the building of an intricate model could add mood as well as a secondary point of interest.

Below *When shooting into mirrors or other reflective surfaces take care not to photograph yourself. This can be avoided by a little forethought to your viewpoint.*

Right *Dressing up is something most children love to do. Because it is fun, inhibitions will soon be lost. Taking photographs could be part of a game if they pretended to be, say, film stars.*

Right below *The ice-cream on this boy's face has added that little bit extra to an already attractive portrait. As a photographer, the use of such props is something to always be aware of.*

Children, naturally enough, are demanding and impetuous people who become easily bored. This will manifest itself early on if you have to pay more attention to the light than to the child. It is therefore an advantage to practise with indoor lighting on a more mature person who will be more patient with you while you observe the variations of the light source.

Before doing any portrait, and children are no exception, get to know your subject. Don't sit them in the studio right away. Relax with them. Do they want a drink of squash or pop?

Do you have a toy or gadget that they are interested in? If so let them have it. Talk with them. Play. Above all create an atmosphere that is fun to be in so that when they are seated you have a good idea of their interests or what they find amusing. If you sense they feel inhibited because a parent, brother or sister is present then diplomatically get that person to leave the studio. Once you have gained the child's confidence, with just a little guile on your part you will be able to coax them into expressing the attitude you desire.

Above Professionals often take lots of shots when photographing very young children to be certain of getting the right expression. Careful editing will reveal the shot that sparkles.
Above right Above all else, when working in a studio it will be your ability to make the child feel relaxed that

will determine the success of the final photographs.
Right In situations like this, where the child is involved in a game that requires concentration, finding the right expression should not be a difficult task.

It will be an asset, in certain cases, when photographing children to include the mother. This is especially so when photographing very young children and babies. No one is going to know the child better, and if a certain amount of cajoling is required she will probably be the most successful.

If you are photographing the mother holding her baby she will be able to position the baby in her arms in the best way for your viewpoint. Be careful in these situations that the mother's head does not cast a shadow over the baby. Your main aim will be to show the natural bond that exists between mother and child. The choice of lighting should be soft to eliminate harsh shadows. It may be an idea to use a soft focus lens attachment so that you increase the romantic feel of the shot.

If you are photographing mother and older children try to get them involved in a joint activity like playing, getting dressed or reading. In the latter situation they could be sitting in the same chair lit by natural light from a window. Although this lighting may be low key, it will not necessarily detract from the intimacy of the situation. Even when a more formal shot is required you should still try to show some body contact, and an animated expression.

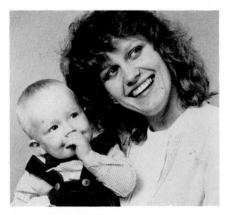

Above *Although this picture was taken in a studio, it shows the natural and relaxed expression of mother and child.*
Right *By using flash balanced with daylight an even intensity of illumination has been achieved.*

Photographing a group of children indoors does not have to result in a static picture, if you pay attention to expression, dress or props. If they are brothers and sisters, or even friends, try to aim for the intimacy that exists between them rather than posing them to sit or stand stiffly side by side. Be careful that your lighting does not cause strong shadows. For this reason it would be better to bounce the light off ceiling and/or reflectors.

In a less formal setting, a group of children playing, say, a card game is alive with possibilities. Not only will you be looking for their interaction as a group, you should also be on the lookout for individual shots. Take care with the background, though, if your camera is not at a fixed point.

If you are going to photograph more ambitious groups, the school play for instance, try to avoid having half the audience in the picture. Perhaps you could go to a full dress rehearsal, which would give you much more freedom of movement as well as the opportunity to set up your own individual shots. If you are photographing such an event you will have to check that the stage lighting is balanced to your film unless you use flash combined with daylight film.

Above When photographing a group of children it is all to easy for one or more of them to cast a shadow over the others. With careful positioning of lighting this situation can be avoided.

Right To get away from the usual 'in-line' approach I asked these five girls to lay on the floor with their heads close together and stood over them to take this shot.

Lighting needs to be planned carefully in advance when photographing babies. Using tungsten lighting in a studio could result in an uncomfortably hot and unpleasantly bright situation for the baby. On the other hand, flash could have the effect of frightening and upsetting it. Daylight indoors is probably the best compromise. A softer light will be achieved further from the window, if that is the light source, but its brightness will decrease. However, with a moderately fast film this should not be a problem. Even so, attention will have to be paid to exposure. There's a good chance that the baby will be dressed in pale colours and could even be lying on a white background. To avoid underexposure, use the incident light reading method on your exposure meter or take a reading from an average tone, such as your hand. Be careful with this method that the meter does not cast a shadow and that you end up overexposing.

If the baby is old enough to hold a toy, introduce one into some of your shots. Because the baby will understand few words, if any, it will be your gestures and mannerisms that will be needed to elicit the required expression.

Right *Rather than use flash, which may have distressed this very young baby, I used the daylight entering through a window in conjunction with a reflector.*
Far right *The mother of this baby attracted his attention by standing just off camera. A continuous white background was chosen to give an overall high-key effect.*

Q What is the incident light reading method?
A This is the method whereby you measure the light falling onto the subject by pointing the meter, with an invercone, at the light source rather than reading the light being reflected from the subject.

Q What is a soft focus lens attachment?
A This diffuses the highlights without affecting the overall definition. As well as giving pictures a romantic feel it is more flattering to skin texture as well as hiding blemishes.

Great care must be taken when photographing older children not to treat them like kids. A girl in her early teens will usually have very definite ideas about how she wants to look, and the last thing you want is an argument over appearance. Make-up, for instance, that looks fine in normal circumstances can look quite terrible in photographs. Before you start taking pictures, discuss such aspects with her. If you show some knowledge and interest this will make the relationship between you far more compatible with obtaining good pictures. On the other hand, boys of this age can be quite sensitive and become quite awkward when in a studio.

In either case maybe the best indoor location would be their own rooms. Here they will feel immediately at home. Try to find an interesting background that will reflect their personality. It could be a wall of posters or pop ephemera. If they play a musical instrument, use this as a prop in the shot. Children of this age usually have many interests and hobbies and to include some aspects of these in your shots will help.

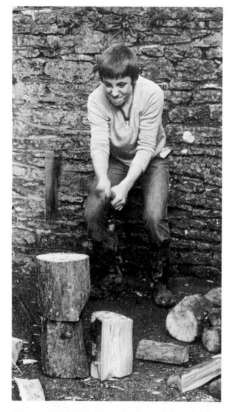

Above This older boy, chopping logs, was as capable as anyone when it came to hard physical work. There are lots of situations like this which will make older children feel at ease.
Above right I met this group of teenagers on the street while I was walking home. When I asked if I could photograph them they were only too eager to oblige.
Right Many older children will feel more relaxed if photographed outdoors. The light filtering through the trees onto this young couple adds to the romantic nature of the shot.

There are many ways that you can add impact to a photograph and one of these is the attention you pay to the background. If, for instance, you are photographing a child against a background that is causing a distraction in the viewfinder and you cannot change your viewpoint, you could use a wide aperture on the lens. This would limit the depth of field and could therefore put the background out of focus. A similar effect can be obtained by changing to a longer focal length lens. Another way of obscuring the background is to backlight the child and expose for the shadows. In this case, the background would be effectively burnt out.

On the other hand the background itself may be beneficial to a photograph and therefore needs to be kept sharp. In this case, if you stop down the lens you will increase the range of what is in focus. If shooting in colour, choose the colour of the background carefully. Most successful photographs are those in which the colours harmonize and are complementary to one another. If you allow the background to be the dominant colour the child will become less strongly attracted to the eye as the main point of interest.

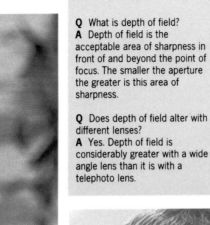

Q What is depth of field?
A Depth of field is the acceptable area of sharpness in front of and beyond the point of focus. The smaller the aperture the greater is this area of sharpness.

Q Does depth of field alter with different lenses?
A Yes. Depth of field is considerably greater with a wide angle lens than it is with a telephoto lens.

Q What is the difference between the focal length of a lens and a long focus lens?
A Focal length is the distance between a lens and the film plane on which an image can be sharply focused when the lens is set on infinity. Long focus is the term given to a lens whose focal length is greater than the diagonal of the film format for which it is being used.

Far left *If the background in your picture is distracting, a longer lens with its reduced depth of field will help to keep the point of focus sharp.*
Left *By taking a higher viewpoint the river has completely filled the frame, providing an even background that adds emphasis.*
Above *Do not be afraid to go in close for effective results.*

Sometimes you can emphasize the child in your photographs by using the foreground. What is important is that the viewer is not distracted and that the foreground leads the eye to the central subject. Taken from a low viewpoint, foreground will become an important part of the overall composition of the photograph. If you select a wide aperture, the background can be made blurred, further emphasizing the fore- and middleground.

Another way of using the foreground is to highlight perspective. Imagine a track or path receding into the distance. If you choose a viewpoint for the picture so that the track plays a prominent part in the bottom of the frame, the eye will be led from the foreground into the picture itself. With a wide angle lens and shot from a low angle, a child sitting astride a bicycle could fill the foreground of the picture to dramatic effect. When using a wide angle lens, care needs to be taken not to include unwanted detail. Because they have a greater depth of field than a telephoto lens, obscuring the background is difficult.

Above Shooting through the water cascading down from this fountain has created foreground interest, but the eye is still drawn to the children in the background.

Right above Foregrounds can be made to create a certain mood. Such is the case in this shot where the fence has created a feeling of being alone.

Right A wide angle lens is useful when shooting subjects that are in the foreground but where the retention of background detail is desirable. This is because of its greater depth of field.

Q Can you only use a wide angle lens to obtain foreground interest?
A No. A normal or telephoto lens can be used to similar effect.

Q What is a fish-eye lens?
A A fish-eye lens has an angle of view of 180°.

Q What is a panoramic camera?
A The lens of a panoramic camera moves through an arc of about 130°. This results in little or no distortion. This is the kind of camera used to photograph very large groups, such as a whole school.

It is important to remember that the term full-length portrait does not mean that the child has to stand up straight and to attention. Broadly speaking, it means a shot which includes more than just the child's head and shoulders: your model could be sitting under a tree or astride a bicycle, lying on the beach or in a field. If you are taking a full-length portrait where the child is walking through a wood or using trees as a prop, care will have to be taken that the light filtering through the leaves does not cast ugly shadows over the face. With this kind of lighting you should also watch that you do not either under- or overexpose.

Even though you may have made the background out of focus in your photograph, strong shapes and highlights can still be a nuisance. Watch that these do not look as if they are an appendage of the child. Either move the child or change your viewpoint. If you are posing the child in a door or archway, make sure they are not standing in shadow, otherwise you are likely to underexpose. This could also be the case if you stand them against a very light background.

Right Although she has her back to the camera this young girl's pose has just the right amount of tantalizing innocence. Learn to explore your subject from all angles.
Far right By turning the picture session into a game of marching soldiers the expression on this boy's face is that of determination. In situations where it is difficult for a child to stand still this approach often works.

It is very easy when taking full-length portraits outdoors to include a lot of unwanted detail. Therefore it will be up to you to compose the photograph so that the surroundings either blend in or are obscured. In either case, you should remember that most good photographs are good mainly because of the thought that has been given to the composition.

In composition there is a rule known as the 'golden section'. What this means is that the subject should stand at the intersection of imaginary lines drawn vertically and horizontally a third of the way along the sides of the picture. Naturally there are photographs that completely reject this rule and are still fine photographs. What you should aim for is to draw the viewer's eye to the main subject by using strong perspective, the contrast of the child to the background or, if you are shooting in colour, the distribution of the various hues. Of course it could be a combination of all of these. By adopting a low viewpoint you will increase perspective, but it could result in a lot of unwanted sky. A child dressed in light clothes will stand out from a dark background and draw the view in, but if the colours vie against one another this will have a discordant effect on composition.

Right *The natural and relaxed pose of this young girl blends in well with the surroundings. Choose your viewpoint carefully in such situations as it is all to easy to include unwanted details.*
Far right *By taking a higher viewpoint the diminutive character of this boy has been emphasized. A reduced depth of field has eliminated any distractions in the background.*

Q Should I always use a low viewpoint for full-length portraits?
A No, but if you take a full-length portrait from a high viewpoint it will foreshorten your subject.

Q When I shoot from a low viewpoint my pictures always have a murky look to them. Why is this?
A Often when you shoot from a low viewpoint you include a lot of sky. This can confuse a TTL meter and cause underexposure.

It is often possible and sometimes desirable to portray children in an informal setting or mood. Informal portraits often work well when the child is out of its normal environment and there is a chance of surprise, like being at the zoo or the fairground or at the seaside.

Although it is advisable to pre-set the camera in the same way that you might for taking candid photographs, it does not automatically follow that your subject will be unaware of your intentions. In fact, it may be advantageous to the finished shot if you can coax a glance out of a child, who may be involved in an activity like digging a sandpit. Often when children are aware that you are photographing them they will play to the camera – often with delightful results – unlike adults who tend to freeze into sheepishly grinning fools.

If the children are shy, organize them into a game or a dance or a race and let them play until they have forgotten you. Don't forget that children will be very interested in your camera anyway, so you should not have any trouble keeping them entertained.

Above A pre-set exposure will enable you to work quickly and to capture those fleeting expressions.
Right Although these three beauties were positioned on the swimming pool steps their lively expressions have eliminated any formal feeling.

There are many ways that you can emphasize your subject by composition. Perhaps the most important is the way you frame your subject. A lot of photographs fail because the photographer stood too far away, submerging the subject in a lot of unwanted detail. A few steps nearer will make all the difference.

Viewpoint is also important. If you shoot from a low angle with the child against either trees or buildings these will converge over the child. The same would be true if the child were standing in front of a group of adults. They could appear giants by comparison. On the other hand, if you stood over the child, thereby taking a high viewpoint, you could emphasize its diminutive size.

Of course there are other ways that you can compose a picture. You could emphasize a colour or an article that the child may be holding. If this is done carefully it can be used to draw attention to the main subject. It is not necessarily true that you will have to use a wide angle lens, but it will emphasize depth and enable you to include more foreground.

Above The rock in the foreground of this shot has been used to effect by leading the eye into the picture, first to the boy and then around to his sisters. **Above right** By standing on the wall that this young girl was leaning on and shooting downwards, her face has become the centre of interest.

Right A low viewpoint has emphasized this young Arab girl in relationship to the background. Also the colour of her clothing gives her further prominence from the almost monotone surroundings.

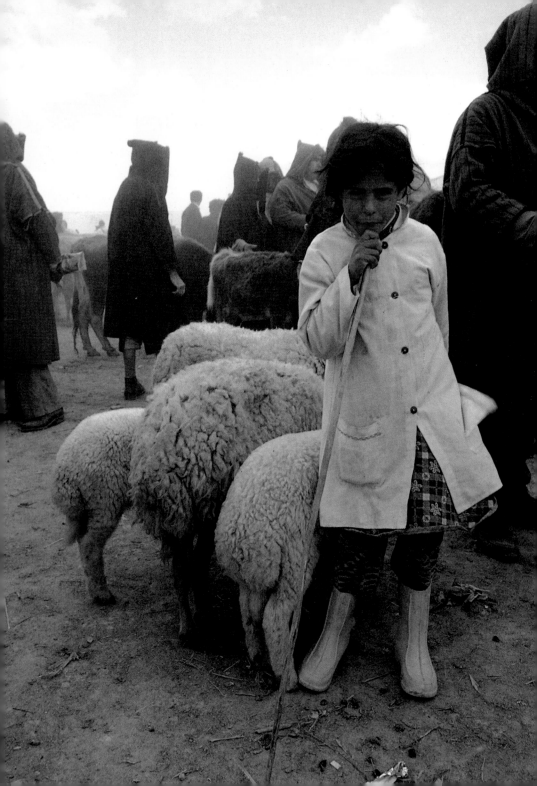

The term action pictures covers a broad spectrum. They could consist of anything from a young child pushing over a brick tower to a teenage champion skateboarding. The important thing is that you get a feeling of movement in your shots. Much of this movement can be created through thoughtful use of the camera controls, and the viewpoint you adopt.

Suppose you want to photograph a child cycling. If you stood at right angles to the child so that it cycled across the viewfinder, you would have to use a fast shutter speed to freeze the action, otherwise the cycle and child would become blurred. The point is that having frozen the action the result is rather static and it can be difficult to distinguish whether the cycle is moving or standing still.

If on the other hand we use a slower shutter speed, pan the camera in line with the cycle and press the shutter when the cycle is at right angles to the camera, the result will be far more dramatic. The background will be blurred but the cycle sharp. This will give the feeling of speed and movement.

Another way of emphasizing action is to take a low viewpoint. This is especially so when photographing something like field sports. For instance, in a hurdle race the jump shot from somewhere near ground level will be far more dramatic than it would be from a normal standing position.

Right above *A low viewpoint was chosen as these two youngsters ran towards the camera. A fast shutter speed was used to freeze the action, but the picture retains the element of movement.*
Right *This boy was being coached in rugby football. A flagpost, not in the picture, was used as a marker for him to run round, making it easy to select the point of focus.*
Far right *By panning the camera the background has become blurred, but the boy on his bicycle has stayed sharp. This technique is called 'panning'.*

Q What is panning?
A Panning is moving the camera in line with a moving subject.

Q Do I need a telephoto lens for action photography?
A Not necessarily, but if you are restricted by how close you can get to a subject a telephoto lens will be useful. You might also consider a teleconverter.

Q What is a teleconverter?
A A teleconverter will double the focal length of a lens, but at the same time reduce its maximum aperture by two stops, therefore making it slower. With even a good teleconverter, the performance of a lens will be reduced and will not match the quality of an equivalent focal length telephoto lens.

Q Do I need a fast film for action photography?
A If you are using a telephoto lens, say 200mm, a shutter speed of not less than $\frac{1}{250}$ second should be used. As most long lenses have smaller maximum apertures than normal lenses, exposure may be a problem. Therefore a faster or uprated film will help.

There are many events that are special in a child's life that are well worth capturing on film, not just for the pleasure they will give you but also for the child to look back on when he or she is older. Such an event could be as informal, although important in a child's life, as the first day at school or something more formal like being a bridesmaid at a wedding. In either case, try to think ahead so that when it comes to taking the shot you will be in position and able to work quickly.

At events where there is an official photographer it may be an idea to keep an eye on what he is doing. If he sets up an interesting situation try to stand as near to his viewpoint as possible, without getting in his way. At outdoor events, arrive early so that you will be able to see in what direction the sun is shining and whether there are any suitable backgrounds.

If you are working indoors you will need a flash, so find out beforehand if this is allowed. Take a fast film as an alternative in case there are objections.

Professional photographers on any assignment have at least two cameras. This not only allows them to work quickly by having different lenses or films in each camera, but provides an instant reserve in case of camera breakdown at a one-off event. Of course, you don't need a wardrobe of cameras and a bevy of assistants, but if you could borrow a spare camera for a special event it might prevent disappointments.

Above *Although the child was shy of her success, choosing the viewpoint carefully has resulted in this pleasing picture. Including the certificate instantly tells the viewer what the occasion was.*

Right *At parties it is very easy to lose the atmosphere by using flash. This picture was taken with fast colour film and illuminated only by the candles on the cake.*

When going on holiday with the children, decide in advance whether you want to record the event from the moment you leave home to the time you arrive back, or if you just want shots only at your destination. If it is the former make a list of all the essential elements of the holiday so that on your return, when presenting your slide show, the narrative unfolds evenly.

If you are going abroad to somewhere hot and sunny, care will have to be taken with film. If it is colour try to buy it all before you leave so that it is all of the same batch. This means that if the film is slightly biased in colour at least all your shots will be consistent when projected. The other reason for buying beforehand is that film on sale at holiday resorts has a dubious shelf life. Wrap the film in foil if you are doing a lot of travelling.

Where you know there will be a lot of blue sky a polarizing filter will help retain or intensify its depth as well as cutting down glare. How much it heightens the sky will depend on the position of the sun in relation to your viewpoint. You will have to make an allowance in exposure when using this filter, but with TTL metering this should not be a problem.

Above *Often on holiday, especially abroad, it is worth looking out for children in ethnic dress or unusual surroundings. This Arab boy with his camel proved such a situation for a worthwhile shot.*

Right *Using a 200mm lens, I concentrated on this child playing on the seashore. This technique needs patience, but invariably pays off with a pleasing picture.*

Q Can I use a polarizing filter with black and white film?
A Yes. It will help cut down unwanted reflections, for instance, in windows and on table tops.

Q All my shots taken on the beach were underexposed. Why?
A There is so much reflected light from the sea and sand that exposure meters can get confused into recording more light than there really is. Try to take a reading from an average skin tone, such as your hand.

Q Can I do anything about X-ray machines at airports?
A You can buy a lead-lined film bag to put exposed and unexposed film in. Or you can ask to be body searched, although at busy times of the year this may not be popular. Whatever you do, don't pack film in your ordinary luggage.

Most children have hobbies of one kind or another and many of these will make for interesting photographs. If their hobby is a solitary one, like modelmaking or sewing, aim for a shot that will show the intensity in what they are doing. Their expression will be vital to this. If the model is finished, you could photograph them launching the ship for the first time or flying the aeroplane. If in situations like this a group of people gathers round, make sure that the child stands out from them. With aeroplanes, kites and other flying objects where you are likely to include a lot of sky area take care not to underexpose.

A child who is a collector of model cars or dolls will provide you with an array of props that will make an interesting picture if you arrange them carefully around the child. If they are keen on model railways or dolls' houses try to get low down so that the scale is emphasized in relation to the child. You may achieve this by shooting through the dolls' house to the child on the other side.

If they are involved with pets, show the other side of having one, like mucking out the stables or grooming the dog. If the child takes sport seriously a colourful portrait could be taken of them in their badge-covered track suit, with the swimming pool or athletic track behind them.

Above Including the swimming pool as a background to this shot instantly tells the viewer what this child's hobby is as well as recording his achievement.
Above right This shot was lit by a window. The music sheet, out of camera, reflected light back into her face. Many devices could be used to the same effect.

Right Always be on the lookout for a different angle when taking pictures. Using a wide angle lens, I positioned myself in front of the bicycle wheel with the two boys behind.

If you are planning to take a series of pictures that will either tell a story or be used for instruction purposes, it will be advantageous to decide beforehand which way the pictures will be displayed. Will they be prints for albums or wall mounting or slides for projection? If slides you should try to shoot them all in landscape as, when viewing, it can be confusing to the eye to jump from one format to another. Try to write a script that includes all the important elements. This does not have to be very elaborate, but it is very easy to forget certain aspects and if the situation cannot be repeated

easily, like a sporting event, the last thing you will want is gaps in the flow of presentation.

A sequence of pictures in an album could be as few as four. Imagine the children going for a walk. You could start with leaving home or getting out of the car. The next picture could be on the way, going over a stile or crossing a river. The halfway stage might be at the top of a hill, being windblown, and then finishing back home worn out and pulling off boots. Although these shots may have been planned beforehand, be on the lookout for the unexpected uninhibited shot.

Above and right *This set of pictures illustrates the essential elements of a family going for a walk. When taking such pictures always have an idea of what you want to show before you set out. If you mount your*

finished prints in an album it may be an idea to add other relevant items. For this picture series such items could consist of dried flowers or leaves pressed in the album.

Q Do I need a motor drive to take a picture series?
A No. But for some action situations they are useful as you will be able to take a lot of pictures quickly from which you can edit the best.

Q How can I take pictures quickly without a motor drive?
A By practising with your camera and getting to know exactly where all the controls are.

In most cases when we are looking for a way of photographing a particular place, we tend to look for the definitive picture which sums up our impression in one picture. Yet it can often be more interesting and sometimes more effective to produce a series of individual pictures which combine to create such a record. This has a number of advantages. Firstly, it encourages you to look more carefully at the subject and to explore it more fully. Secondly, it enables a wider variety and scope of image to be included in the record. Thirdly, it encourages a more imaginative and perceptive approach to provide this variety. In addition it can often provide a motivation for picture-making since it generates a stronger sense of purpose than just waiting for a picture to turn up.

The key to a successful photo essay is variety which is visibly part of a single theme or subject. For this reason, it is usually most effective to combine, say, long shots with close-ups of details within the wider scene and with shots from different aspects and angles which reveal a variety of qualities. Apart from the thematic link between the pictures, you should also aim to create a continuity in a photographic sense. Whether the pictures are viewed collectively – laid out on a single spread in an album for instance – or sequentially, there should be a common quality in the style of the pictures, colour quality or lighting, which helps them to become elements in a large unit.

These four pictures are part of a series taken in a small alpine village during the harvest. Although individually they are pleasing pictures, collectively they are able to say much more about the occasion and the setting than could be achieved in one shot.

Q Are there any famous professionals I should study to learn more about this technique?
A The great *Life* photographers such as Eugene Smith and Margaret Bourke-White and the work appearing in such magazines as *Geo*. Good photo magazines often feature classic photo essays.

Q Do extension tubes alter exposure time?
A Yes, since the lens is being moved further away from the film.

Q What speed film is best for close-up work?
A Since most close-up pictures rely upon elements such as texture and pattern, it is best to use the slowest film possible to maximize image quality.

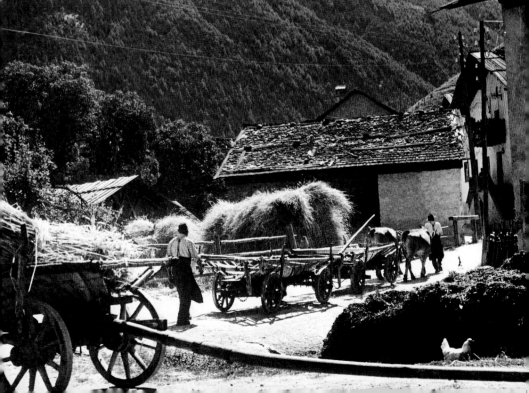

9 PROCESSING AND PRINTING

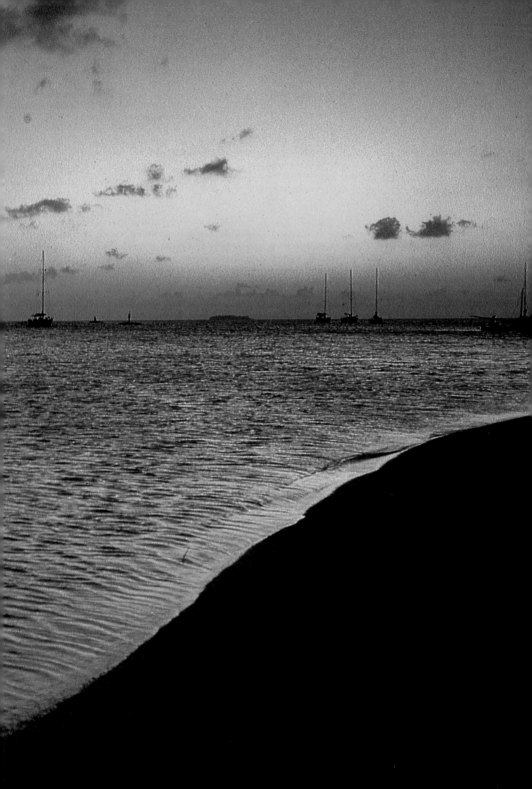

300 PROCESSING COLOUR FILM

It is part of the natural progression from taking snapshots to making planned and satisfying photographs that you should not want to delegate the processing and printing of your pictures to some anonymous laboratory. Although processing colour film is largely a routine and mechanical procedure there is much satisfaction in being able to do it yourself, experiencing the almost magical transformation of a latent image into a full colour photograph.

All you will need in addition to the processing kit is a *developing tank*, a *photographic thermometer*, a selection of storage bottles and measures and a dark place to load the tank. Once the film is loaded into the tank the remaining steps can be carried out in daylight. As most colour processes are carried out at higher temperatures than that of the room being used, it is necessary to maintain the working temperatures of the solutions by immersing them (in their containers) in a large bowl of water heated to the correct temperature. Provided you follow the manufacturer's instructions carefully with regard to processing times and temperatures, and the film is agitated in the recommended way there is no reason why you should not obtain first class results every time. Make sure that you are scrupulously careful in the cleanliness of containers and utensils to avoid contamination.

Above The items required for colour film processing – from left to right. A daylight developing tank, water bath, rubber gloves for mixing solutions, individual containers for each solution, a funnel, a measuring cylinder and thermometer, scissors, wetting agent, solution concentrates and, at the back, a concertina bottle for long-term storage.

Right The sequence for transferring a roll of exposed 35mm film, in darkness, after removing it from the cassette. From top to bottom. The film is aligned with the spiral held in one hand and the film, held by its edges, in the other. The leading edge is fed into the grooves of the spiral. Finally, twist the edges of the spiral back and forth until all the film is drawn in.

Q Is a darkroom feasible at home?
A Yes. It is a simple matter to set up a temporary darkroom – for even just a few hours – in any space that can be conveniently blacked out. A large cupboard will do. Running water is not essential. Many processes can be carried out in daylight once the film or paper is loaded into a light-tight tank. Essentially, any space that is large enough to accommodate you and the equipment you need and give you a little elbow room will make a perfectly adequate darkroom.

Q What will I need?
A For processing films you can even use a light-tight changing bag which can be bought in photographic stores, instead of a darkroom. You will also need a developing tank and film spiral, a measuring jug or cylinder, storage bottles for the solutions and an accurate photographic thermometer.

Q Do you treat negative film differently from transparency?
A The basic principle is the same, but the chemicals and sequence of processing is different.

Q What is the best way of drying film?
A The safest way to avoid damage and drying marks is to give the film a final rinse with wetting agent added to the water. Hang it up from a line in a dry, dust free place and let it dry naturally. For a quick dry you can use a squeegee to remove surplus water and place a fan heater in the room, but make sure that the squeegee blades are absolutely clean and that no drops of moisture are left behind on the film to cause drying marks.

Although colour transparencies can be viewed perfectly well by projection, you may also need to have prints made from them, either to give copies to friends or to use for display purposes. A print is in any case a very satisfying way of viewing a photograph and to make your own allows you to realize the full potential of the picture. Making prints from transparencies is in many ways easier than from colour negatives, particularly for beginners.

In addition to the equipment required for black and white printing, and of course the colour paper and chemicals, you will also need a set of *colour printing filters* or an *enlarger* with a *colour head*. Since it is somewhat more difficult to process colour paper than black and white in open dishes, a *print processing drum* is also recommended. Once loaded in darkness the remaining steps can be carried out in room light. The prepared solutions can be brought to the recommended working temperature and maintained in the same sort of water bath used for processing film. In addition to establishing the correct exposure for the print by means of test strips you will also have to find the correct colour balance and adjust it by the use of the colour printing filters.

Remember that when printing from transparencies more exposure produces a lighter print and you need a filter of the opposite colour to correct a colour cast – for example a red filter to correct a cyan cast.

Right *The effect of giving both more and less than the correct exposure. The exposure latitude of a reversal paper such as Cibachrome is greater than that of negative/positive papers and up to 20 per cent variation will seldom be critical. Because of reciprocity failure, however, it is better to make major changes in the exposure by varying the aperture of the enlarging lens rather than the exposure time. Do not forget to make an allowance in the exposure when adding or subtracting filters.*

Q What is an enlarger with a colour head?
A It is an enlarger with a light source that can be controlled by dials to alter its colour quality. An ordinary enlarger with a set of colour printing filters will do just as well.

Q How do you make a test strip?
A You place a strip of the paper you will use for the finished print – about one-third of a sheet – in the most important part of the picture area and give it a basic exposure, say about five seconds. Cover about a fifth of it with a piece of opaque material and repeat the action five times. If it is all too light or too dark, repeat the test increasing or decreasing the basic exposure accordingly. When you find the most satisfactory exposure, note it down.

Above An exposed colour print being loaded into a processing drum. The print is curled with the emulsion on the inside and then fed into the drum. The room light can be switched on when the lid is in place, and the processing solutions can be poured through the light-tight hole.

Below A water bath or tempering unit. This allows the maintenance of an accurately controlled temperature. A small quantity of each solution is poured into the drum in sequence, which is then replaced in the water bath and rotated either by hand or by an electric motor.

304 PRINTS FROM COLOUR NEGS

The basic equipment required is the same as for printing from transparencies – an enlarger with a colour head or a set of colour printing filters and a print processing drum. The exposure and colour balance assessment is, however, quite different. You will need to make one or more test strips to establish these factors and they both tend to be more critical than for reversal prints. Remember that greater exposure will produce a darker print when printing from a colour negative and that to correct a colour cast you must use a correction filter of the same colour as the cast – a blue filter to correct a blue cast and so forth. Unlike reversal printing you will find that quite small variations in filtration and exposure will make a significant difference to the print quality, so it is necessary to make test strips and filtration changes in quite small increments.

It is a good idea before embarking on making enlargements to make a set of contact prints. This will not only make it easier to choose the best negatives but will also help you to assess the differences in exposure and filtration that will be needed for different negatives. It is also a good idea to have a standard negative, one which contains a full range of tones and colours including grey, and to make a good print from it, noting the exact details of filtration and exposure. Then if you experience problems or change to a different paper you can refer back to your standard negative to help identify the error or establish what changes are needed.

Above and right With colour printing, exposure and colour filtration have to be controlled. Select a filter of the same colour as the colour bias in order to eliminate it – a print which is too blue will need a blue filter. Allow for the addition or subtraction of filters by adjusting the exposure time. Each batch of paper has a recommended filter pack, which should be used for the first test to establish the correct exposure. The next tests should attempt to correct any colour bias in the first by adjusting the filter pack. The illustrations compare red, green, blue, cyan, magenta and yellow colour bias with the correct print. **Left** A Kodak Ektaflex colour printer.

Everybody, including the most experienced photographers, makes mistakes and occasionally gets disappointing results. Unfortunately the inexperienced photographer often finds it difficult to identify the cause of the error since even the most basic fault, such as the image being too dark, can be caused by a number of different factors. The following examples are intended to help you discover the exact reason for a failure and to indicate how to avoid it in the future.

Below *An unsharp image can be caused in a variety of ways. If, as in this picture, part of the image is sharp but the rest unsharp, it may be the result of the shutter speed not being fast enough to freeze a moving element in the scene. It can also be caused by inaccurate focussing or by not using a small enough aperture to obtain adequate depth of field.*

Right A pale image with washed-out colours is most commonly the result of overexposure, setting the film speed to an ISO number lower than that of the film in use or by allowing the meter to be influenced by abnormally large dark tones.

Below right A dark, murky image is invariably the result of underexposure. Setting the camera or exposure meter to a film speed faster than that of the film being used is the first thing to check. Failing to make any allowance for a filter when using non-TTL metering can also easily be done.

308 PLANNING A TRIP

Whether photography is the prime factor in your choice of destination or whether you are interested in discovering the photographic potential of a place to which you have already planned to go, the more research you do before you leave home the greater your chances of a fruitful trip. The first step should be to contact the appropriate tourist office. Most countries, regions and towns have an information centre which can provide a variety of advice and maps, usually free of charge. This may include local events and festivals, country houses and castles which are open to the public, industries and places of historical interest and many other details. If you have a special interest, they can often give up-to-the-minute information which could help you to plan a schedule or save a wasted journey, like travelling to photograph a cathedral that is covered in scaffolding.

The weather is something that can be relied upon in only a few places and it is a good idea to get some ideas of subjects you can photograph when it is raining. A good guide book, such as the Michelin series, is an invaluable aid, not just to tell you where to go but also to help you to show a taxi driver, for example, where you want to go if you are unable to speak the language. When visiting a foreign country it is vital to have just a few key words of the language, even if they are only 'please' and 'thank you' and 'may I take your photograph please?'

Above and right *A little research before you leave can often produce many ideas and useful locations for photography, such as this archaeological site in Israel and a colourful sailing regatta in Holland. A little* forethought prevents valuable time being wasted wondering where to go and what to do after you arrive.

One of the pleasures of bringing back a set of pictures from a holiday or a trip abroad is, understandably, showing them to friends. All too often, however, the pleasure is a little one-sided, and looking at other people's holiday pictures can easily become tedious even if the pictures themselves are quite good. This can be avoided if the pictures are presented well. Very often they are simply handed over in a pile and shown without any attempt at organization or thought.

The first thing to do when you get your pictures back from the processing laboratory is to edit them. You should be quite ruthless. Eliminate any that are incorrectly exposed or focussed and even those that are poorly composed or badly lit. These should only be retained for your own nostalgic interest. You should also avoid any undue repetition of images; two or three similar pictures of the same subject, no matter how good, will become tedious to the viewer. Once you have pared your pictures down to the very best then you must consider how to present them most effectively. An album is an ideal solution for smallish prints, because it enables you to decide the sequence in which they will be seen and will also help to protect them from damage. It is best to treat an album like a designer considers a book, in terms of a spread of two pages at a time upon which you can juxtapose different images which will complement each other. Select them with regard to their colour quality, format and visual effect as well as subject matter. It is well worth spending a little time simply moving them around and trying different combinations of image and layout before you decide to mount them down.

Left and below These two photographs are typical of the type of shot taken when on holiday. One is a landscape capturing the mood of the countryside, the other an interesting scene which highlights a point of interest.

One area of photography which is often neglected by otherwise careful workers is presentation of their photographs. This is a pity, since good presentation will not only greatly enhance even the best pictures but it will also prevent them from deteriorating.

It is important to remember that all photographic materials will be damaged unless they are stored away from extreme temperatures, damp and humidity and are kept in darkness when not being displayed. Colour transparencies should be mounted and protected in acetate sleeves. These can be in the form of viewpacks, which make for easy access and filing, or in the more elaborate card mounts, which also provide an effective means of presentation with more room for identification. Colour prints should be mounted for maximum protection and the surface should also be covered. Small prints can be mounted several to a page into an album with acetate covered leaves. If the pictures are carefully selected and laid out to create a pleasingly balanced arrangement this in itself is an impressive form of display. Larger prints can be dry mounted onto mounting boards and either stored in a portfolio box or a portfolio album with acetate sleeves. Extra finish and protection can be given by the use of cutout overlays or mats.

Your very best pictures can make an effective contribution to the decor of your home or office when framed, but remember to hang them well away from direct sunlight. If possible use the Cibachrome process for your prints as this is more resistant to fading.

Right *Good photographs can make an effective contribution to the decor of a room if they are chosen well and mounted and framed to complement each other. While a single strong image can often stand well on its own, it can often be more interesting to plan and arrange a group of pictures in the way shown in this illustration.*

Q Are there ways of mounting photographs other than by dry mounting?

A Yes, you can use a rubber adhesive such as cow gum or an aerosol spray mountant, but you should ensure that what you use is recommended for photographs as some adhesives contain chemicals that could cause the prints to stain or discolour.

Q Is there any way of protecting colour prints from fading when displayed?

A Some additional protection may be gained by the use of a UV absorbing glass, or spray, which can be obtained from dealers.

Q How can you clean sticky fingermarks from slides and prints?

A Special fluid is obtainable from photographic stores, but you can use carbon tetrachloride.

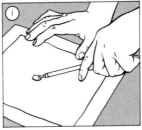

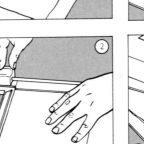

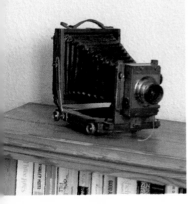

Above The stages involved in dry mounting. 1 The adhesive tissue is positioned on the back of the print and fixed at the centre with a hot tacking iron. 2 The print is trimmed flush with the tissue. 3 The print and attached tissue are positioned on the card mount and the corners are tacked down with the iron. 4 The print and mount are then slid into the heated press with a protective sheet on each side. 5 Pressure is applied for the recommended time.

314 PRESENTATION AND DISPLAY

Having taken and processed your photographs you will want to show them to their best advantage. With enlargements this will best be done in frames that can either be free standing or wall hung. A very simple but effective frame is a clip frame that anyone could make. This consists of a piece of hardboard onto which your print or prints are mounted. A piece of glass, the same size as the hardboard, is then placed on top and they are clipped together. The advantage of such a frame is that it can be made at reasonable cost to any size and is very striking when a collage of smaller-sized prints is mounted. If you have several framed enlargements try hanging them as a group. Lay them on the floor first and organize them so that they complement one another and that smaller frames balance with larger ones.

When displaying any colour print its overall colour will be affected by the light it is being viewed under. Therefore a print lit by tungsten light will take on a warmer tone than if the same print is viewed in daylight or fluorescent light. The reverse is also true.

If you do not project colour slides they can be mounted on black presentation cards. These can be purchased for individual or up to 24 slides. If you decide on this method of presentation, try to balance the cards for colour as well as theme.

To give a slide show with a degree of professionalism you could make an AV. This stands for audio visual, and it is the method of projecting slides using more than one projector and synchronizing them to a sound track. Depending on the system you use, i.e. whether you change the projection of slides manually or the soundtrack is pulsed to do it automatically, careful editing and choice of pictures is essential. Continual showing of slides in a projector will alter the dyes, and over a period of time the colour will fade. In this case you may want to use duplicate slides to protect your originals.

The effectiveness of clip-frames is shown here. A simple method of displaying your photographs that could be made to any size at minimum cost.

Q Is it true that colour prints fade if they are on display?
A Apart from Cibachrome prints, all colour prints will fade, especially those exposed to strong sunlight.

Q How can I improve my slide show?
A If you use two projectors with a dissolve unit, the change from one slide to another will be that much more pleasing on the eye. A synchronized sound track will also add professionalism.

Q What is canvas mounting?
A This is when the emulsion layer is removed from the backing paper of a print which is then mounted onto canvas to give the appearance of an oil painting.

318 INDEX